Solid State

Solid State

The Story of *Abbey Road* and the End of the Beatles

Kenneth Womack

Foreword by Alan Parsons

Cornell University Press

Ithaca and London

First published 2019 by Cornell University Press

Library of Congress Cataloging-in-Publication Data

Names: Womack, Kenneth, author.
Title: Solid state : the story of Abbey Road and the end of the Beatles /
 Kenneth Womack.
Description: Ithaca [New York] : Cornell University Press, 2019. |
 Includes bibliographical references and index.
Identifiers: LCCN 2019011210 (print) | LCCN 2019012075 (ebook) |
 ISBN 9781501746864 (pdf) | ISBN 9781501746871 (epub/mobi) |
 ISBN 9781501746857 | ISBN 9781501746857 (cloth : alk. paper)
Subjects: LCSH: Beatles. | Beatles. Abbey Road. | Rock music—
 1961–1970—History and criticism. | Rock musicians—England. |
 Sound recordings—Production and direction—England.
Classification: LCC ML421.B4 (ebook) | LCC ML421.B4 W67 2019
 (print) | DDC 782.42166092/2—dc23
LC record available at https://lccn.loc.gov/2019011210

For Geoff Emerick

What we call the beginning is often the end
And to make an end is to make a beginning.
The end is where we start from.

—T. S. Eliot

Contents

Foreword

My entire career in sound recording has been based on an incredible series of "right place, right time" events. At age eighteen, I began working for EMI Records, the parent company of Abbey Road Studios, in a tape duplication department in West London. One of my assignments was to make a copy of the master tapes of an album called *Sgt. Pepper's Lonely Hearts Club Band*. I had been a long-standing Beatle fan, but hearing that album had a profound effect on me—actually bringing me to tears during "She's Leaving Home." From that moment, I resolved to do whatever it took to seek out a job at Abbey Road. It proved easier than I thought. A few months later, I wrote to the studio manager at the time, Allen Stagg, who granted me an interview at the studios and a tour of the building with Richard Lush—a second engineer who was working on the final stages of the Beatles' *White Album*. Just before my twentieth birthday, I earned my transfer to Abbey Road, initially working in their tape library, but enjoying the experience of hearing some of the *White Album* recordings as they resounded around the building.

After barely three months of "fly on the wall" training sessions—and following a shortage of second engineers after two of them had been sacked—I was approached by Vera Samwell, the studio

bookings manager, who asked if I would lend a hand as a tape operator at the Beatles' Apple basement studio on Savile Row in central London. EMI technical engineers had recently installed a pair of four-track consoles following the complete failure of the legendary "Magic Alex" to deliver a working recording system for the studio.

When I arrived at the Apple building, I was ushered into the basement control room, where I sheepishly sidled in, red-faced, to encounter all four Beatles, George Martin, Glyn Johns, Yoko Ono, and Linda Eastman. It was quite a moment, to say the least.

Over the next few days, I operated a 3M eight-track machine that belonged to George Harrison. The machine was constantly in record mode—nonstop, except for the time it took to change reels after each tape had run out. The brief was that every moment was to be captured as they trudged through take after take of the songs on the album that eventually became *Let It Be*.

Then came the idea to go up to the roof of the Apple building and have the band perform their new songs live. We ran microphone cables provided by EMI Studios' mobile recording unit along passages in the basement and up the stairwell. On the rooftop, we set up a makeshift stage facing the office buildings on the other side of Savile Row.

It became immediately apparent that this was exactly what was needed to get some enthusiasm out of the band. The basement sessions had mostly been a series of disastrous recordings and playbacks to long faces—not to mention the added distraction of film cameras and crew everywhere. The rooftop session had a real sense of occasion, and many of the chosen takes for the *Let It Be* LP came from the rooftop performance.

I was on the roof for the entire concert, but unfortunately had positioned myself *behind* a camera on stage right, next to Paul

McCartney, so I do not feature in a single frame of the *Let It Be* movie! However, there were photos in the book accompanying the album where I can be seen sporting a striped jacket, an orange shirt, and a trendy thin black tie. I will never forget that day, although I had a bittersweet feeling that I was witnessing the last-ever live performance by the Fab Four.

My next "right place, right time" experience was as second engineer on the Beatles' final recorded statement, *Abbey Road*. It was an eye-opening experience as I witnessed how the Beatles approached studio work in contrast to live recording. It was also a privilege to work with and learn from two great recording engineers, Geoff Emerick and Phil McDonald. It's an academic point perhaps, but *Abbey Road* and *Let It Be* were released in reverse order to the dates in which they were recorded. Just as I had anticipated that the rooftop concert would be their last performance, I also knew that, realistically speaking, *Abbey Road* would be the last time the Beatles would be the Beatles. But even still, I felt enormously fortunate to have been one of the few who experienced the creation of their magic firsthand.

In the post-Beatles period, I went on to work with Paul on the *McCartney* and Wings' *Wild Life* albums, and with Harrison and Phil Spector for a couple of sessions on *All Things Must Pass*, for which I served as second engineer. Having progressed to a fully-fledged engineer—following arguably my greatest "right place, right time" moment, the recording of Pink Floyd's *The Dark Side of the Moon*—I engineered Paul's *Red Rose Speedway* album, as well as the singles "My Love" and "C Moon."

That brings us to the book that you presently hold in your hands. Impeccably researched, *Solid State* is an accurate history not only of the characters and personnel involved in the Beatles' final album (including myself, I am pleased to add), but also digs

deeper behind the scenes into the technical aspects of the recording equipment and the musical instruments used by the Fab Four in the production of this timeless LP. In the coming pages, you will become aware of many hitherto unknown facts about the making of *Abbey Road* and the events that led to the eventual demise of the greatest rock band that ever was.

Alan Parsons
Music producer, engineer, musician, and composer

Solid State

Introduction

When it was released in the autumn of 1969, the Beatles' *Abbey Road* album enjoyed generally favorable reviews, with the likes of *NME* (*New Musical Express*), *Rolling Stone*, and *Time* rewarding the Fab Four's latest album with strong notices. For the most famous band on the planet—having commercial and critical dominion over the world of pop music for nearly six years—it was a very enviable par for the course. But other reviews were mixed, even disparaging at times. The venerable *New York Times* took surprising issue with the Beatles' offering, deriding the LP's contents as a clear departure from their earlier, ostensibly more sophisticated and fully realized works. In his *New York Times* review of October 5, 1969, Nik Cohn gave the Fab Four their props, lauding *Abbey Road*'s concluding medley as "the most impressive music they've made since *Rubber Soul.*" But his admiration ended there. For the balance of his review, Cohn didn't pull any punches, criticizing the majority of the LP's songs as ranging from "pretty average stuff" to "unmitigated disaster." For Cohn, something didn't sound quite right on *Abbey Road*. "The words are limp-wristed, pompous, and fake," he wrote. The latest compositions from George Harrison were "mediocrity incarnate," and he asserted that "the badness ranges from mere gentle tedium to

cringing embarrassment." What exactly was Cohn hearing in those tracks that made him feel that way?[1]

In spite of Cohn's relatively tender age, the twenty-three-year-old Brit had already earned considerable stature among the music critics of his day. During the previous winter, the Who's Pete Townshend had discussed an early draft of his rock opera *Tommy* with Cohn, who helpfully suggested that the songwriter round out his deaf, dumb, and blind protagonist by reimagining him as a pinball wizard, a shrewd recommendation that resulted in the eventual album's most recognizable flourish and one of the Who's signature concert staples. When Cohn's review of *Abbey Road* made the pages of the *New York Times*, the rock world took notice, just as it had more than two years earlier when Richard Goldstein lambasted the Beatles' *Sgt. Pepper's Lonely Hearts Club Band* in the same paper. As with Cohn, Goldstein heralded a new breed of cultural critic. A wunderkind of sorts at just twenty-two years of age, he had already published a book on campus drug abuse and, even more impressively, had joined the staff of the counterculture's most esteemed crew of writers at the *Village Voice*. While the whole of the Western world seemed to embrace *Sgt. Pepper* as the purest distillation yet of the group's aesthetic vision—including Robert Christgau, Goldstein's colleague at the *Voice*, who praised the album in *Esquire* as "the epitome of studio rock"—Goldstein pooh-poohed the LP as "a pastiche of dissonance and lushness. The mood is mellow, even nostalgic. But, like the cover, the overall effect is busy, hip, and cluttered. Like an over-attended child *Sgt. Pepper* is spoiled. It reeks of horns and harps, harmonica quartets, assorted animal noises, and a 91-piece orchestra."[2]

For the Beatles, critical jests from the likes of Cohn and Goldstein hardly resulted in a wound, much less a scar. As artists, they were far more unhinged in December 1967 in the aftermath of

Magical Mystery Tour's television debut. After the film's BBC premiere on Boxing Day, the reviews were swift and merciless. "The bigger they are, the harder they fall. And what a fall it was," James Thomas wrote in the *Daily Express*. "The whole boring saga confirmed a long held suspicion of mine that the Beatles are four pleasant young men who have made so much money that they can apparently afford to be contemptuous of the public." Meanwhile, the *Daily Sketch* couldn't help poking fun at the Beatles' recent forays into Eastern mysticism: "Whoever authorized the showing of the film on BBC1 should be condemned to a year squatting at the feet of the Maharishi Mahesh Yogi." For its part, the *Daily Mirror* condemned *Magical Mystery Tour* as "Rubbish . . . Piffle . . . Nonsense!"[3]

For the Beatles, it was a critical drubbing that had proved difficult to stomach—especially after enjoying the artistic heights of *Sgt. Pepper*. As Hunter Davies, the band's authorized biographer, commented, *Magical Mystery Tour* marked "the first time in memory that an artist felt obliged to make a public apology for his work." Indeed, McCartney later acknowledged the problems: "We don't say it was a good film. It was our first attempt. If we goofed, then we goofed. It was a challenge and it didn't come off. We'll know better next time." Paul added, perhaps inadvisably, "I mean, you couldn't call the Queen's speech a gas, either, could you?"

As perhaps the Beatles' greatest artistic failure, *Magical Mystery Tour* marked an anomaly in the band's unprecedented career—not merely because of the television movie's aesthetic shortcomings but also because of the sheer fact that it was decidedly *different*. It stood out from their extant musical and filmic corpus.[4]

In its own way, *Abbey Road* too acted as an outlier, somehow distinct from a clutch of landmark LPs that included *Rubber Soul* (1965), *Revolver* (1966), *Sgt. Pepper* (1967), and *The Beatles* (1968),

popularized as *The White Album*. When it came to *Abbey Road*, Cohn wasn't the only critic who winced in dismay at the Beatles' latest offering. In his November 1969 review in *Rolling Stone*, Ed Ward lambasted *Abbey Road* for treading "a rather tenuous line between boredom, Beatledom, and bubblegum." Ward's critique existed in stark variance with the opinion of his colleague John Mendelsohn, who had rewarded *Abbey Road* with a rave review in the pages of *Rolling Stone* that same month. In contrast with Cohn, who lauded the medley as the LP's solitary saving grace, Ward dismissed the song cycle's component parts as "so heavily overproduced that they are hard to listen to." Writing in the *Guardian*, Geoffrey Cannon followed suit, observing that the Beatles' "old rock and roll had energy and purpose. And this is what *Abbey Road* has not." Ultimately, the Beatles' new LP is "a slight matter," Cannon added. "Perhaps to their own relief, the Beatles have lost the desire to touch us. You will enjoy *Abbey Road*. But it won't move you." Writing in *Life* magazine, Albert Goldman echoed Cannon's complaints, remarking that the medley "seems symbolic of the Beatles' latest phase, which might be described as the round-the-clock production of disposable music effects."[5]

Abbey Road was hardly the first work of art to be met with critical scorn in spite of its creators' contemporary renown. Cultural history is replete with exemplars, great artists of their day who have been maligned by the same critics who hailed their apotheosis. In this way, the Fab Four were no different from, say, James Joyce (or Toni Morrison later). As Christgau opined in *Esquire*, the Beatles had been writ large not merely as the most revolutionary artists of their time, but of *all* time. By the advent of *Pepper*, Christgau observed, the Beatles had been compared, "unpejoratively and in order, to Alfred Lord Tennyson, Edith Sitwell, Charlie Chaplin, Donald Barthelme, Harold Pinter, and T. S. Eliot—and *not* to Elvis

Presley or even Bob Dylan." As with the other revered artists of the preceding few centuries, the Beatles' latest works were treated as bravura cultural events. In the run-up for these, the critical main readies itself for a veritable feast of sublimity, keeping in mind the opportunity for a high-profile media massacre if it finds the awaited work lacking in style or substance. Take none other than Beethoven's Symphony No. 9 in D Minor. Originally premiered in Vienna in May 1824, Beethoven's Ninth finally made its London debut in March 1825, when it was presented by the Philharmonic Society of London under the conduction of Sir George Smart. The prominent British music journal *Harmonicon* minced few words in delivering its pronouncement, writing in a banner editorial, "We find Beethoven's Ninth Symphony to be precisely one hour and five minutes long; a frightful period indeed, which puts the muscles and lungs of the band, and the patience of the audience, to a severe trial."[6]

And then there was the twentieth century, when a new era of mass communication and mass cultural events took hold, when popular journalism gained an international reach. Long before Cohn commenced his dissection of *Abbey Road* in the *New York Times*, influential critical publications took aim at the larger-than-life writers and artists of the day. Take, for example, the publication of James Joyce's *Ulysses* by the Paris-based Shakespeare and Company bookshop in 1922. Marking the occasion in its distinctive salmon-colored pages, the weekly *Sporting Times* pulled no punches in reviewing the Irish writer's most experimental effort to date. "James Joyce is a writer of talent, but in *Ulysses* he has ruled out all the elementary decencies of life and dwells appreciatively on things that sniggering louts of schoolboys guffaw about. In addition to this stupid glorification of mere filth, the book suffers from being written in the manner of a demented George Meredith.

There are whole chapters of it without any punctuation or other guide to what the writer is really getting at. Two-thirds of it is incoherent, and the passages that are plainly written are devoid of wit, displaying only a coarse salacrity [*sic*] intended for humor." A few years later, L. P. Hartley famously pummeled F. Scott Fitzgerald—the preeminent short-story author of his time—on the publication of his novel *The Great Gatsby* (1925). "Mr. Scott Fitzgerald deserves a good shaking," Hartley wrote in the *Saturday Review*. "Here is an unmistakable talent unashamed of making itself a motley to the view. *The Great Gatsby* is an absurd story, whether considered as romance, melodrama, or plain record of New York high life."[7]

In terms of the critical reception of *Abbey Road*, the reviews of *Ulysses* and *The Great Gatsby* are doubly instructive. On the one hand, they remind us about the wider critical lens devoted to creative stalwarts, but, on the other hand, they demonstrate the kinds of critical reception that artists sometimes experience during moments of technical or stylistic shift. In the cases of Joyce and Fitzgerald, *Ulysses* and *The Great Gatsby* marked key transformations in each writer's career. For his part, Joyce's novel was a radical departure from such earlier works as *Dubliners* (1914) and *A Portrait of the Artist as a Young Man* (1916), which must have seemed like downright conventional narratives in comparison to the brashly experimental *Ulysses*. In terms of the reception of *The Great Gatsby*—Fitzgerald's novel following the publication of *This Side of Paradise* (1920) and *The Beautiful and Damned* (1922)—the author wasn't merely under fire for deigning to present a tawdry portrait of the Gilded Age. With *Gatsby* he had dared, for the third time, no less, to present himself to the literary set as a serious novelist—in contrast with his renowned persona as author of popular short stories. In both cases, the artists had opted to defy

the understandable expectations of their audience, who had grown comfortable with the Joyce and Fitzgerald of old. By any measure, the writers' respective radical experimentation and generic shifts played a signal role in the critical reception of their latest novels.

With *Abbey Road*, the Beatles experienced a similar, albeit slightly more nuanced, twist of critical fate. The overarching common denominator among the LP's reviews, both for good and ill, was that it sounded *different*. For writers like Cohn, Ward, and Cannon, the album reeked of overproduction. They were not alone. In his rave review in a December 1969 issue of the *Times*, William Mann praised the album as "teeming with musical invention," while lamenting that some listeners would likely deride the LP's intricate production for being too "gimmicky." This was a remarkable observation after the soaring technological heights that the Beatles had achieved with *Sgt. Pepper* only a few years earlier. In addition to emerging as the soundtrack for 1967's Summer of Love, the groundbreaking LP had dazzled the world of music and art for its high-concept production as much as the Fab Four's timeless compositions (if not more). By any comparison, *Abbey Road* made for a more demure listening experience in comparison to *Sgt. Pepper*'s revolutionary Technicolor soundscapes. So why, then, did *Abbey Road*'s critics continue to call out the Beatles' latest record so explicitly because of its production?[8]

Plainly and simply, *Abbey Road* sounded vastly different from the Beatles' previous studio efforts due to a series of technological upgrades that EMI Studios had undertaken during the late autumn months of 1968—namely, the adoption of a new eight-track mixing desk that afforded the bandmates and their production team with solid-state technology after years of working, for the most part, with tube equipment. The sound of the Beatles that had thrilled the world—the "maximum volume" that their producer

George Martin had coaxed out of EMI's aging studio gear—had been conspicuously altered by the subatomic properties inherent in solid-state electronics. For workaday fans and seasoned audiophiles alike—who likely had little, if any working knowledge about the equipment upgrades at EMI Studios—the sonic differences were palpable. As far as they were concerned, the sound of the Fab Four had been—*somehow*—irrevocably changed.[9]

But like all works of art, musical or otherwise, *Abbey Road* was the sum of its parts, as well as the result of a very particular socio-historical context. The LP existed as only the latest advance along a creative continuum that had begun with the group's earliest recordings. The Beatles had progressed—often with remarkable leaps in songwriting and musicianship—from the primitive to the virtuosic. Explicating the role of solid-state electronics in *Abbey Road*'s production affords us with a signal means for understanding the ways in which recording and instrumental technology acted as potent ingredients in the LP's status as a cultural event. Of course, technology was only partly responsible for the album's enduring acclaim. In many ways, *Abbey Road* was the result too of a highly particularized instant in time when technical innovations and appreciable advances in the band members' performances and musicianship came together in astonishing, even unexpected harmony. When the four lads from Liverpool gathered at EMI Studios in the early spring of 1969, the notion of going forward in any capacity as a working unit was tenuous. The January 1969 *Get Back* sessions had stretched the group's interpersonal relations to the brink of disbandment. At mid-month, George Harrison had briefly quit the Beatles—famously uttering "See you 'round the clubs" as he made his exit—only to be coaxed back via a carefully negotiated Fab Four détente. By month's end, they had climbed atop the roof of their Savile Row office building for a final attempt at

live performance—a last hurrah with portents that were not lost
on anyone fortunate enough to be in attendance on that blustery
January day. And if the rooftop concert had spelled the end of the
Beatles—well, nobody in their inner circle, least of all the band-
mates themselves, would have been surprised.

The fact that *Abbey Road* came into being in any form was re-
markable under the circumstances. Reuniting in *Get Back*'s de-
structive wake seemed all but impossible, especially to Martin, who
had been frozen out from the band's inner workings for months.
Martin felt that the January 1969 sessions, with so much infight-
ing and at times lackluster musicianship, marked a pitiful way
for their partnership to conclude. Yet when the bandmates made
their way back to EMI Studios over the following months—when
they decided to give it one final go before slipping into the waiting
arms of history—the Beatles somehow made it work. Aided by the
studio upgrades for which they had long clamored and their own
evolving talent and artistry, they willed one last production into
being. Flourishing under these remarkable conditions, they honed
an improbable musical epitaph for the ages.

1

EMI TG12345 Mk1

In February 1969, the Beatles were at a crossroads. There was plenty to celebrate, as usual, for the world's most commercially and critically successful act. Their ninth LP, *The White Album*, was lording it over the charts and well on its way to becoming the biggest-selling album of the 1960s. Their most recent single, "Hey Jude" (backed with "Revolution"), was a global hit, and they were two years into a contract with the EMI Group that promised to keep their coffers overflowing until 1976. ("EMI" was at first an initialism for "Electric and Musical Industries.") But then there was the issue of the group's management, which was in disarray. Brian Epstein, the manager who had guided them to global stardom, had been dead for eighteen months, a period that found them adrift and seemingly without direction in the wake of their universally acclaimed *Sgt. Pepper's Lonely Hearts Club Band* album. In the intervening months, they had alienated their magisterial producer George Martin, whom they had begun shunting aside during the sessions associated with *The White Album*.

And then there was their business empire itself. Announced at a press conference at New York City's Americana Hotel in May 1968, their creative music and film ventures, associated with Apple Corps, had gotten off to a rocky start. John Lennon remarked in January

1969 that if the company continued to lose money at its current rate, the Beatles would be bankrupt by midsummer. To make matters worse, Lennon and girlfriend Yoko Ono had developed a dependence on heroin, which the Beatle later claimed to have developed in the wake of a raid on his Montagu Square flat by Detective-Sergeant Norman Pilcher's notorious drugs squad. Lennon attributed Yoko's mid-November 1968 miscarriage to the raid, and he later remarked "we were in real pain" (after the miscarriage). In truth, Lennon's experimentation with the drug had begun much earlier—most likely during Ono's summer 1968 exhibition at London's Robert Fraser Gallery. "I never injected," he liked to say. "Just sniffing, you know." But as journalist and Lennon confidant Ray Connolly observed, Lennon "rarely did anything he liked by halves. Before long, heroin would become a problem for him." Meanwhile, Lennon's addiction had his bandmates alarmed. By the advent of the *Get Back* sessions, Ono openly joked about shooting heroin as the couple's form of exercise. "The two of them were on heroin," said McCartney, "and this was a fairly big shocker for us because we all thought we were far-out boys, but we kind of understood that we'd never get quite that far out."[1]

In January 1969, the group's fortunes seemed to be taking a turn for the worst as they attempted to subvert the high-gloss production associated with *Sgt. Pepper* by virtue of a lo-fi return to their musical roots. With producer Glyn Johns at the helm and Martin relegated to the sidelines, they had slogged through the recent *Get Back* project only to triumph over their interpersonal demons with the January 30 rooftop concert and a flurry of sessions that resulted in a spate of recordings that would become classics, including "Let It Be" and "The Long and Winding Road." If anything, their saving grace, demonstrated time and time again over the years, was their capacity to wrest victory from the jaws of defeat. As far back

as April 1964, John Lennon had penned "A Hard Day's Night" in the nick of time to provide a title track for Richard Lester's feature film at the height of Beatlemania. And then there was the November 1965 production of *Rubber Soul*, which found Martin and the Beatles barely beating the clock as they brought the album to the finish line in time for its bravura December release (in time for Christmas). As recently as October 1968, they'd been at it again, with the increasingly estranged Martin and engineer Ken Scott joining Lennon and McCartney for a breakneck, twenty-four-hour mixing session in which they prepared and sequenced the sprawling *White Album* for release.

But with Apple Corps spiraling out of control and the battle royal for the group's management getting increasingly ugly—would it fall into the hands of brash American businessman Allen Klein, whom Lennon, George Harrison, and Ringo Starr favored, or Lee and John Eastman, McCartney's attorneys and future in-laws?—the Beatles' ability to move forward as a creative team was hindered. As history knows, they would put aside their differences, if only temporarily, just long enough to extract one final triumph via their *Abbey Road* LP. But how did they manage to pull it off against all odds? Yes, they were at the height of their powers, but they were struggling. How were they able to wrest new sounds out of their weary partnership that fateful final summer together?

As it happened, the last of the band's remarkable achievements as recording artists was borne on the back of an EMI Studios mixing desk. The facilities located at 3 Abbey Road had served, with only a few notable exceptions, as the Beatles' studio of choice since they had first alighted there on June 6, 1962, for their inaugural recording session with Martin. Nestled among the stately Edwardian homes of London's St. John's Wood, the studios had been built in 1830 as a luxurious residence along the footpath to

nearby Kilburn Priory, a twelfth-century abbey that fell into the hands of the Crown after Henry VIII dissolved the monasteries in 1537. Known as Abbey Lodge, the main house comprised nearly twenty-three thousand square feet and included five reception rooms, nine bedrooms, a wine cellar, a substantial rear garden, and servants' quarters. In its last years as a private residence, Abbey Lodge was divided into flats. One of the building's last tenants was Maundy Gregory, a one-time theatrical producer and notorious political fixer who was rumored to have murdered his flatmate, famed British actress Edith Grosse, after persuading her to change her will and name him as the sole beneficiary of her £18,000 estate.

Purchased by the Gramophone Company in 1929 for £16,500 and rechristened EMI Studios, the facility officially opened its doors in November 1931—scant months after Columbia Graphophone had merged with the Gramophone Company and formed the EMI Group. In the early 1930s, English composer Edward Elgar conducted recording sessions at EMI Studios for *Pomp and Circumstance*, the series of five marches that would immortalize his name. (The first march's tune "The Land of Hope and Glory" emerged as a British sporting anthem and signature melody for American graduation ceremonies.) During EMI Studios' early years, the facility developed a reputation for classical recordings by the likes of Yehudi Menuhin and Pablo Casals. In keeping with EMI's air of formality and British aplomb, studio personnel sported white lab coats. In 1940, Winston Churchill visited EMI to make propaganda recordings for the war effort. Seeing the white-coated engineers milling about, the prime minister famously quipped that there were so many white coats in evidence that he thought he'd ended up in a hospital.[2]

During the Beatles' heyday, the EMI complex comprised three studios constructed behind the original estate, which served as the

administrative quarters. The largest facility, Studio 1, which can hold a full orchestra and chorus, still accommodates much of the orchestral recording at present, with Studio 2 and Studio 3 providing progressively smaller creative spaces. During the seven years in which they had been in residence at Abbey Road, the Beatles had witnessed a number of studio improvements, including the facility's shift from twin-track to four-track recording. By 1968, they were eager to make the shift to eight-track, which was rapidly emerging as the industry standard. Formally known as the EMI TG12345 Mk1, the eight-track desk had finally been installed at EMI Studios in late 1968, scant days after the group had completed work on *The White Album*. By that juncture, the REDD.51 recording console, EMI Studios' mainstay technology since January 1964, had reached the end of a remarkable era that had seen the Beatles change popular music with a slew of hit singles and one landmark LP after another. From an original design by German audio engineer Peter K. Burkowitz, the legendary console drew its name from the Record Engineering Development Department, which had been founded by EMI technical engineer Len Page in 1955. The REDD.51 supplanted the REDD.37, the mixing desk via which the Fab Four had fashioned the early hits of Beatlemania, from "Please Please Me" and "Twist and Shout" to "She Loves You" and "I Want to Hold Your Hand." Given its signal role in the evolution of the Beatles' sound, the four-track REDD.51 machine came to be known as the "The Beatles' Console." The REDD.51 famously featured two EQ (equalization) settings, "Pop" and "Classic," reflecting the binary thinking of a bygone era in which records were understood as being from either one of two vastly different camps, a distinction that the Beatles blurred via the incorporation of symphonic, experimental, and ambient sounds into their evolving musical palette. The REDD.51 technology was distinguished

by the mixing desk's valve circuitry, which relied on vacuum tubes for its power supply and produced recordings characterized by a dynamic frequency range, especially on the bottom end.

Recognizing that the REDD.51 was nearing the end of its heyday—and with transistor technology having come to dominate the global electronics marketplace—EMI Studios' white-coated technical engineers had begun making preparations for enhancing the facility's multitrack recording capabilities long before the TG12345 came to fruition. In addition to the technological leaps associated with state-of-the-art electronics, the features coupled with EMI's new mixing desk had their origins in the increasing sonic demands of the record conglomerate's artists, producers, and engineers. In 1967, EMI Studios' technical staff had begun holding meetings with the design engineers from the company's Central Research Labs with the mission of designing a more comprehensive mixing console that could not only handle the current expectations of the studio's clientele but also the anticipated technological shifts lurking just beyond the horizon. With their new design, the EMI engineers intended to supplant their reliance on tube circuitry with solid-state electronics. The prototype console for the TG12345 arrived at EMI Studios in June 1968. The machine's TG prefix was an abbreviation for "The Gramophone Company," an anachronistic reference to EMI's parent organization, which was founded in 1898. While the TG prefix was intentional, the desk's sequential 12345 suffix was purely a matter of coincidence. Working in the bowels of EMI Studios, the technical engineers at Abbey Road carried out an extensive testing phase with the TG12345. As the engineer Alan Parsons later recalled, studio personnel soon began to refer to the console as "the TG" or "the transistor desk," in reference to its solid-state circuitry. In comparison with the REDD.51, the new mixing console was enormous, with twenty-four microphone

inputs and eight outputs. Over the next several months, the engineers familiarized themselves with the operation of the new desk. As Amp Room engineer Brian Gibson later recalled, "I remember when we first got the TG in 1968. We had the Mark I, which was more or less a prototype, and Abbey Road used to have what they called the 'Experimental Room' [room 65]. It was a little room off to the side of the studios which had tie-lines through to all of the studios. . . . And I remember everybody was really knocked out at how *clean* the thing sounded. It had this sort of top-end sparkle, if you like, which I suppose is characteristic of solid-state equipment and maybe slightly lacking on some of the valve, vacuum tube designs. But I also remember that everyone thought that because it was so huge, it would be difficult to use—compared to the REDD desks, where you could reach every control whilst sitting down. Little did they know how big consoles would become!"[3]

With its testing phase completed, the TG console was finally installed in Studio 2 during the weekend of November 23, 1968, the day after the release of *The White Album*. EMI personnel were immediately struck by the size of the new mixing desk, which was six and a half feet wide—two feet wider than the REDD console that it replaced. But the TG console's size was deceiving. Weighing 500 pounds, it was 250 pounds lighter than its predecessor, thanks to its transistors replacing the REDD console's hefty valve equipment. The width of the new console required the remodeling of Studio 2 to accommodate it. While the REDD desk had been situated in the middle of the control room, affording production staff with a vantage point that allowed them to observe the action below on the studio floor, the TG console's extra width rendered this impossible. To remedy the problem, studio personnel shifted the new console 90 degrees in relation to the control room window. Anyone seated at the mixing desk now faced a newly installed

window peering into room 2A, the machine room where the studio's corresponding 3M eight-track recorder was housed. When production staff began working the new desk, they were often astounded by its seeming complexity and the sheer amount of gadgetry now at their disposal. The new console featured twenty-four faders compared to the fourteen sported by the REDD.51 desk. Perhaps most significantly, the TG console was eminently more nimble. Not only did each of the twenty-four faders provide considerably more flexibility for its user, each of the console's faders had its own EQ settings that allowed its operators to have greater control over the frequency spectrum. The TG console also possessed far greater panning control across the sonic field than the REDD.51.[4]

Now working in conjunction with one of EMI's newly installed 3M eight-track machines—which themselves had been sequestered, until other forces intervened, as the EMI techies ran them through their paces that same summer—the TG console in Studio 2 made its debut on a session, produced by Columbia's Norrie Paramor, by Cliff Richard and the Shadows (née the Drifters), the beat band that pioneered British pop music's shift from skiffle to rock and roll in 1958 with "Move It." For the TG console's inaugural November 1968 session, Paramor recorded a German-language version of Richard's "Don't Forget to Catch Me" ("Zärtliche Sekunden") for the singer's forthcoming West German release *Hier Ist Cliff*. As it happened, producers like Paramor and Martin required very little training on the new equipment, as they hardly ever touched the consoles. "It was considered bad protocol," Parsons later commented. Instead they left such duties almost entirely in the hands of the studio's engineering staff. As veteran maintenance engineer Ken Townsend later observed, the workaday balance engineers of the day relied heavily on EMI Studios'

maintenance engineers to handle the technical aspects of procuring microphones and deal with the more complex tasks associated with the mixing desks. In so doing, the maintenance engineers created a turnkey operation of sorts for Martin and his colleagues. When a given session commenced, said Townsend, producers and their balance engineers could go straight to work, saving valuable studio time for recording new music. Not surprisingly, an inevitable rivalry developed among the maintenance and balance engineers, with the former deriding the balance engineers as "jumped-up button pushers" because of the way they would step into the control room and take over after the maintenance engineers had already done the technical legwork.[5]

After its installation, the TG console was all the rage at EMI. The company newsletter, *EMINews*, with the bravado that one might expect from an in-house publication, described the mixing desk as "the most comprehensive sound mixing console in the world." *EMINews* highlighted the space-age qualities of the console, "with no less than 479 knobs and controls and 37 meters for use by the recording engineer." There was no denying the technical leap that EMI's engineers had achieved with the console, which boasted three times the microphone inputs associated with the REDD.51, as well as built-in limiters/compressors on every channel. The possibilities of the recording studio had been expanded considerably.[6]

For the Beatles, when they finally laid eyes on it, EMI's newfangled mixing desk had been long overdue. As a working unit they shared an abiding suspicion that they had been hoodwinked by the record conglomerate's management into believing that their primary recording environs were state-of-the-art. To a man, the Beatles believed that they knew better, that there were more dazzling soundscapes to be had in many other studios beyond EMI. As far back as February 1966, as the Beatles prepared to record their

Revolver album, they had looked to the United States, most particularly to Stax Studio in Memphis, for the recording environment of which they had long dreamed. They even went so far as to dispatch Epstein to Memphis in March that year to scout out recording studios with equipment superior to the existing technology at EMI Studios. Martin had been skeptical about the quality of EMI's technology since at least the late 1950s—especially after he had taken in a session with Frank Sinatra at Capitol Studios during the recording of Sinatra's *Come Fly with Me* LP. The producer was particularly impressed with the Capitol production team's approach to stereo sound, which he considered a "wonderful technique" that was light-years ahead of EMI's practices at the time.[7]

As for the Beatles, the bandmates were especially interested in being able to capture the "Stax sound" associated with such American acts as Wilson Pickett, Otis Redding, and Booker T. and the MG's, among others. Stax Studio was especially alluring to the Beatles because of the unique sound that the facility produced due to the former cinema's sharply sloping floor. As McCartney remarked at the time, "There's some extra bit they get to the sound over there that we haven't quite got. You put a record of ours [on after] an American record and you'll find the American record is always a fraction louder and it has a lucid something I can't explain." To the bandmates' minds, there were plenty of recent examples that the Beatles could recount—most significantly, the Rolling Stones' international hit "(I Can't Get No) Satisfaction," which they had recorded at Chicago's Chess Studios and Hollywood's RCA Studios. In the end, the Beatles had become galvanized over a spate of new compositions—such as "The Void," which would later morph into "Tomorrow Never Knows"—and they would opt for expediency and familiarity over their pipe dreams of an American recording mecca and assemble at EMI Studios on April 6, 1966, along with

Martin and their newly promoted balance engineer, twenty-year-old wunderkind Geoff Emerick.[8]

Until EMI got its TG console, the Beatles' quest for new production vistas did not end. They imagined what might be possible if they had more tracking at their fingertips. If only they could move beyond the four-track recording that was in vogue at EMI Studios, they reasoned, they might be able to more fully capture the expansiveness of their revolutionary artistic vision. Martin was forced to improvise increasingly complex workarounds to facilitate Lennon and McCartney's evolving creative imaginations. Take February 1967, for example, when Martin had temporarily stayed the bandmates' yen for more spacious soundscapes as he prepared to record the symphonic track associated with "A Day in the Life," *Sgt. Pepper*'s dramatic climax. Back in those days, Martin called the shots at EMI's Abbey Road complex, shuttling between its three studios to fulfill the Beatles' visions, no matter how outlandish. Formerly EMI's Parlophone label head, Martin's influence at the studio was rooted, not surprisingly, in his commanding role in the Beatles' creative universe, and he knew it. Earlier, in the autumn of 1965, he had left the record conglomerate's employ to strike out on his own as a freelancer, having grown tired of EMI's conservative, pecuniary ways. But while he may no longer have been on the EMI payroll, Martin's opinions more often than not held sway at Abbey Road. During a visit to EMI Studios in the winter months of 1967, David Crosby had taken notice of Martin's interactions with the Beatles. As the Byrds' rhythm guitarist later recalled, watching the producer at work with the Fab Four left him with a single, ineluctable conclusion: "That dude was in *charge*."[9]

On the morning of February 10, 1967, with a half-orchestra waiting in the wings for an evening session at EMI Studios, Martin approached Ken Townsend with a whale of a problem on his hands.

A veteran of seventeen years at EMI Studios, Townsend was no stranger to addressing the Beatles' whims. For example, after hearing Lennon complain about their arduous task of double-tracking his vocals during the spring of 1966, Townsend had invented Artificial Double-Tracking (ADT) as an innovative means for not only saving valuable studio time but also affording Martin with a dynamic capacity to manipulate the sounds that the group produced via their voices and instruments alike. When it came to "A Day in the Life," though, the existing rhythm track and superimpositions had already gobbled up much of the recording real estate.

For his part, Martin needed to double EMI Studios' standard four-track recording capabilities in order to accommodate the orchestral overdubs that Lennon and McCartney had in mind. As Townsend later recalled, "George Martin came up to me that morning and said to me, 'Oh Ken, I've got a poser for you. I want to run two four-track tape machines together this evening. I know it's never been done before, can you do it?' So I went away and came up with a method whereby we fed a 50-cycle tone from the track of one machine then raised its voltage to drive the capstan motor of the second, thus running the two in sync. Like all these things, the ideas either work first time or not at all." For the time being, the Beatles' aspirations were met, as Townsend's eleventh-hour effort resulted in a recording of uncompromising power and effect. For "A Day in the Life," Martin had succeeded in building a veritable wall of sound by recording his half-orchestra four times on all four tracks supplied by Townsend and ultimately mixing them down to one. As a consequence of Townsend's workaround, Martin was able to afford the bandmates with the sonic equivalent of 160 musicians![10]

But by the advent of the recording sessions associated with *The White Album*, makeshift workarounds were no longer acceptable

to the Beatles. After all, they were the biggest act in the world, and they reasoned, understandably under the circumstances, that they should accept nothing short of cutting-edge production capabilities from the EMI Group, for whom they had produced hundreds of millions of pounds in revenue. The Beatles had taken to recording at Trident Studios in order to take advantage of the Soho facility's Ampex eight-track recording capabilities. Besides EMI Studios, where the band recorded the lion's share of their output, Trident served as the site for fifteen Beatles sessions in the late 1960s, including the landmark recording session devoted to "Hey Jude." Norman and Barry Sheffield, Trident's proprietors, could rightly boast that their studio introduced the first eight-track recording desk in London; it was the feature that drew the Beatles to the Soho facility in the first place. But unbeknown to the bandmates, the personnel at EMI Studios had been secretly working on an eight-track machine of their own. As it happened, EMI Studios had been in possession of three 3M eight-track recorders since May 1968, when sessions for *The White Album* had commenced, but studio techs had not yet afforded any of their recording artists with access to the new technology.

Over the summer months of 1968, EMI Studios' maintenance personnel had been putting the recorders through their paces and making various adjustments. "Whenever we got in a new piece of equipment at Abbey Road it went to Francis Thompson, our resident expert on tape machines, and he would spend about a year working on it," Townsend later recalled. "The joke was always that when he'd finished with it he'd let the studios use it! He was unhappy with the overdub facility, it didn't come directly off the sync head as it did with the Studer four-track, and there was no facility for running the capstan motor varispeed from frequency control. Francis had to make some major modifications." Even as studio

personnel surreptitiously tinkered with the eight-track desks, the Beatles were relentless in badgering the likes of Townsend for studio upgrades. As Townsend recalled, "I remember George Harrison asking why we hadn't got one—'When are you going to get an eight-track, Ken?'—and we had a wooden replica of the new desk EMI was making to go with it. He said, 'When are you going to get a real one, not a wooden one?'"[11]

By September 1968, the Fab Four had had enough. In an event that would come to be known as the "Great Tape Recorder Robbery" among studio insiders, they finally took matters into their own hands. On September 3, they learned about the eight-track machines in Thompson's office and decided to "liberate" one of them for their immediate use. "When you've got four innovative lads from Liverpool who want to make better recordings, and they've got a smell of the machine, matters can take a different course," technical engineer Dave Harries later recalled. With Scott and Harries as their willing confederates, the bandmates removed one of the 3M machines from Thompson's office and installed it in Studio 2, the group's favorite haunt at EMI Studios, where they resumed work on "While My Guitar Gently Weeps." For the Beatles, commandeering the 3M machine must have felt like a victory in the face of EMI's arcane ways, a covert DIY opportunity for the biggest artists on the record conglomerate's roster—on the planet, really—to take matters into their own hands and hijack the technology that they so desperately coveted.[12]

But finally, by February 1969, when the Beatles had reconvened after the trials and tribulations of the *Get Back* project, the management at EMI Studios was fully prepared to acquiesce to the bandmates' expectations for cutting-edge technology. Indeed, the TG console eight-track mixing desk had been installed and ready for production in Studio 2 for a few months. But when the time

came to record their new LP, the Beatles were not in evidence in the St. John's Wood studio that had become synonymous with their recording exploits. In fact, it wasn't even possible, as Studio 2 was already booked and hosting Cliff Richard and producer Norrie Paramor during the last few weeks of the month. EMI Studios enjoyed an especially busy period during the early months of 1969, with Richard making progress on *Sincerely Cliff,* his latest LP, while the Hollies were beginning work on *Hollies Sing Dylan.* So it would be that the Beatles would begin work on *Abbey Road,* not at Abbey Road (as EMI Studios would come to be called) but some three miles away at Trident, where they had developed a working familiarity with the studio's Ampex eight-track machine.

There were other issues at play in the Beatles' decision to work outside of the (mostly) friendly confines of EMI Studios. For one thing, Apple Studio was no longer available. The Beatles' original concept for a basement studio in their office building at 3 Savile Row had been a world-class, state-of-the-art recording facility. When Martin scouted the premises in mid-January, he quickly realized that the group's dream of owning their own recording studio had come up short—at least for the time being. In order to make the space more palatable to the band's evolving expectations, Martin had arranged for portable equipment to be delivered from EMI to the basement studio. The whole business had been necessitated by the shenanigans of Alexis "Magic Alex" Mardas, a crackpot would-be inventor who had promised to build a seventy-two-track recording studio in the band's office building. When Johns first caught a glimpse of Magic Alex's creation, he was aghast. To his mind, the mixing desk "looked like something out of a 1930s Buck Rogers science fiction movie." For his part, Harrison didn't mince words, later remarking that "Alex's recording studio was the biggest disaster of all time. He was walking around

with a white coat on like some sort of chemist, but he didn't have a clue what he was doing. It was a 16-track system, and he had 16 tiny little speakers all around the walls. You only need two speakers for stereo sound. It was awful. The whole thing was a disaster, and it had to be ripped out." Recognizing the need for quick action, Martin dispatched novice EMI tape operator Alan Parsons to Abbey Road to procure legitimate sound equipment. For the twenty-year-old Parsons, working with the Beatles was a dream come true: "I couldn't believe it," Parsons later remarked. "There I was. One day I was making tea at Abbey Road, and the next day I was working with the Beatles at their studio." In short order, Martin and Johns spent two days turning Apple's basement into a respectable recording studio by bringing in two mobile four-track mixing consoles from EMI, as well as overhauling the basement's amateurish soundproofing. But the return of the borrowed EMI equipment to St. John's Wood meant that Apple Studio was virtually inoperable. With Studio 2 unavailable for the time being, the Beatles had few options beyond Trident.[13]

First up on February 22 was a relatively new composition titled "I Want You." The song had been briefly debuted by the group back at Apple Studio as part of the *Get Back* sessions on January 29 with Billy Preston sitting in on the keyboards. Uncannily, the Beatles' studio albums more often than not had begun with the recording of a Lennon composition, and their latest record would be no different in this regard than *Rubber Soul*, which was set into motion by recording "Run for Your Life" in October 1965, or *The White Album*, which the group inaugurated with the recording sessions associated with "Revolution 1" in May 1968. In January 1969, the instrumentation for "I Want You" had consisted of Lennon playing his Epiphone Casino, a hollow-bodied electric guitar, McCartney playing his Höfner hollow-bodied bass, Harrison

working his Fender Rosewood Telecaster, and Starr playing his Ludwig Hollywood maple drum kit. With Preston playing the Hammond organ, "I Want You" had begun life as a smoldering instrumental blues jam.

During three more iterations of the song at Apple Studio, Lennon began to improvise lyrics about the desperation associated with falling in love—in the songwriter's case, in terms of his burgeoning relationship with performance artist Yoko Ono. "When you're drowning," Lennon remarked to *Rolling Stone*'s Jann Wenner in 1970, "you don't say, 'I would be incredibly pleased if someone would have the foresight to notice me drowning and come and help me.' You just *scream*." The balance of the January 29 Apple Studio session was devoted to an impromptu, largely directionless jam session in which the Beatles reached back—*way back*—to perform two late-1950s Buddy Holly B-sides, "Not Fade Away" and "Mailman, Bring Me No More Blues." They also tried their hand at Consuelo Velázquez's bolero "Bésame Mucho," a sentimental throwback to their Abbey Road debut on June 6, 1962, the fateful day when the bandmates first strolled into EMI Studios with a bona fide record contract. (After ripping through a rough version of the Mexican standard, which the Beatles performed in the style of the Coasters' 1960 cover, they had stunned studio personnel on that June 1962 day in London by playing a composition of their own called "Love Me Do.")[14]

The Beatles wouldn't attempt "I Want You" again until the Saturday, February 22, 1969, session at Trident. In the weeks since they had concluded work on the *Get Back* project, Johns and Preston had been occupied elsewhere. For his part, Johns had been in Hollywood, where he had started production on the Steve Miller Band's new album *Brave New World*. Meanwhile, Preston had been back in the States carrying out a brief tour in his native Texas. At

the same time, Starr had been acting with Peter Sellers on the set of *The Magic Christian*, which was being directed by Joseph McGrath based on Terry Southern's eccentric 1959 novel. But the most beleaguered member of the Beatles'—and the prime reason for the delay—was Harrison, who had been felled by tonsillitis, eventually spending eight days in a London hospital and having the offending tonsils removed. The Beatles' lead guitarist was scarcely a month removed from having quit the band on January 9 after a spat with Lennon at Twickenham Studios, the soundstage where they had begun work on the *Get Back* project, only to return three days later.

In order to mark the end of their hostilities, Harrison good-naturedly performed a duet of "You Are My Sunshine" with Lennon. Shortly after he returned to the fold on January 12, 1969, Harrison brought Preston to Apple Studio. Lennon, McCartney, and Harrison had first met the ace keyboard player in Hamburg in 1962 when he was a member of Little Richard's backup band. As it happened, Harrison and Eric Clapton had seen Preston performing with Ray Charles's band on January 19. Remembering the positive effect that Clapton's guest performance on "While My Guitar Gently Weeps" had produced for the band during the *White Album* sessions, Harrison felt that a well-timed appearance by Preston could serve as an emollient for the group's recent spate of bickering and backbiting. "I pulled in Billy Preston," Harrison later recalled. "It helped because the others would have to control themselves a bit more. John and Paul mainly, because they had to, you know, act more handsomely," he continued. "It's interesting to see how people behave nicely when you bring a guest in because they don't want everyone to know that they're so bitchy."[15]

Harrison's strategy succeeded beyond all expectations. With Preston in tow, the Beatles managed to bring the *Get Back* project

to fruition, including the rooftop concert, in nine days. Buoyed by the group's convivial spirits, Lennon even floated the idea of Preston becoming a permanent member of the band. But for McCartney, the idea of five Beatles seemed preposterous, and he famously exclaimed, "It's bad enough with four!" While Preston may not have been offered full membership in the Beatles, he was a welcome presence in the studio in February 1969—and as far as the bandmates were concerned, clearly worth waiting for. By this point, it had already been decided that the band's next single, "Get Back" backed with "Don't Let Me Down," would be culled from the *Get Back* sessions, with the record being credited to "The Beatles with Billy Preston," marking the only occasion in the band's history in which another artist would receive billing on a Beatles production.[16]

Not surprisingly, the band's February 22 instrumentation for "I Want You" at Trident mirrored the January 29 session, albeit with McCartney and Harrison having exchanged their Höfner and Fender guitars for a Rickenbacker 4001S bass and Gibson Les Paul electric guitar, respectively. Working from 8:00 p.m. that evening until 5:00 a.m. the next morning, Lennon led the Beatles through thirty-five takes of the song, including one experimental attempt featuring McCartney on lead vocals. The bandmates exploited Trident's eight-track capabilities to their extreme, distributing electric guitar parts on tracks one, seven, and eight, with the organ, bass, lead vocals, drums, and bass drum relegated to the other five tracks. By the end of the session, "I Want You" was comprised of a sprawling mélange of subsections, including several discrete movements in Lennon's brooding, frenetic tribute to Ono. The song's lyrics encompassed just fifteen words, drawn mostly from its title, which reflected both the speaker's inherent, unquenchable desperation in concert with the object of his love, who is "heavy,"

which in 1960s slang connotes intensity and depth. Later that same year, the song would be lampooned on BBC TV's *24 Hours* for what the commentators perceived to be its simple-minded lyrics and the trivial nature of popular music. Lennon was predictably incensed. As music critic Steve Turner has remarked, a song like "I Want You" was "not a reversion to mindless monosyllabic pop, but simply economy of language." In fact, the song was a harbinger of a much larger ambition of Lennon's to compose a song with only one word—much like a 1964 poem by Ono consisting solely of the word "water."[17]

In the Beatles' studio performance of "I Want You," Harrison turned in sizzling guitar work with "Lucy," the name he had given his Les Paul (a gift from Clapton), while McCartney ran the gamut on his Rickenbacker fretboard. Harrison, in particular, was entranced by the song, enjoying the act of performing it in the studio. "It is very heavy," Harrison remarked at the time. "John plays lead guitar and sings, and it's just basically an old blues riff he's doing, but again, it's a very original John-type song as well." For the Beatles and Preston, the February 22 session had been highly productive, not to mention a refreshing burst of energy after the dog days of the *Get Back* project at Twickenham and later at Apple Studio. The bandmates may have regained their mettle, but they pointedly did so without Martin in tow. The producer who had guided them to international stardom was no longer "in charge," to borrow David Crosby's phrase. On February 22, 1969, he wasn't even *there*. For his part, Glyn Johns was surprised that the Beatles hadn't invited their forty-three-year-old producer to participate. After all, in Johns's mind, Martin had saved the day in late January when he'd retrofitted Apple Studio with the borrowed EMI equipment and then proceeded to supervise a series of highly productive sessions. As Johns later recalled about that session, "George Martin came to the rescue."[18]

And Martin wasn't at Trident the next evening either, when the group resumed work on "I Want You." On Sunday, February 23, with Johns looking on in his role as producer of record, the bandmates listened to playbacks from the previous day's work. And that's when Lennon hit upon the idea of editing portions of three different takes into a single "master take." In this way, Lennon began to perceive of "I Want You" as a series of movements. Working in a similar fashion to Martin's revolutionary efforts involving "Strawberry Fields Forever" back in December 1966—albeit without the confounding issue of synchronizing divergent tape speeds—Johns and engineer Barry Sheffield attempted to bring Lennon's idea for the song to life. Drawing from the February 22 takes, Lennon selected Take 9 for the first movement, which was highlighted by his anguished lead vocal. For the second movement (commencing at 2:21), Take 20 was chosen to effect a central bridge for "I Want You," with the third movement (commencing at 3:43) being drawn from Take 32 in order to bring the track to a close. With Johns and Sheffield's handiwork carried out to Lennon's satisfaction, "I Want You" had reached fruition, running more than eight minutes in length. For all intents and purposes, the Beatles had all but completed the first song for their as-of-yet-untitled album, having made full use of Trident's eight-track mixing desk in the process. On February 24, Sheffield returned to Trident in order to make a safety copy of the edited master take for "I Want You." Afterward he delivered the tape copy to Abbey Road, where it was stored in the studio vault.[19]

Meanwhile, back at EMI Studios, the TG console remained unused—at least as far as the Fab Four were concerned. With the Beatles having not recorded there since October, the studio was bustling with many of the artists who had been left to their own

devices during the group's extended five-month stay during the *White Album* sessions. By 1970, the desk would be available in all three studios at Abbey Road. But even in its earliest days, the TG console had exceeded all expectations by most accounts, ushering EMI Studios into the vanguard of the UK's most advanced recording technology. Almost immediately, EMI's clientele found themselves struck by the notable differences that they gleaned from the mixing desk's output. The transistorized desk, with its expansive eight-track features, was a far cry from the vacuum tube–powered REDD mixing console that had previously been the studios' workhorse. Sonically, the recordings produced with the TG console clearly benefited from the separation afforded by the desk's eight tracks. Take *The Hollies Sing Dylan* (1969), which found the Manchester band attempting to regroup following the departure of standout member Graham Nash. Produced by Ron Richards and recorded almost entirely using the TG console, the album's instrumental separation is striking in comparison with their earlier efforts at Abbey Road. In the Hollies' cover version of "My Back Pages," for instance, the sound spectrum easily accommodates the instrumentation, which features drums, lead vocals, orchestration, organ, bass, and acoustic guitar. Recorded only a few months later, several of the studio tracks from Pink Floyd's *Ummagumma* (1969), produced by the group and Norman Smith, stand in stark contrast with their debut LP *The Piper at the Gates of Dawn* (1967). Indeed, the earlier album sounds positively compressed in comparison with the expansive sonic range inherent in such *Ummagumma* tracks as "Grantchester Meadows," with its dreamy soundscapes and vivid animal sounds, and "The Narrow Way," which showcases David Gilmour's multitrack talents on lead vocals, electric and acoustic guitars, bass, piano, organ, and drums.

For many listeners, the TG console's sonic imprint went well beyond the separation afforded by its tracking capabilities. Almost immediately, EMI Studios' clientele began to characterize their new productions with the console in terms of the recordings' inherent "warmth" and "brightness." Yet, for some, the mixing desk's sound became a source of outright irritation, with engineers complaining that its output was far too "trebly," even jarringly so at times. Emerick's first pass at using the TG console was dispiriting. The shift from recording with vacuum-tube equipment to solid-state transistors would not necessarily be an easy one for studio personnel like Emerick, who had spent his brief career working the REDD consoles at EMI. "Personally, I preferred the punchier sound we had gotten out of the old tube console and four-track recorder," he later recalled. To his ears, "everything was sounding mellower now. It seemed like a step backward." At least it did at first.[20]

As for the Beatles, the February 22 session at Trident had come and gone, with no plans, it seemed, for a follow-up session. That's not to say that the bandmates weren't busy. McCartney composed and produced "Goodbye," the latest single from Apple artist Mary Hopkin, as well as the successor to her blockbuster "Those Were the Days." In short order, Hopkin's sophomore effort would earn for her a number two showing on the UK pop charts. Then there was March 12, 1969, when McCartney and fiancée Linda Eastman exchanged their nuptial vows at the Marylebone Register Office. Years later he would reflect on the day, recalling that he had neglected to round up his mates for the occasion. "I really don't remember whether or not I invited any of the band to the wedding. Why not? I'm a total bastard, I suppose—I don't know, really. Maybe it was because the group was breaking up. We were all pissed off with each other. We certainly weren't a gang any more. That

was the thing. Once a group's broken up like that, that's it." Lennon
and Ono would follow suit eight days later, having set their sights
on consecrating their marriage near the Rock of Gibraltar. As he
later remarked, "So we were in Paris and we were calling [Beatles
assistant] Peter Brown, and said, 'We want to get married. Where
can we go?' And he called back and said, 'Gibraltar's the only place.'
So—okay, let's go!' And we went there and it was beautiful. It's
the Pillar of Hercules, and also symbolically they called it the End
of the World at one period. There's some name besides Pillar of
Hercules—but they thought the world outside was a mystery from
there, so it was like the Gateway to the World. So we liked it in the
symbolic sense, and the Rock [embodied the] foundation of our
relationship." As for the bride and groom, Lennon later described
Gibraltar as being "like a little sunny dream. I couldn't find a white
suit—I had off-white corduroy trousers and a white jacket. Yoko
had all white on."[21]

Lennon and Ono celebrated their honeymoon with a weeklong
"Bed-In" for peace in room 902 at the Amsterdam Hilton Hotel.
The Bed-In provided John and Yoko with a means for exploiting
their celebrity to stage a nonviolent protest of the Vietnam War. Re-
sponding with attendant gusto, the media afforded the newlyweds
with sustained coverage, including twelve-hour press conferences
each day from the couple's hotel room bed, which was framed by
handwritten signs extolling "Hair Peace" and "Bed Peace" for all
the world to see. As Lennon remarked to the assembled journalists
at the time, "We're staying in bed for a week to register our protest
against all the suffering and violence in the world. Can you think
of a better way to spend seven days? It's the best idea we've had."
In surviving audio from his Amsterdam sojourn, Lennon can be
heard performing an a cappella version of the Jewish folk song
"Hava Nagila" for Israeli poet Akiva Nof, who was interviewing the

pajama-clad Beatle, before abruptly shifting gears and delivering an impromptu public debut of "I Want You," which he punctuated at the end by saying "Hello, Israel" to Nof's audience back home. "That's from the new Beatles album actually. It's not released yet," said Lennon, cryptically referring perhaps to the *Get Back* project or its as-yet-untitled follow-up LP, which was still in its infancy. During this same period, Lennon had begun chronicling his recent adventures on the global stage with Ono with a new composition tentatively titled "They're Gonna Crucify Me."[22]

As with Lennon, Harrison had been engaged in new work. On February 25, his twenty-sixth birthday, he ventured into EMI Studios to record a trio of demos, including "All Things Must Pass," "Old Brown Shoe," and "Something," with engineer Ken Scott working in the booth. Harrison had debuted the exquisite "Something" for producer Chris Thomas during the *White Album* sessions back in September 1968. Harrison had only recently made his first pass at recording the song. "'Something' was written on the piano while we were making *The White Album*," he said. "I had a break while Paul was doing some overdubbing so I went into an empty studio and began to write. That's really all there is to it, except the middle took some time to sort out." And that's when he shared the fledgling song with Thomas. "While George and I were tinkling away on this harpsichord," Thomas later recalled, "he started playing [a] new song to me, which later turned out to be 'Something.' I said, 'That's great! Why don't we do that one instead?' and he replied, 'Do you like it, do you really think it's good?' When I said 'yes,' he said, 'Oh, maybe I'll give it to Jackie Lomax then, he can do it as a single!'"[23]

While Lomax opted not to use the song on his debut album, Harrison continued tinkering with the tune, playing it for the

other Beatles during the January 1969 *Get Back* sessions. To Harrison's chagrin, Lennon and McCartney seemed unimpressed with his new love song, as did Martin, who later confessed to finding the composition "too weak and derivative" at that point. During a January 28 session at Apple Studio, Harrison can be heard fine-tuning the lyrics with his mates in tow and happening upon the A-major chord that would perceptibly alter the song's dynamics. After reciting the composition's first line—which the songwriter had borrowed in its entirety from the title of Apple recording artist James Taylor's "Something in the Way She Moves"—Harrison toyed with singing the phrase "attracts me like a pomegranate," although Lennon had playfully suggested "like a cauliflower." After making their way through two performances of "Something," the Beatles set the song aside yet again, leaving the composition's future in doubt—at least for the moment. As for Taylor, the singer-songwriter took Harrison's act of lyrical petty theft in stride, later remarking, "I never thought for a second that George intended to do that. I don't think he intentionally ripped anything off." Besides, "all music is borrowed from other music." Years later, Taylor would joke that the final lyric of "Something in the Way She Moves"—"I feel fine"—had been stolen from the Beatles' chart-topping 1964 single of the same name, so "what goes around comes around."[24]

Since completing his February 25 demo session, Harrison's life had been thrown into disarray. On the evening of the McCartneys' wedding, Detective-Sergeant Pilcher struck again, claiming to have discovered a block of hashish in Harrison's Esher home. By month's end, Harrison and wife Pattie Boyd would receive probation and a black mark on their travel documents. As for Starr, the Beatles' drummer was still toiling away on his acting gig with

Sellers in *The Magic Christian*. At one point he was cornered by the press, who received an ominous quote in response to their questions about the future of the Beatles: "People really have tried to typecast us," said Starr. "They think we are still little Mop Tops, and we are not. I don't want to play in public again. I don't miss being a Beatle anymore. You can't get those days back. It's no good living in the past."[25]

While the bandmates may have been pursuing their interests in separate spheres, the Beatles' business partnership chugged on unabated in April, when EMI, always hankering for new material from the Fab Four, was rewarded with the release of the "Get Back" single (backed with "Don't Let Me Down"). Released in the UK on April 11, "Get Back" promptly topped music charts around the globe, with EMI's advertising copy trumpeting the single as being "the Beatles as nature intended." While the single flew atop the UK charts, Johns toiled at Olympic Sound Studios in suburban Barnes, where he scoured the *Get Back* recordings in a pained effort to extract suitable performances for a new Beatles LP. He was occasionally joined by Martin, who lamented the state of the band's musical affairs, not to mention the generally shoddy quality of their January recordings. Together Johns and Martin produced a rough mix of the LP, which was slated to be titled *Get Back, Don't Let Me Down, and 12 Other Songs*. But to Martin's ears, the mix was "warts and all, with the mistakes and count-ins and breakdowns and so on. That was the album. I thought it was a write-off. I didn't hear any more, and I thought that was the end of our days. I thought, 'Well, that's the finish of the Beatles. What a shame.'"[26]

Hence Martin was caught by surprise on Monday, April 14, when he was summoned to join the Beatles at EMI Studios along with Emerick, who had angrily left the band's production

team back in July 1968 when he could no longer stomach the infighting. The band's maiden voyage with the TG console, it seemed, was finally at hand. But when Martin and Emerick strolled into Studio 3 that afternoon, there were only two Beatles in evidence.

2

Stereophonic Sound

On April 23, 1960, Lennon and McCartney—having briefly taken flight as the Nerk Twins—played the Fox and Hounds pub in Caversham. Sitting on barstools, the duo performed jazz standards like "The World Is Waiting for the Sunrise" and "How High the Moon" in the style of Les Paul and Mary Ford, before launching into the songs they really wanted to play—numbers like Gene Vincent's "Be-Bop-a-Lula." As McCartney later recalled, "It was a lovely experience that came from John and I just hitching off down there. At the end of the week, we played in the pub as the Nerk Twins. We even made our own posters." Some nine years later, the friendship that they had shared since teenage-hood had ebbed dramatically, but they could still belt out a tune.[1]

On April 14, 1969, Lennon and McCartney were at it again, convening at EMI Studios to record "They're Gonna Crucify Me," which would shortly be rechristened "The Ballad of John and Yoko." When the session in Studio 3 began that afternoon, Martin and Emerick were greeted by an unusual sight. With Harrison traveling in the United States and Starr still working on the set of *The Magic Christian*, Lennon and McCartney were going it alone. As it happened, the session had been rather hastily convened. Martin and Emerick's participation had been accomplished via a pair of

phone calls the previous week. After a nine-month absence from the band's production team, Emerick had been coaxed back into the Beatles' fold by Apple's Peter Brown, who informed the engineer that Lennon was dead set on recording his new composition as quickly as possible and wanted Emerick to engineer the track. At first, Emerick was suspicious, fearing Lennon's erratic behavior of late. "He's fine," Brown assured Emerick. "He's in really good spirits at the moment, and he's really up about the new song. And he specifically asked me if I could get you to engineer it." Emerick would shortly learn that the Beatles had a much bigger objective in their sights.[2]

As it turned out, Martin proved to be a much more difficult sell, although his misgivings—as with Emerick's—concerned the quality of Lennon's state of mind, not to mention the Beatle's level of commitment to the project at hand. During the prior week, McCartney had telephoned Martin and announced that the Beatles were going to make another record. "Would you like to produce it?" McCartney asked. "Only if you let me produce it the way we used to," Martin countered. "We do want to do that," said McCartney. "John included?" asked Martin. "Yes," McCartney replied. "*Honestly*." That was all the producer needed to hear. He was eager to put the dreary, recent months behind them, to plot a return to the creative heights of *Revolver* and *Sgt. Pepper's Lonely Hearts Club Band*. He was ready to accept any opportunity, no matter how slight, to shift the Beatles' fortunes after the darkest days of *The White Album* and the *Get Back* project.[3]

And so it was that Martin and Emerick had improbably rejoined the Beatles' fold in April 1969. Earlier that day, April 14, Lennon and McCartney had completed writing "The Ballad of John and Yoko" at Paul's home on nearby Cavendish Avenue. The only thing left was to commit their latest work to tape. Originally the

Beatles—all four of them—had been scheduled to meet later that week at EMI Studios, but Lennon and McCartney were working "on heat," McCartney later remembered, and were not interested in waiting around for their bandmates to wind their way back to Abbey Road. As it happened, the Beatles, especially McCartney, had found themselves working "on heat" before. Indeed, being driven by the excitement of their artistry—namely, Lennon and McCartney's impulsiveness as composers—was essential to the Beatles as artists. The duo's creative caprice had always been characterized by a fervent desire to bring their vision to fruition as soon as reasonably possible after first having discovered the germ of an artistic idea—whether as a result of a collaborative writing session or, as was becoming the norm, their individual efforts.

Paul would later talk about this rage for creation—how he and John would become so overwhelmed by their creative impulses that they had to get into the studio as soon as possible to purge the latest composition from their synapses and move on to the next thing. McCartney's rashness had landed him in trouble with Martin back in March 1967, when the Beatle—having just completed the lyrics for "She's Leaving Home"—wanted an orchestral arrangement posthaste. At that moment, Martin had been working with Cilla Black at Abbey Road, and McCartney simply couldn't wait for his regular arranger—the man whose idea of a string quartet had brought "Yesterday" soaring into life—to become available. McCartney turned to Mike Leander for the arrangement instead, and Martin was hurt by the impetuosity of his longtime friend and collaborator. "The Ballad of John and Yoko" demonstrated that Lennon and McCartney's old creative instincts were alive and well, that their zeal to commit their concept to tape as soon as humanly possible was as unrelenting as ever. "John was 'on heat,'" McCartney later recalled. "He needed to record it, so we just ran and did it."[4]

When the session began that Monday afternoon, April 14, Lennon and McCartney leapt into action. While Emerick may have had his doubts about the TG console and solid-state circuitry, the two Beatles were delighted to be working—*finally*—with honest-to-goodness cutting-edge technology at EMI Studios. Having held numerous sessions at Trident by this juncture, they were well-versed in negotiating the more expansive real estate inherent in eight-track production. With Martin, Emerick, and Ono looking on from the Studio 3 control room, Lennon and McCartney arrayed their instruments across the expansive space. To create a backing track, the duo would record eleven takes that day. The backing track featured Lennon's Gibson Jumbo (J-160E) on track one, McCartney playing Starr's Ludwig Hollywood drums on track three, and Lennon's lead vocal on track four. During a break in the session, Lennon can be heard saying "Go a bit faster, Ringo!" with McCartney good-naturedly replying "Okay, George!" from his place behind Starr's drum kit.[5]

Having chosen Take 10 as the best version of their efforts, the two Beatles set about superimposing a series of overdubs onto "The Ballad of John and Yoko." The available track one was relegated to McCartney's bass line on his Rickenbacker, with track five allocated to Lennon's lead guitar. For the song's electric guitar outro, Lennon borrowed from his own efforts on the introduction to the Beatles' cover version of Johnny Burnette and his Rock 'n' Roll Trio's "Lonesome Tears in My Eyes," which the Beatles had recorded during the BBC radio program *Pop Go the Beatles* back in July 1963. Another round of overdubs included Lennon doubling his guitar work on track six with an impressive series of call-and-response figures, as well as McCartney's backing vocal on track seven and percussion on track eight comprising McCartney's maracas and Lennon rapping the back of his Jumbo. And

just like that—in under seven hours—the song had come to fruition. The other Beatles scarcely minded being left off of the record, with Starr later complimenting McCartney's drum work. Harrison matter-of-factly recalled, "I didn't mind not being on the record because it was none of my business. If it had been 'The Ballad of John, George, and Yoko,' then I would have been on it."[6]

During the session devoted to "The Ballad of John and Yoko," Emerick's presence had paid off immediately. Always a master of mic placement, the engineer had situated microphones both above and below the snare. In so doing, Emerick afforded McCartney's drums with a distinctive cracking sound, one of the sonic hallmarks of the eventual record. For his part, Emerick was tremendously relieved: "It was a great session, one of those magic times when everything went right and nothing went wrong," he later recalled. "The two Beatles seemed remarkably relaxed, despite the horror stories I had heard about the rows and bad feelings engendered by the [*Get Back*] sessions," he later recalled. "On this one day, they reverted to being two old school chums, all the nastiness of recent months swept under the rug and replaced by the sheer joy of making music together."[7]

With the recording session completed, Martin and Emerick turned their attentions to mixing the new Beatles single for release. As it happened, "The Ballad of John and Yoko" would become the first Beatles single to be mixed primarily for stereo without benefit of a corresponding mono mix. Prior to "The Ballad of John and Yoko," the entire catalog of Beatles singles releases in the UK had been monophonic mixes, ranging from October 1962 and "Love Me Do" through "Get Back," which had been in British record stores since the Friday before "The Ballad of John and Yoko" was recorded. In the States, the Beatles singles had been prepared via "fake stereo" (or "Duophonic") mixes for release by

Capitol Records, EMI's US subsidiary. Over the years, a practice had been developed at Capitol: Martin's mono mixes would be transformed into Duophonic mixes to simulate a stereo sound for the American marketplace. Capitol personnel would create a Duophonic mix by redirecting the signal from Martin's mono mixes and splitting the left and right channels. To produce this fake stereo sound, the high end would be filtered in one direction, and the low end would filter toward the other. After so doing, these Duophonic mixes would create the sonic illusion of separation and true stereo.

Stereo had been on the rise since the early 1960s, with stereophonic sound being widely marketed to music fans as a richer, more satisfying aural experience. But in 1968 the tipping point was reached, and the tables turned against monophonic sound. In January, a *Billboard* article had trumpeted the format's death, which it attributed to the major record manufacturers working in collusion to bring mono down. Martin, Emerick, and the Beatles had devoted their energies to creating monophonic mixes for the vast majority of the record-buying public, who lacked home stereo components. Indeed, prior to the late 1960s, stereophonic sound was considered to be the purview of high-end users and audiophiles. As Emerick later observed, "Our focus was on the mono mixes, which were the real mixes as far as we were concerned, since so few people had stereo record players in those days." At the same time, the Beatles themselves preferred the mono mixes that they had produced in the studio over the years. As Harrison later remarked, "When they invented stereo, I remember thinking 'Why? What do you want two speakers for?' because it ruined the sound from our point of view. You know, we had everything coming out of one speaker; now it had to come out of two speakers. It sounded, like, *very* naked."[8]

Now in his seventh year as the band's producer, Martin had devoted most of his efforts to supervising the creation of the Beatles' mono mixes—often allocating several days to an album's mono mixes and as little as a few hours to producing the stereo versions, which were treated as afterthoughts. But by 1969 he was only too happy to follow the marketplace and turn his attentions to stereophonic sound. Besides, he appreciated the sonic possibilities that stereo promised in an age of evolving multitrack recording. And with the benefit of eight-track recording, he possessed the capacity for manipulating a much wider soundscape. Despite being admittedly very "twelve-inch" in his thinking, Martin had long preferred the stereo format to mono's lack of definition. As he later recalled, "I like to sit right in front of the desk, right *within* the triangle of the optimum stereo. So that you get the real feeling of sitting in a theatre or cinema, then shutting your eyes and hearing things. One of the fascinating things I used to find was when you panned something from left to right, it didn't just go straight across, it goes up in an arc *above* you. It was like going through a proscenium arch in a theatre. And you could then see—very vividly in your mind—what the sounds were doing as a stereo picture."[9]

The TG console enabled Martin and Emerick to create a wide-ranging stereophonic palette for "The Ballad of John and Yoko." The stereo picture that they fashioned for the Beatles' latest single benefited from eight-track technology in myriad ways. In order to achieve the cinematic vistas that stereo portended, Martin took advantage of the separation that the TG console afforded. In the finished mix, the Beatles' jaunty new song can be heard as it thunders into life. The recording's vivid sound—cleanly arrayed across eight tracks—evinces the power of numerous musicians, rather than merely the work of Lennon and McCartney toiling for a few hours in the studio. Martin and Emerick took

full advantage of the stereophonic picture by expertly deploying McCartney's clipped backing vocal at the opposite end of the sound spectrum from Lennon's lead vocal. Even more impressively, Martin and Emerick cleverly panned Lennon's lead guitar fills from left to right, imbuing the riffs with an innovative call-and-response quality.

From Martin's perspective, the experience of producing "The Ballad of John and Yoko" had been a success, albeit a largely rudimentary one in comparison with the high-water marks of the Beatles' career. He was particularly happy to have had generally pleasant interaction with Ono, who had seemed like an unwelcome distraction during the *White Album* sessions. As Martin later remarked, "John and Yoko got better as they went along. Once they got down into their sensible period, so to speak, it was nice working with them. John would bring me a cassette of different things he had made, and say: 'Can you make something out of this?' I would try to do things for him because he wasn't terribly good technically. I enjoyed working with John and Yoko on 'The Ballad of John and Yoko.' It was just the two of them with Paul." In this way, Martin added, "it was hardly a Beatle track—yet it was a Beatle track. It was a kind of thin end of the wedge, as far as they were concerned."

But Martin held no illusions about the band's long-term outlook, observing that "John had already mentally left the group anyway, and I think that was just the beginning of it all." Given his experience with the band since the previous summer—when he had taken to carting in an ample supply of newspapers and chocolate in order to divert himself during the interpersonal doldrums associated with the *White Album* sessions—Martin harbored understandable doubts about the Beatles' longevity—even their ability to last through April, much less record a new album's worth of songs.[10]

While he may have reasonably questioned the Beatles' capacity for going forward as a working rock and roll band at this juncture, Martin was buoyed by the exquisite possibilities for recording artistry that the TG console seemed to portend. Since September 1950, when he first came into the orbit of EMI Studios, Martin had wholeheartedly believed that the studio could function in innovative yet unforeseen ways. Even during his bygone years as a producer of comedy and spoken-word records, Martin understood implicitly that the studio could work as a sound effects lab of sorts in which artists used artifice to take the listener into unexpected, vivid worlds of their own invention. "We made things out of tape loops, slowed things down, and banged on piano lids," Martin later recalled. "Directors don't have to make films look like stage-plays, and I felt that we as producers could make our recordings differently." In short, the studio had the potential to become, in Martin's words, "a real magical workshop." And to his mind, the TG console was the missing ingredient in bringing this dream to fruition.[11]

But Emerick still wasn't entirely sold on the new mixing desk. As with Martin, he was eminently satisfied with the TG console's capacity for achieving separation and definition. But when it came to the sonic output, the engineer was of two minds. "The new mixing console had a lot more bells and whistles on it than the old one," Emerick later observed, "and it gave me the opportunity to put into practice many of the ideas I'd had in mind for years, but it just didn't sound the same, mainly because it utilized transistor circuitry instead of tubes." To his ears, the solid-state equipment seemed to produce smoother, more mellow tones, which led to a great deal of frustration for Emerick. With the TG console, "in no way could I re-create the same bass drum, snare drum, or guitar sounds that I'd been able to get on the REDD valve consoles," he recalled. "I'd only used the REDD valve consoles (and tape

machines) on Beatles sessions up to that point, and I think that the tubes played a big part in those sounds. I found that the transistors clipped everything, they wouldn't let any low end distortion go through." By way of example, Emerick pointed to "Paperback Writer," which he had engineered on tube equipment back in April 1966. In the recording, "you really hear the bass guitar and the kick of the bass drum. There was no way you could get that sound on a transistorized desk," Emerick maintained. "There are many theories—unnatural harmonics, distortion, whatever—but we couldn't create those sounds anymore."[12]

By Wednesday, April 16, Harrison had returned from the States and rejoined the fray. Working "on heat" himself, he led his bandmates through several takes of "Old Brown Shoe" and "Something," the songs for which he had created rough demos two months earlier. During the previous month, he had still been uncertain about the fate of "Something," which he had given to Joe Cocker to record. The raspy-voiced Yorkshire singer had recently scored a British chart-topper with his cover of Lennon and McCartney's "With a Little Help from My Friends," and Cocker jumped at the chance to try his hand with Harrison's composition, which he slated for release on his second studio album. During the April 16 session, the Beatles attempted several versions of "Old Brown Shoe," which they recorded by leaving the tape running during rehearsal, a technique that Martin and the bandmates had frequently deployed since working on *Help!*'s "Ticket to Ride" back in February 1965. Leaving the tape running as they rehearsed a given track afforded Martin and the group a sense of creative immediacy, allowing them to capture moments of innovation and artistic caprice as they happened live in the studio. In this way, the Beatles and their production team recorded "Old Brown Shoe" in an economical four takes, complete with a rollicking piano part from McCartney.

During the composition phase, Harrison's song had begun as a kind of slow-burning, blues effusion, only to take on a more galloping, rambunctious pace. For Harrison, the lyrics of "Old Brown Shoe" consider his long-held spiritual view that human beings will only begin to progress when we free ourselves from the illusory realities of our corporeal selves. As he later wrote, "We must struggle even though we are all rats and valueless, and try to become better human beings." With this heightened sense of consciousness, Harrison reasoned, humankind could dispense with binary thinking—notions of right versus wrong and spirit versus matter. As music critic Steve Turner has observed, "Old Brown Shoe" enjoys a kinship with McCartney's "Hello, Goodbye," yet another song in which lyrics engage in a "game based on opposites." As for the song's title, the notion of "stepping out of this old brown shoe" connotes the idea of leaving our former selves behind in favor of a more divine consciousness.[13]

Played on Studio 3's Challen "jangle" piano, McCartney activated the instrument's unusual sound by depressing the third foot pedal. Also known as a "tack piano," the keyboard was first deployed by the Beatles in April 1966 for *Revolver*'s "Tomorrow Never Knows." The jangle piano achieved its unique sound when a series of brass-tipped felt strips moved between the piano's hammers and strings. In so doing, McCartney was able to create a distinctive percussive, tinny sound for "Old Brown Shoe." The basic track for "Old Brown Shoe" also featured Harrison's lead guitar and vocals, Starr's drums, and Lennon's rhythm guitar. Harrison overdubbed the song's distinctive barreling low end by borrowing McCartney's Fender Jazz bass and doubling the sound on his Telecaster. "That was me going nuts [on the bass]," he later remarked. "I'm doing exactly what I do on the guitar." Later that day, Harrison and his mates took another pass at "Something." As the song unfolded that

evening in Studio 3, Martin heard "Something" in a starkly differ-
ent light. "It took my breath away," said Martin, "mainly because I
never thought that George could do it—it was a tremendous work
and so simple." Rehearsing with the tape running, the bandmates
recorded a basic track for "Something" that included Harrison's
electric guitar, McCartney's bass, Starr's drums, and their pro-
ducer on piano. For Martin, it must have seemed like a revelation
to be playing on a Beatles track again when days earlier he had all
but given up on the notion of working with the band in any ca-
pacity. At the same time, Martin belatedly began to reconsider his
expectations of "the Quiet Beatle," as George had become known
at the height of Beatlemania. Like Lennon and McCartney, the
producer had been admittedly too quick to relegate Harrison to
junior status in the band's songwriting team. Years later, Martin
observed that Harrison's work had been "awfully poor up to then.
Some of the stuff he'd written was very boring. The impression is
sometimes given that we put him down. I don't think we ever did
that, but possibly we didn't encourage him enough. He'd write,
but we wouldn't say, 'What've you got then, George?' We'd say, 'Oh,
you've got some more, have you?' I must say that looking back, it
was a bit hard on him. It was always slightly condescending. But it
was natural, because the others [Lennon and McCartney] were so
talented."[14]

On Friday, April 18, Martin and Emerick were busy elsewhere,
leaving Chris Thomas, Martin's protégé and a veteran of the *White
Album* sessions, in the producer's chair, along with Jeff Jarratt and
John Kurlander as his engineering team. Just twenty-two, Thomas
was in his second year of employment with AIR (Associated Inde-
pendent Recordings), the company that Martin had founded after
leaving EMI in 1965. Meanwhile, Jarratt had been in the studio's
employ since 1966, while eighteen-year-old Kurlander, who hailed

from St. John's Wood—and was living at the time with his parents only a block away from EMI Studios on Hall Road—was a relative newcomer. During the previous year, Kurlander had endured a trial by fire of sorts after he was asked to join his very first Beatles session. Understandably nervous at the prospect of working with the most celebrated pop group in the world, the young tape operator found himself tasked with conducting a playback session for "Hey Jude." After being ordered by Martin to gather up the different versions of the Beatles' latest recording, Kurlander observed in awe as the bandmates and their producer listened to "Hey Jude" over and over again, whiling away the hours until late in the evening as the song's famous chorus looped round and round.[15]

Scant days before the "Old Brown Shoe" session, maintenance engineer Dave Harries had informed Kurlander that Martin and Emerick wanted his services for the new Beatles album. The tape operator jumped at the opportunity to work with the group again, and this time, he hoped for a chance to do more than facilitate their playback sessions. As he sat in the Studio 3 control booth on April 18, Kurlander observed as Harrison completed work on "Old Brown Shoe," overdubbing a lead guitar part for the song, which was slated for release as the B-side of "The Ballad of John and Yoko" on May 30. After midnight, the bandmates returned to "I Want You," which they revisited for the first time since February. Earlier that evening, Thomas had supervised a tape reduction session of the song's Trident master in order to free up additional space for superimpositions. Working in Studio 2, Lennon and Harrison took up their instruments and began layering the song's foreboding, Wagnerian-like coda with a searing swathe of guitar-laden grunge. As Jarratt later recalled, "John and George went into the far left-hand corner of Number 2 to overdub those guitars. They wanted a massive sound so they kept tracking and tracking,

over and over." As it happened, the "I Want You" session was not without its share of fireworks. At one point, Jarratt interrupted the guitarists' work to ask Harrison to turn down his volume knob slightly. As Jarratt later recalled, "I was getting a bit of pick-up so I asked George to turn it down a little. He looked at me and said, drily, 'You don't talk to a Beatle like that.'"[16]

During that same session, Harrison had enhanced his guitar sound on "Old Brown Shoe" via a technique that the Beatles had been employing to great effect since April 1966. The catalyst for the sonic innovation occurred after Lennon requested a particular sound for "Mark 1"—the song that would become "Tomorrow Never Knows." Lennon wanted his vocal to take on the ambience of "the Dalai Lama chanting from a mountaintop." For Emerick, who was engineering his very first Beatles session that day, the challenge of meeting Lennon's unusual demand caused mild panic. "The whole time, I kept thinking about what the Dalai Lama might sound like if he were standing on Highgate Hill, a few miles away from the studio," Emerick later recalled. "I began doing a mental inventory of the equipment we had on hand. Clearly, none of the standard studio tricks available at the mixing console would do the job alone. We also had an echo chamber, and lots of amplifiers in the studio, but I couldn't see how they could help, either. But perhaps there was one amplifier that might work, even though nobody had ever put a vocal through it." And that's when it hit him: Emerick knew that the studio's Hammond organ was connected to a Leslie speaker system, which comprised a large wooden box containing an amp and two sets of revolving speakers emitting bass and treble, respectively. Named for Donald J. Leslie, the innovator behind the Vibratone sound, the Leslie speaker had been designed to soften the churchlike sound of the Hammond organ by using a system of rotating baffles that create

a vibrato effect. In short order, Townsend joined the proceedings and rewired the Leslie speaker system to bring Emerick's idea to fruition. Later, as Martin and Emerick observed from the control booth, Lennon gave a thumbs-up as he sang his lead vocal, and the Leslie speaker innovation was born—at least as far as the Beatles were concerned.[17]

In truth, Emerick wasn't the only person to happen upon the speaker cabinet's possibilities. In September 1965, American engineer Stu Black had deployed the Leslie speaker to similar effect on behalf of Buddy Guy after the guitar legend's amp had cratered during a session with Junior Wells and his Chicago Blues Band. During the "Old Brown Shoe" session, Harrison availed himself of the Leslie speaker effect—but he deployed it in conjunction with his electric guitar rather than his lead vocal. After their experience with "Tomorrow Never Knows" back in April 1966, the Beatles and their production team had been anxious to experiment with their latest studio enhancement. In the ensuing years, they would deploy the Leslie speaker on numerous occasions, including Harrison's haunting tamboura track on "Across the Universe" and McCartney and Starr's dueling pianos on "Don't Pass Me By." In such instances, the Leslie speaker effect tended to afford the Beatles' instruments greater sonic textures and nuance. Prior to "Old Brown Shoe," Harrison had most recently attempted the effect during an October 1968 recording session with Cream, the famed British power trio. Having cowritten the song "Badge" with the band's guitarist and vocalist Eric Clapton, Harrison deployed the Leslie speaker for his sizzling rhythm guitar part on the recording. He enjoyed a similar result with "Old Brown Shoe," with the Leslie's rotating speakers imbuing his guitar part with an edgy, steely sound, particularly on the raucous guitar solo that the Quiet Beatle had concocted for the song.

By the next Sunday, April 20, the Beatles were beginning to regain their stride, turning at this juncture to "Oh! Darling," a McCartney composition that had begun making the rounds during the *Get Back* sessions. McCartney had debuted the song on January 6, and during the succeeding days he would often return to his new tune, which he would bang out on the piano in the style of Fats Domino's triplet pattern on his 1956 classic "Blueberry Hill." On January 27, the Beatles finally attempted a full-band version of the song, which went under the working title of "I'll Never Do You No Harm," with Billy Preston working the Fender Rhodes electric piano. With a doo-wop sound borrowed from the Platters' "The Great Pretender," McCartney's song was being shaped into a no-holds-barred throwback to the band's teen years, complete with a late-fifties rock and roll feel and a throat-wrenching lead vocal.

For the April 20 session, the instrumentation on "Oh! Darling" featured McCartney's bass, Lennon's doo-wop piano, Harrison's electric guitar, and Starr's drums. The song's title now reflected the composition's opening lyric, with its conspicuous punctuation acting as a tribute of sorts to Little Richard's 1958 hit "Ooh! My Soul." Working in Studio 3 that day, McCartney led the proceedings, which amounted to twenty-six takes, with a guide vocal—an initial pass at the lyrics that he intended to replace later with a more polished vocal performance. With Thomas remaining in the producer's chair, Jarratt and Kurlander observed the Beatles as they rehearsed and refined "Oh! Darling" across successive takes, finally opting for Take 26 as the best of the lot. During Take 7, the bandmates briefly went off script when Lennon led his mates in a jam session that included a wild reading of Joe South's "Games People Play," a spirited song that was currently roiling the UK charts. But unlike the *Get Back* sessions, when their jams would rage on and on, the Beatles quickly made their

way back to "Oh! Darling." Harrison afforded the song with even greater nuance when he played his Leslie-amplified lead guitar on the recording, concocting a series of hard, stabbing chords on the verses, along with an arresting array of arpeggios for its middle eight. Meanwhile, Lennon's piano answered Harrison's guitar figures with triplets in the style of McCartney's original idea for the song.[18]

Suddenly the Beatles seemed to be making real progress on their new LP, apparently having jettisoned the interpersonal problems that had polluted so many of their sessions earlier in the year. With their work on "Oh! Darling" completed for the evening, they turned back to "I Want You" yet again, superimposing conga ornamentation onto the existing recording. The drums arrived courtesy of longtime Beatles roadie and personal assistant Mal Evans, who had ferried the narrow, high-pitched drums to the studio that night for Ringo to play. As it happened, Starr was enjoying a creative renaissance during this period, having procured new drum heads for the kit that he had purchased the previous year. He and his bandmates had been inspired to gravitate toward instruments that were not covered with a heavy finish, and in this they followed Donovan Leitch, the singer-songwriter behind the recent hits "Sunshine Superman," "Mellow Yellow," and "Hurdy Gurdy Man." During their early spring 1968 sojourn together in Rishikesh, India, Donovan recommended that the Beatles improve their sound by sanding the finish off of their instruments. Donovan was not alone in this belief. During the late 1960s, sanding off the paint was all the rage among guitar gods like Eric Clapton and Jeff Beck. Clapton famously removed the finish on the necks of his guitars to improve the action, while Beck just thought it looked cool. Convinced that Donovan was onto something, Lennon and Harrison had the finish sanded away from their Epiphone Casino

electric guitars, with McCartney following suit with his Ricken-backer bass. "I think that works on a lot of guitars," Harrison later remarked. "If you take the paint and varnish off and get the bare wood, it seems to sort of breathe."[19]

With this idea in mind, Starr opted to replace his signature Lud-wig Super Classic kit and its trademark Black Oyster Pearl finish with the vaunted drum manufacturer's new maple set. For Starr and the Beatles, a new kit marked a changing of the guard of sorts, as images of Ringo playing his Black Oyster Pearl kit on *The Ed Sul-livan Show* loomed large in his legend. After the Beatles had scored their first number one UK album in April 1963, the drummer hot-footed it down to London's Drum City to purchase his first-ever Ludwig kit to replace his tattered Premier drums. To his mind, the Ludwig brand was the crème de la crème—the true measure of having "made it" as a professional drummer. With manager Brian Epstein in tow, Starr selected Black Oyster Pearl finish for his new kit, with Epstein requesting that the store's owner, Ivor Arbiter, prepare a logo for the head of Ringo's bass drum. Without hesita-tion, Arbiter created the Beatles' soon-to-be world famous logo, with its exaggerated capital B and drop-T, on the spot. Suddenly the Beatles' brand was born. As Gerry Evans, the manager of Drum City, later recalled, "The Beatles logo that we know today with the drop-T was created in our store by Eddie Stokes, the songwriter who used to do the front of the bass-drum heads for us. He would come in during his lunchtime because he had worked locally. Ivor Arbiter drew the Beatles logo on a pad of paper, then had Eddie put what he had sketched on the drum head. . . . I think we charged £5 extra for the artwork."[20]

When he placed his order with Drum City for his new kit with the maple finish, Starr made one of the very few changes to his sound during his Beatles tenure—and the first major shift in six

years. Christened "the Hollywood Outfit" by PR folks at Ludwig and marketed to "creative drummers," the new kit was said to be "the latest in 'twin' tom-tom design." Starr took possession of his Ludwig Hollywood kit in the latter months of 1968, and it can be heard on "Hey Jude," "Revolution," and a number of tracks on *The White Album*. Footage from the January 1969 rooftop concert captures Starr playing his Ludwig Hollywoods, with the maple kit holding fast. Starr made very few modifications to the new set, save for retaining his trusty Black Oyster Pearl snare from his old kit because he couldn't bear to part with it, believing that it was a key element in his sound. As was his usual practice, Mal Evans used tea towels to dampen Starr's drums, particularly his snare, which was fortified with a pack of Everest cigarettes—Emerick's favorite brand—positioned atop the drum head to enhance the effect.[21]

His new kit enabled Starr to achieve a markedly different sound. The kit had two tom-toms as opposed to the single rack on his Ludwig Super Classic drums, and it was bolstered by Starr's recent purchase of calfskin drum heads. With their natural give, the calfskin heads afforded him with a richer, warmer sound than the Mylar drum heads that had been in vogue since the late 1950s. The calfskin also provided a more acute response, which in turn imbued Starr's drums with a fulsome, more natural sound. Not surprisingly, Ringo was thrilled. Recording the latest batch of Beatles tunes "was tom-tom madness," he later remarked. "I had gotten this new kit made of wood, and calfskins, and the toms had so much depth. I went nuts on the toms. Talk about changes in my drum style—the kit made me change because I changed my kit." For Starr, the calfskins, in particular, allowed him to attain a more organic, less artificial sound in his playing. Years later he would contend that the result was especially apparent on vinyl records. "I got the new heads on the drum, and I naturally used them

a lot—they were so great. The magic of real records is that they showed tom-toms were so good. I don't believe that magic is there now, because there's so much more manipulation."[22]

As with songs like "Old Brown Shoe" and "Oh! Darling," the conspicuous sound of Starr's new kit can be heard loudly and clearly on "Octopus's Garden," a composition that the drummer had begun during the nadir of the *White Album* sessions. On Thursday, August 22, 1968, as McCartney unveiled a new upbeat rocker called "Back in the USSR," Starr abruptly quit the Beatles. As it happened, he never really attended the session. Ron Richards, Martin's partner with AIR, recalled the genesis of the incident years later: "Ringo was always sitting in the reception area waiting, just sitting there or reading a newspaper. He used to sit there for hours waiting for the others to turn up. One night he couldn't stand it any longer, got fed up, and left." It wasn't the first time that someone had departed the Beatles. McCartney had walked out of the studio in a huff during the "She Said She Said" sessions at the end of recording *Revolver*.[23]

Having left the band back in London, Starr took his family on an impromptu vacation to Sardinia, where he spent a memorable day lounging on Peter Sellers's yacht and trying to forget about his troubled life with the Fab Four. On one occasion, the yacht's captain spoke movingly about octopuses. "He told me that they hang out in their caves," Starr later remarked, "and they go around the seabed finding shiny stones and tin cans and bottles to put in front of their cave like a garden." For Starr, the idea of escaping beneath the ocean waves held great appeal. "I thought, 'How fabulous!'" he later admitted, "'cause at the time I just wanted to be under the sea, too. I wanted to get out of it for a while." By early September, Starr had been summoned back to the Beatles' fold via a well-timed telegram from his mates: "You're the best rock 'n'

roll drummer in the world. Come on home, we love you." For Starr, that was convincing enough. "And so I came back," he said, reasoning, "We all needed that little shake-up." To celebrate his return, Harrison arranged for Ringo's drum kit to be decked out with flowers. And while the episode had clearly been traumatic for Starr and his mates, the drummer's Mediterranean jaunt had afforded him with arguably the most charming composition in his career as a songwriter.[24]

Starr debuted the song back on January 6 during the *Get Back* sessions. In the 1970 *Let It Be* documentary, Harrison and Martin can be seen working with Starr to refine the chord progressions as Lennon chipped in with a rare stint behind the drums. The song would lie fallow for three months as the Beatles righted themselves and began making plans for a new album. With Chris Thomas in the control booth, the Beatles tried their hand at "Octopus's Garden" on Saturday, April 26, when they recorded thirty-two takes of Starr's first vocal performance since *The White Album*'s "Don't Pass Me By" and "Good Night." Three months after debuting during the *Get Back* sessions, Starr's composition was primed and ready.[25]

As it happened, Martin had planned to helm the session that weekend, but, having been suddenly called away on AIR business, he left Thomas, his protégé, to look after things in his stead. At the time, Martin was feverishly working with Cilla Black to put the finishing touches on her new LP, to be entitled *Surround Yourself with Cilla*, for a late May release. As Thomas later recalled, "George Martin informed me that he wouldn't be available. I can't remember word for word what he said, but it was something like 'There will be one Beatle there, fine. Two Beatles, great. Three Beatles, fantastic. But the minute the four of them are there that is when the inexplicable charismatic thing happens, the special magic no

one has been able to explain. It will be very friendly between you and them, but you'll be aware of this inexplicable presence.'" "Sure enough," Thomas later remarked, "that's exactly the way it happened. I've never felt it in any other circumstances. It was the special chemistry of the four of them, which nobody since has ever had." With all four Beatles present and in marvelously good spirits, Martin's premonition came true that evening and then some. For "Octopus's Garden," Harrison fashioned a jaunty lead guitar intro on his Leslie-amplified Fender Strat in order to imbue Starr's song with a nascent country-and-western flavor. The basic track was rounded out with Ringo playing his Ludwig Hollywoods and providing a guide vocal, Lennon on rhythm guitar, and McCartney on bass. Working his snare throughout and playing his toms to punctuate the verses, Starr drove his Ludwig Hollywoods to great effect. Filled with the group's inside jokes and unbridled conviviality, the session found the Beatles in solid form. On the few occasions when the music didn't quite jell, they took it in stride. After they faltered during take eight, Starr good-naturedly announced, "Well, that was superb!" as his bandmates fell into uproarious laughter. Later Starr replaced his guide vocal with the song's complete lyrics while overdubbing a new lead vocal track.[26]

As the band worked in the studio in London, rumors about a new documentary about the Beatles—presumably, Michael Lindsay-Hogg's filming of the January *Get Back* sessions—were reaching a fever pitch. At McCartney's instruction, Lindsay-Hogg had been directed to capture audio and video from the January sessions at Twickenham and Apple for a potential documentary in which the Beatles symbolically "get back" to the raw sound of their musical roots. The April 25–29, 1969, issue of *TV Guide* published a feature story titled "Four Cats on a London Roof" in reference to the January 30 rooftop concert. Beatles fans around the world

were yearning for news that the group might return to live perfor-mance. By this point it had been nearly three years since the band had played a concert (San Francisco's Candlestick Park on August 29, 1966), and fans were hungry for any sign that the Beatles might be returning to the road. With a weekly circulation in excess of fif-teen million copies, *TV Guide* commanded an enormous stateside audience. The article promised that the new film would serve "to let the world—all over which the Beatles hope to sell the docu-mentary in a few months—know just how the Beatles go about their work." A similar ruckus had emerged in the UK a few months earlier when rumors began swirling in the media that the band would be playing a trio of concerts in December 1968 at London's Roundhouse. Beatles fans had clearly had their appetites whetted by the group's bravura TV appearances in the autumn of 1968. That September they had filmed performances of "Hey Jude" and "Revolution" (mostly mimed) at Twickenham under the direction of Lindsay-Hogg. The promotional films were subsequently broad-cast on David Frost's popular British talk show *Frost on Sunday* and on US variety show *The Smothers Brothers Comedy Hour* to massive audiences. By the early spring of 1969, it had been several months since the release of *The White Album*—an unfathomable period of time for Beatles fans, who had become used to frequent releases of new singles and albums during the high tide of Beatlemania.[27]

Meanwhile, back in Studio 3 on the evening of Wednesday, April 30, the group's frivolity and forward momentum continued. "The Ballad of John and Yoko" (backed with "Old Brown Shoe") had been readied for release as a single at the end of May, and other songs slated for inclusion on the band's new album were in various stages of production, including "I Want You," "Octopus's Garden," "Oh! Darling," and "Something." For the next three days, the Bea-tles worked in Studio 3 with the understanding that on Monday,

May 5, they would be moving their production to Olympic Sound, one of the UK's most esteemed independent studios at the time, having recently undergone a massive redesign at the hands of engineer Keith Grant and his father, innovative architect Robertson Grant. With space in EMI Studios at a premium, they had little choice; even though they were the biggest rock group in the world, the Beatles hadn't bothered to book additional studio time at EMI. Besides, Glyn Johns was ensconced at Olympic—still working with the Steve Miller Band and toiling away on the Beatles' *Get Back* recordings, hoping to knock them into shape to meet the vague specifications of Lennon and McCartney. Johns had his work cut out for him. Pleasing the Beatles would be no easy feat—especially when it came to the *Get Back* recordings. As Johns later recalled, "I got a call from John and Paul asking me to meet them at Abbey Road. I walked into the control room and was confronted by a large pile of multitrack tapes. They told me that they had reconsidered my concept for the album that I had presented to them in January and had decided to let me go ahead and mix and put it together from all the recording that we had done at Savile Row. I was thrilled at the idea and asked when they would be available to start. They replied that they were quite happy for me to do it on my own as it was my idea. I left feeling elated that they would trust me to put the album together without them, but soon realized that the real reason had to be that they had lost interest in the project."[28]

For his part, Martin couldn't have been happier with how things were shaping up with the band. The Beatles seemed to be adhering to their commitment to recording an LP with their producer like they had in the old, pre–*White Album*, pre–*Get Back* session days. Better yet, as the Beatles continued recording the basic tracks for their still-untitled album, the TG console let them record additional overdubs as their project progressed. Just as they had hoped,

eight-track recording had expanded the limits of their imaginations inside the studio, while also creating a wider, more defined sound palette with which to work.

During the April 30 session in Studio 3, with Martin's return to the fold only a few days away, Thomas handled production duties again. The proceedings began with an extended playback of the group's post–*Get Back* session recordings in the control room, after which Harrison overdubbed a Leslie-amplified lead guitar solo onto "Let It Be," which the Beatles had last visited on January 31 at Apple Studio. But the real story that day was the bandmates' surprising return to "You Know My Name (Look Up the Number)," a novelty recording that had lain dormant since June 1967. Lennon had suddenly recalled the track during a recent interview with *NME*'s Alan Smith. "There was another song I wrote around *Pepper* time that's still in the can, called 'You Know My Name and Cut [*sic*] the Number.' That's the only words to it. It just goes on all the way like that, and we did all these mad backings. But I never did finish it. And I must." While visiting McCartney's 7 Cavendish Avenue home two years earlier, Lennon had glanced at the 1967 London metropolitan telephone directory, with the words "You know their NAME? Look up their NUMBER" screaming from the directory's cover. At first Lennon began concocting a doo-wop number in the style of the Four Tops as he and McCartney made the short trek over to EMI Studios. By the time they set to work recording, it had been transformed, at McCartney's suggestion, into a zany, screwball comedy tune in the tradition of the Goons, or, more recently, the Bonzo Dog Doo-Dah Band. During its initial May 1967 sessions, the song had begun life as an instrumental, complete with Rolling Stones guitarist Brian Jones wailing away on an alto saxophone. The original track clocked in at more than six minutes and comprised five discrete musical sections.[29]

With the assistance of the unwavering Mal Evans, John and Paul overdubbed a series of uproariously funny vocals on April 30, 1969, finally transforming the instrumental track into a novelty song of the highest order. Working "on heat," seizing the moment, Lennon had hustled McCartney back into the studio to pick up where they had left off two years earlier. Singing together around one of the studio's vintage microphones, the two fashioned a series of sidesplitting voices. Nick Webb, who served as second engineer that day, couldn't help wondering, "What are they doing with this old four-track tape, recording these funny bits onto this quaint song?" As Thomas looked on from the booth, Lennon and McCartney tasked Evans with stirring a pile of gravel with a shovel, while they coughed and sputtered their way through one hilarious take after another. In its latest incarnation, "You Know My Name (Look Up the Number)" comes into being with an intentionally overwrought, soulful introduction before cascading into "Slaggers," a smoke-filled cocktail lounge where McCartney adopts the smooth jazz stylings—and the breathy lower register—of nightclub singer "Denis O'Bell," whose name was fashioned after Beatles assistant Denis O'Dell. As Slaggers fades out into obscurity, O'Bell surrenders the stage to Lennon, who, adopting a pseudo-grandmotherly voice, absurdly counts out loud, while singing the song's title, mantra-like, amid penny whistles and percussion. The song's penultimate segment showcases McCartney's piano and Jones's alto sax before coalescing—with a trademark Beatles false ending—into Lennon's a cappella gibberish. Lennon and McCartney's effusive wit is on full display in this track from the April 1969 session, and it moves from droll into all-out absurdity. Their sheer delight in producing the composition resounds at every turn, with the old friends rejoicing in each other's company.

The Beatles, it seemed at the time, were just getting started. Having listened to the playback of "Oh! Darling" the preceding afternoon, McCartney returned to the song with a vengeance during the group's session on Thursday, May 1. As he later recalled, McCartney was determined to adorn "Oh! Darling" with the most raucous lead vocal possible, and at this juncture he was far from satisfied. Nor, for that matter, was Chris Thomas, who was present when McCartney took a crack at the vocal during this period. Upon first hearing the Beatle sing "Oh! Darling," Thomas was surprised by McCartney's lackluster performance. "I didn't like it because it didn't sound like him," Thomas later recalled, "and he was the greatest rock 'n' roll singer on the planet. I said to him, 'You sang "I'm Down,"' and McCartney replied that 'I can't sing like that anymore. You know, I'm older now.'" For his part, Thomas thought that Paul's excuse was a "cop out," but McCartney was determined to get the vocal right—and soon. The next evening, Harrison led his bandmates in a remake of "Something." The new basic track featured Harrison's Leslie-amplified guitar, Lennon's Casino, McCartney's bass, Starr's Ludwig Hollywoods, and Billy Preston sitting in on piano. During the session, which ran until four on Saturday morning, Take 36 was selected as the best, clocking in at 7:48 and including an extended instrumental play-out driven by Preston's piano. By this point, the other Beatles had become genuine converts to the quality of Harrison's "Something," a composition at which they had openly scoffed earlier in the year. By this point, McCartney took special notice of the song, which had emerged as one of the strongest cuts among their current spate. But he also realized that his own controlling nature might have been working against him—possibly for quite some time. As McCartney recalled, "George's 'Something' was out of left field. It was about [Harrison's wife] Pattie, and it appealed

to me because it has a very beautiful melody and is a really struc-
tured song. I thought it was great. I think George thought my
bass-playing was a little bit busy. Again, from my side, I was trying
to contribute the best I could, but maybe it was his turn to tell me
I was too busy." But still, by McCartney's reckoning, "Something"
was pure joy.[30]

For Harrison, the group's affirmation had been long overdue
but no less satisfying. Starr took special notice of Harrison's grow-
ing currency among the band's core creative team. "George was
blossoming as a songwriter," he later recalled. "With 'Something'
and 'While My Guitar Gently Weeps,' are you kidding me? Two
of the finest love songs ever written, and they're really on a par
with what John and Paul or anyone else of that time wrote. They're
beautiful songs." For his part, Emerick took notice of the band's
shifting attitude about Harrison's work. "A lot of time and effort
went into 'Something,'" he later recalled, "which was very unusual
for a Harrison song, but everyone seemed aware of just how good
a song it was, even though nobody went out of his way to say so.
That's just the way the Beatles were: compliments were few and
far between—you could always tell more about the way they were
thinking by the expressions on their faces."[31]

On Sunday evening, Lennon and McCartney attended the wrap
party for *The Magic Christian* to support Starr and his costar Peter
Sellers. Held at the swanky London nightclub Les Ambassadeurs,
the celebration included actors Richard Harris, Sean Connery,
Roger Moore, and Christopher Lee, among others. It was in this
convivial mood that Lennon and McCartney joined their band-
mates on Monday, May 5, at Olympic for a four-day stint with
Martin, who had finally returned to the helm, and Glyn Johns. As
events would soon come to demonstrate, the Beatles' era of good
feelings wouldn't last.

The May 5 session, which ran from seven-thirty that evening until after four the next morning, featured Harrison and McCartney refining their guitar parts for "Something." While Harrison remade his Leslie-amplified guitar track, McCartney presented a radically improved bass part, complete with a variety of dramatic flourishes in support of the Quiet Beatle's love song. The highlight of the day came in the form of Harrison's magnificent guitar solo as the shimmering centerpiece at the heart of "Something." Meanwhile, Martin and Johns devoted their energies to assembling a new mix of the *Get Back* sessions for the Beatles' consideration. Still attempting to meet Lennon and McCartney's vague expectations for the LP, Johns had shared his mixes with Martin, and the older producer assisted him in compiling yet another version of the record that the band had soundly rejected back in February. Working with Johns at Olympic, Martin attempted to "put together an album which captured this documentary approach and included their mistakes and interjections." But Martin knew that even though "the sessions were over, not one of those titles was perfect. They needed more work on them, but John wouldn't have that at all." With *The White Album*'s release in the rearview mirror, six months past, Martin was already under pressure from EMI to present a new Beatles LP and, besides, Lennon and McCartney were eager to see their January labors come to fruition. Lennon thought that *Get Back, Don't Let Me Down, and 12 Other Songs* should evoke the sound of a highly primitive recording, largely free of the postproduction and other studio-enhanced niceties inherent in records like *Revolver* and *Sgt. Pepper* and even *The White Album*.[32]

Martin and Johns were under considerable pressure to bring the *Get Back* project to fruition. Johns's original mixes had all the earmarks of Lennon's specifications, but the Beatle had found it to be

lacking when he listened to the test cut. Perhaps he liked a bit more polish than he cared to admit. Working at Olympic that week, the Beatles rode their wave of geniality through yet more overdubs onto "Something"—with Harrison continuing to refine the guitar solo for his love song—and they even began to imagine, at Martin's urging, a kind of symphonic suite as the centerpiece for their new album. But in the whirlwind world of the Beatles during the heady days of the 1960s, life would often turn on a dime.

Despite the activity, creative energy, and surprisingly profound goodwill within the group and between the band and Martin, the positive working environment that the Beatles had developed over the preceding few months was about to change for the worse. The first catalyst would be a fight—not over the direction of their music but over their business. The Beatles had been without a formal manager since Epstein's accidental death, at age thirty-two, after an overdose of barbiturates in August 1967. For Lennon especially, the Beatles' capacity for surviving without Epstein had always seemed problematic at best. "I knew that we were in trouble then," he later recalled. "I didn't really have any misconceptions about our ability to do anything other than play music and I was scared. I thought, 'We've fuckin' had it.'" As it happened, there had been a suitor for the right to manage the Beatles since 1964, when Epstein was still very much alive. Allen Klein had attempted to angle his way into Epstein's world by offering his services as a go-between with RCA, promising that he could win a better deal for the band if they would abandon EMI. After being rebuffed by Epstein, who preferred to remain loyal to the British record conglomerate, Klein began gathering pop acts by the bushel, including such luminaries as Bobby Darin, Donovan, the Dave Clark Five, and Herman's Hermits. In 1966, Klein added the Rolling Stones to his stable after he succeeded in strong-arming Decca Records

into rewarding the group with a lucrative signing bonus. Still hoping to land the Beatles, he had similarly approached Epstein about restructuring the Beatles' EMI contract. By this point, Epstein had become deeply suspicious of the American interloper, particularly after McCartney inquired about Klein's recent success on the Rolling Stones' behalf. "What about us?" Paul asked the Beatles' beleaguered manager.[33]

By the advent of the *Get Back* sessions, the Beatles had found themselves in a world of fiscal trouble and with a paucity of business acumen. Having gone into business for themselves with Apple Corps back in January 1968, the bandmates had begun to realize the extent to which their dream was transforming into a financial nightmare. They had hoped to create a democratizing creative enterprise via Apple, a place where one could live out one's artistic visions, come what may. Martin saw the inherent beauty in the Beatles' conception of Apple, later observing that "it was a marvelous Utopian idea. If it had been handled properly it would have been a great boon to the music business." But he had long seen the writing on the wall, privately believing that Apple was destined for ruin and reasoning that the fledgling company "was being run by four idealists, with nobody really in control." By January 1969, Lennon had also come to realize the extent of Apple's impending doom. In an interview published in the January 17 *Disc and Music Echo*, a British music industry publication, Lennon remarked, "Apple is losing money. If it carries on like this, we'll be broke in six months."[34]

And with that, the brash Klein saw his opening. Eager to doubledown on his power play to manage the group, Klein hastily arranged for a meeting with Lennon to strike a deal. Promising to renegotiate the Beatles' contract and win a lucrative advance on their behalf, he succeeded in wooing Lennon, Harrison, and Starr

to the fold. The lone holdout was McCartney, who wanted his new in-laws, father-and-son attorneys Lee and John Eastman, to handle his affairs. In Klein's mind, the battle for managing the most famous band in the world came down to a culture war of sorts, with the thirty-seven-year-old Klein waging a street fight against the effete, upper-crust Eastmans. Since his early days as the manager of Sam Cooke—for whom he famously bested the RCA Records juggernaut back in 1963—Klein had fancied himself as a kind of Robin Hood, who would aim his bow and arrow at the faceless record companies bent on giving their artists short shrift. For the Newark-born Klein, who had recently been deemed "The Toughest Wheeler-Dealer in the Pop Jungle" by the *Sunday Times*—the idea of taking out the Eastmans, with their sophisticated Westchester County ways, made his long-running quest for the right to manage the band seem all the more heroic.

By the spring of 1969, Klein was pressing the Beatles to sign an exclusive management contract with ABKCO (an acronym denoting Allen and Betty Klein and Company), the umbrella firm that encompassed his multifarious business interests. In so doing, he set into motion a showdown between the three Beatles already committed to him and McCartney, who still hoped for his in-laws to capture the prize. Things finally came to a head, and brutally so, on the afternoon of Friday, May 9, as the Beatles sat in on Johns and Martin's latest *Get Back* mixing session. The proceedings came to an abrupt end when Lennon, Harrison, and Starr demanded that McCartney sign Klein's management contract with the band at once. The day before, the other Beatles had inked their agreement with Klein, who was anxious to close the deal. As McCartney later recalled:

> They said, "Oh, are you stalling? He wants 20%."
> I said, "Tell him he can have 15%."
> They said, "You're stalling."

I replied, "No, I'm working for us; we're a big act." I remember the exact words: "We're a big act, the Beatles. He'll take 15%."

But for some strange reason (I think they were so intoxicated with him) they said, "No, he's got to have 20%, and he's got to report to his board. You've got to sign now or never."

So I said, "Right, that's it. I'm not signing now."

At this point, McCartney reportedly threw up his hands, saying "we could easily do this on Monday. Let's do our session instead." But the other Beatles wouldn't budge, with everyone's tempers getting the better of them. And that's when McCartney felt like his back was truly against the wall. He'd be waiting until Monday, when his lawyer could be present, to continue the discussion about Klein. For the others, Lennon especially, such a declaration amounted to turning his back on his mates, who had always carried out business together as a miniature democracy in which a majority ruled. "Oh, fuck off!" they roared. And with that, McCartney's bandmates left the studio, leaving him alone and bewildered at Olympic.[35]

Inking a manager to replace Epstein was not the only contentious issue for the Beatles at the time. Since March, Lennon and McCartney had been in a desperate struggle to retain their ownership in Northern Songs, the company that Epstein had created in 1963 with music publisher Dick James. According to Apple's Peter Brown, Epstein and the bandmates held little understanding of the significance and value of music publishing. As Brown later remarked, "It was very much let's get what we can get—any deal would be a good deal, just the fact that we actually had a deal." Moreover, "as I understand it," Brown recalled, "Brian sat them down and told them what the structure of the deal was and they said fine." As events would transpire, Lennon and McCartney's agreement with Dick James Music would emerge as one of the most vexing subplots in the story of the Beatles. In retrospect,

Brown saw James as having enacted "a clever deal" that succeeded in seeing the Beatles' manager "sign over to Dick James 50 percent of Lennon and McCartney's publishing fees for nothing." Years later, McCartney would attribute his easy compliance to sheer ignorance. "John and I didn't know you could own songs," he remarked. "We thought they just existed in the air. We could not see how it was possible to own them. We could see owning a house, a guitar or a car, they were physical objects. But a song, not being a physical object, we couldn't see how it was possible to have a copyright in it. And therefore, with great glee, publishers saw us coming."[36]

In later years, as the woes of Apple Corps had begun to spiral out of control, the Beatles' growing financial problems were compounded by Lennon and McCartney's powerlessness to purchase Northern Songs when James placed it on the open market. As historian Brian Southall has observed, the Beatles were confronted with a perfect storm in the form of Apple's financial turmoil coupled with the Beatles being cash-poor at the worst possible moment. "Dick James was of the old school and had had enough of it," Southall wrote. "He saw the Lennon and McCartney partnership falling apart and he and his partner Charles Silver, who founded the company with him, decided to sell their stake in Northern Songs." In March 1969, James and Silver sold their shares to Lew Grade at the British television company ATV. For their part, Lennon and McCartney were stunned by this development, having been caught by surprise by their partners' sudden divestiture.[37]

On April 11, 1969, the Beatles announced their plans to tender a counteroffer against ATV to take control of Northern Songs themselves. While Klein structured a new deal that would have allowed Lennon and McCartney to maintain their holdings in Northern Songs, it eventually began to collapse when John learned that Paul

had been secretly buying up shares of Northern Songs behind his back. At the same time, they recognized that their artistic freedom would be mitigated by faceless businessmen in suits, as opposed to the homegrown organization that Epstein had once established on their behalf. During a pivotal meeting in April, Lennon caused a stir when he refused to deal any further with Lord Grade and ATV. "I'm sick to death of being fucked about by men in suits sitting on their fat arses in the City!" he exclaimed. With one stroke, with this expression of his vitriol for the establishment, any of the investors who were on the fence began siding with the media mogul, further strengthening Lord Grade's chances of taking control of Northern Songs. Worse yet, the business consortium Epstein had established on the band's behalf back in 1963 with James was suddenly in tatters, leaving the Beatles' own partnership in the direst of straits.[38]

Meanwhile, after his bandmates had stormed out of Olympic Sound Studios on May 9, McCartney was left alone to stew and lick his wounds. Not long afterward, Steve Miller arrived at the studio to continue working on *Brave New World* with Johns. Miller was no stranger to acrimony, having recently bemoaned the departure of his fellow founding members Boz Scaggs and Jim Peterman from the Steve Miller Band, and the American proved to be a sympathetic ear for McCartney, who was still livid after his confrontation with the other Beatles. "Can I drum for you?" McCartney asked. "I just had a fucking unholy argument with the guys there." Miller and McCartney jammed together, eventually trying their hand at a Miller composition called "My Dark Hour," a strikingly appropriate descriptor for McCartney's state of mind at the time. "I thrashed everything out on the drums," he recalled. "There's a surfeit of aggressive drum fills, that's all I can say about that. We stayed up until late. I played bass, guitar, and drums and sang backing vocals." For McCartney, the spring of 1969 proved to

be "a very strange time in my life, and I swear I got my first grey hairs that month. I saw them appearing. I looked in the mirror, I thought, 'I can see you. You're all coming now. Welcome.'"[39]

Even nearly half a century later, McCartney's fury can be heard raging through the grooves of "My Dark Hour," his blood-curdling backup vocals ringing out, à la "Helter Skelter," from Miller's album. In its own way, "My Dark Hour" documented one of the darkest days in the Beatles' story. In just a matter of hours, the momentum that the group had built up after the *Get Back* sessions had all but disappeared, leaving uncertainty and pent-up anger in its wake. That October, when Miller's album was released in the UK, McCartney asked to be credited as "Paul Ramon," referencing a very different time in the Beatles' lives, when the group had assumed pseudonyms on their first professional tour in 1960. Back in their Silver Beetles days, they hungered for "real showbiz names." McCartney selected "Paul Ramon" because he thought it to be "suitably exotic," while George recast himself as "Carl Harrison" to honor rockabilly guitarist Carl Perkins and Lennon reimagined himself as "Long John," as in "Long John Silver," the leader of that band of ruffians from Liverpool. For McCartney, revisiting his Beatles past in such a pointed way must have felt bittersweet, nostalgic even. But by that time, when Miller's *Brave New World* hit the British record stores some five months after the verbal fireworks at Olympic, the Beatles had entered a very different phase in their career as a working rock and roll band.[40]

3

Tales of Men and Moog

McCartney's extracurricular work with Steve Miller was not anomalous during this period of the Beatles' career. All four band members had been engaging in side projects of one sort or another for months, if not longer. Indeed, by the time they settled down to make their new LP with Martin, the individual members had steadily increased the energies they devoted to working outside the group. Unsurprisingly, these efforts as producers and side musicians for other artists would shape and inform the writing and recording of their latest album during the spring and summer of 1969. They comprised another factor that would help distinguish the Beatles' eventual album from all they had previously recorded.

McCartney had actually been sharing his compositions with other artists virtually since first achieving stardom back in 1963. As always, McCartney credited the songs, via an informal agreement that had been in vogue since approximately 1960, to "Lennon-McCartney." As McCartney later remarked, "Crediting the songs jointly to Lennon and McCartney was a decision we made very early on because we aspired to be Rodgers and Hammerstein. The only thing we knew about songwriting was that it was done by people like them, and Lerner and Loewe. We'd heard these names

and associated songwriting with them, so the two-name combination sounded interesting." In recent years, McCartney had been increasingly sharing his talents as a session musician for a wide range of artists. In the autumn of 1966, McCartney played bass on Donovan's *Mellow Yellow*; he can even be heard whooping it up as one of the revelers on the LP's title track. In April 1967, he turned in one of his strangest guest appearances when he munched on celery during the recording of the Beach Boys' "Vegetables," one of the Brian Wilson–Van Dyke Parks numbers recorded during the torturous sessions associated with the *Smiley Smile* album. During a break from the sessions devoted to *The White Album*, he provided a somber bass part for James Taylor's "Carolina in My Mind," which was released on the American singer-songwriter's eponymous debut album in December 1968.[1]

As record producer, McCartney had accelerated his activities on behalf of other artists, most recently Mary Hopkin and Badfinger. Since the highly public debut of Apple Corps in May 1968, McCartney—along with Harrison—had devoted considerable time and energy to grooming new artists for the big time. In February 1969, McCartney had prepared a demo of a new song called "Goodbye," which he had written for nineteen-year-old Hopkin. In 1968, the Welsh singer had scored a global smash hit with "Those Were the Days," one of the young label's earliest bestsellers. For "Goodbye," McCartney imagined a seafaring tune about a lonely sailor who has left his love behind in port. As he was wont to do, McCartney prepared a demo for the song at his Cavendish Avenue home in order to familiarize Hopkin with the song.

When it came to recording "Goodbye," McCartney worked with Hopkin at Morgan Studios in suburban Willesden. As the song developed in the studio, McCartney raised the key from C to E major to effect a better match with Hopkin's range. McCartney

completed the production in short order, performing bass, acoustic guitar, drums, and percussion himself. For the song's arrangement, McCartney turned to Richard Hewson, the orchestrator behind "Those Were the Days," and Hewson created suitably plaintive choral, horn, and string parts for "Goodbye." Apple press officer Tony Bramwell was on hand to film a promotional video, which featured Hopkin and McCartney—the young songbird and her doting, megastar producer—sharing a moment in the control room. Duly credited to Lennon-McCartney, "Goodbye" provided the anchor (and eventual lead single) for Hopkin's debut Apple LP, *Postcard*. McCartney's production work earned high marks from the likes of *Rolling Stone's* John Mendelsohn, who rightly noted McCartney's outsized role in the project: "*Postcard* is as much Paul McCartney's as it is Mary Hopkin's, which is to say that it is one of those albums on which the producer is as big a star as the performer."[2]

Since the mid-1960s, McCartney had been keen on accepting film commissions. His maiden assignment, the soundtrack for Roy and John Boulting's *The Family Way*, marked the first solo foray by any of the Beatles. But when it came to doing the actual work, McCartney was nowhere to be found, leaving the indefatigable Martin to jumpstart the project. Eventually McCartney came through with what his producer admitted was the germ of "a sweet little fragment of a waltz tune," the basis of "Love in the Open Air," and Martin was off to the races. "If it sounds like it was done in a hurry," Martin later pointed out, "it's because it was done in a hurry." It would be McCartney who would earn an Ivor Novello Award for Best Instrumental Theme for his work on *The Family Way*.[3]

Along with Starr's turn in *The Magic Christian* (principal photography had only recently been completed), McCartney

produced a trio of new songs by Badfinger to contribute to the soundtrack. With incidental music being scored by Ken Thorne, the composer behind the *Help!* soundtrack (1965), the folks at Apple concocted the idea of showcasing Badfinger on a pseudo-soundtrack to be entitled *Magic Christian Music*, an LP that would double as the Welsh band's debut album. Formerly known as the Iveys, Badfinger had taken their name from "Bad Finger Boogie," the Beatles' working title for *Sgt. Pepper*'s "With a Little Help from My Friends." McCartney had composed "Come and Get It" to serve as *The Magic Christian*'s central theme, later recording a solo demo version of the song during a break from a Beatles session in July 1969. McCartney's work on "Come and Get It" was a harbinger of things to come, with the Beatle producing the song from start to finish in less than an hour and handling all of the instrumentation himself. For the track, he worked in Studio 2 alone, with Lennon and engineer Phil McDonald up in the booth. Working with the TG console, McDonald supervised the session as McCartney recorded a basic track that included his lead vocal and piano accompaniment, swiftly followed by a series of overdubs composed of McCartney's double-tracked vocal, maracas, drum, and bass guitar parts. For the drums, McCartney took advantage of Starr's Ludwig Hollywoods, which were set up in wait for the Beatles session later that day. In early August, McCartney would produce Badfinger's note-for-note performance of his "Come and Get It" demo, followed by two additional compositions destined for *Magic Christian Music*: "Rock of All Ages," which featured McCartney on piano, and "Carry on Till Tomorrow," for which Martin arranged and conducted the strings. The album would be rounded out by productions of Badfinger tracks by twenty-five-year-old American newcomer Tony Visconti and Beatles personal assistant Mal Evans, who had discovered the

Iveys, along with Apple A&R (artists and repertoire) man Peter Asher, after taking in the band's July 1968 performance at London's Marquee Club.

During this period, Lennon had been pursuing plenty of extracurricular work of his own—namely a series of ventures with Ono, as well as a conceptual musical fusion that he dubbed the Plastic Ono Band. As a duo, Lennon and Ono had made their debut in November 1968, rather notoriously, with *Unfinished Music No. 1: Two Virgins*, a series of experimental recordings—musique concrète in the style of *The White Album*'s "Revolution 9"—that might have gone unnoticed had it not been for the LP's outlandish cover art: a full-frontal nude photo of John and Yoko in all of their unvarnished glory. In December 1968, the couple appeared in *The Rolling Stones' Rock and Roll Circus* as part of a supergroup called "The Dirty Mac," which included guitarists Eric Clapton and Keith Richards, and drummer Mitch Mitchell, accompanied at times by violinist Ivry Gitlis. In the new year, the Lennons ramped up their efforts, staging their widely publicized Bed-Ins for Peace (one in Montreal in addition to the one in Amsterdam), and releasing *Unfinished Music No. 2: Life with the Lions*, their second experimental recording foray, on May 9, 1969—the very day that all hell broke loose with the Beatles at Olympic Sound Studios. A third and final experimental LP, *Wedding Album*, would be released that November, with the artists credited simply as "John & Yoko." By this point the couple had become household words, no longer requiring the pesky nicety of surnames. Together they had intentionally decided to transform their life together into performance art. Nothing was off-limits. Everything that they said or did was fodder for consumption in the name of creativity and—perhaps most important, by the summer of 1969—the hope of

attaining, as fanciful as it may sound, global peace. As Lennon remarked at the time:

> Yoko and I are quite willing to be the world's clowns, if by doing it we do some good. For reasons known only to themselves, people do print what I say. And I'm saying peace. We're not pointing a finger at anybody. There are no good guys and bad guys. The struggle is in the mind. We must bury our own monsters and stop condemning people. We are all Christ and all Hitler. We want Christ to win. We're trying to make Christ's message contemporary. What would he have done if he had advertisements, records, films, TV and newspapers? Christ made miracles to tell his message. Well, the miracle today is communications, so let's use it.[4]

While Lennon and Ono's peace efforts enjoyed plenty of media fanfare in 1968 and 1969, their album-length releases racked up one commercial failure after another—indeed, all three had failed to make a dent in the UK LP charts in spite of their notorious origins. The notable exception during this period was the single "Give Peace a Chance" backed with "Remember Love," which notched an unexpected—and decidedly unconventional—number two UK hit during the summer of 1969. The composition had emerged, somewhat organically, during John and Yoko's Bed-In for Peace held in room 1742 of Montreal's Hôtel Reine-Élizabeth. On May 30, 1969, Lennon had been asked by a reporter about the purpose of his Canadian visit with Ono, and he had replied that "all we are saying is give peace a chance." And with that, "Give Peace a Chance" was born.[5]

The following day, Lennon hired André Perry, a local producer, who hastily rented a four-track recorder and microphones from a Montreal recording studio and joined John and Yoko, along with a cast of hangers-on, in their tiny hotel room. "It was chaos," Perry later recalled. "People were banging on telephone books, on

ashtrays, bells, all kinds of crap. The Hare Krishnas were there, laying on the floor. There was Timothy Leary stoned out of his mind. It was like a goddamn circus." As for the recording itself, Perry held out little hope for a high-fidelity, state-of-the-art production: "When came the time to do this, I said, 'Man, I don't know what this is going to end up like, but it's gonna be really weird.'" Wearing his bedclothes and strumming his Jumbo, Lennon was joined on vocals by a cast of music and counterculture luminaries that included Ono, Leary, singer Petula Clark, poet Allen Ginsberg, civil rights activist Dick Gregory, and DJ and self-anointed "Fifth Beatle" Murray the K, among others. Comedian Tommy Smothers helpfully pitched in with acoustic guitar accompaniment. After a quick and suitably ragged rehearsal, Lennon and Ono's ragtag band of makeshift musicians captured "Give Peace a Chance" in a single take.[6]

The next morning, Perry returned the equipment to the studio and listened to the shabby, unprofessional recording. Determined to salvage Lennon and Ono's song, he gathered up a group of local singers and musicians, announcing "Here's what I want to do. I want to reproduce what should have been. So we're not gonna sound like a bunch of guys in the studio, we're not gonna sound slick. We're gonna sound like we're having fun." To give the recording some much-needed oomph, Perry decided to simulate "that Beatle-ish thump they used to have in those days. So I went and got my garbage can, which was made of rubber. That thump that you hear that builds up, that was me hitting my rubber garbage can." To Perry's mind, "The idea was not to cheat. The idea was to save the event." That afternoon, after Perry had mixed "Give Peace a Chance" in the studio, he brought the recording to Lennon back at the Hôtel Reine-Élizabeth. When he heard the finished product, a jubilant Lennon hugged Perry, exclaiming "Man, this is unbelievable!"[7]

That summer, Lennon and Ono hailed the song as the inaugural release from the Plastic Ono Band. But as it happened, the Plastic Ono Band wasn't really a band at all but rather the concept of a group. As Lennon later recalled, "It originally started off as Yoko's idea as a band, a kind of joke, a concert band that didn't exist. We built the whole group so we thought, 'why not call it the Plastic Ono Band instead of just John and Yoko' for the fact that there were all sorts of people singing on it. It wasn't the Beatles, it was like a rabbi, a hotel waiter, and all things like that. It was a bit of everybody. The whole world is the Plastic Ono Band." At the single's press launch in July, Lennon and Ono pressed this agenda even further, portraying "Give Peace a Chance" as a kind of intercultural accomplishment—one in which people from all walks of life could share in the song's origins and meaning. The couple even devised a slogan—"YOU are the Plastic Ono Band"—to express their new faux supergroup's inherent artifice and subterfuge.[8]

As for the authorship of "Give Peace a Chance," Lennon defaulted to his long-standing agreement with Beatle Paul to credit their songs' compositions—even when written separately and without the other's input—to the corporate Lennon-McCartney. In retrospect, Lennon felt understandably unsettled about ascribing "Give Peace a Chance" to their songwriting partnership, given that the record marked his first non-Beatles single. Years later, he would regret the move, which he attributed to feeling "guilty enough to give McCartney credit as co-writer on my first independent single instead of giving it to Yoko, who had actually written it with me." With "Give Peace a Chance," Lennon imagined that the song would emerge as a peace anthem in the same vein as the gospel standard "We Shall Overcome." And for a while, at least, it was.[9]

Later that year, during a November 15 Vietnam Moratorium Day rally in Washington, DC, American folksinger and activist

Pete Seeger led some five hundred thousand people in a rendition of "Give Peace a Chance" across the street from the White House in Lafayette Park. As the assembled phalanx of protesters sang, "All we are saying is give peace a chance," Seeger shouted a series of interjections among the verses: "Are you listening, Nixon? Are you listening, Agnew? Are you listening, Pentagon?" For Lennon, the Vietnam Moratorium Day rally proved to be a watershed moment in a career that was chock-full of such instances. "That was a very big moment for me," he later recalled. "In my secret heart, I wanted to write something that would take over 'We Shall Overcome.' I don't know why, that's the one they always sang. I thought, 'Why isn't somebody writing one for the people *now*?' That's what my job is. Our job is to write for the people *now*."[10]

While McCartney and Lennon were blazing new trails in England and elsewhere, Harrison was continuing to make inroads into the pop world as a bona fide songwriter-producer in his own right. After languishing in his older and much more celebrated mates' collective shadow since the earliest days of the group's inception, the Quiet Beatle was enthralled with the artistic liberation that he had been pursuing, which manifested itself both in his production work and as a solo act. *Wonderwall Music*, Harrison's debut release, dated back to November 1968, although its production began more than a year earlier, when Harrison had traveled to India to conduct recording sessions for an art film being directed by Joe Massot. Entitled *Wonderwall*, the movie narrated the life and work of an introverted scientist named Oscar Collins (Jack MacGowran), who becomes obsessed with his neighbors, especially the aptly named Penny Lane (Jane Birkin), a delectable model. The "wonderwall" of the film's title refers to a shaft of light that streams through a hole in the wall that separates their apartments, illuminating Penny while she poses during a photo session. As time passes, Oscar's

obsession begins to overwhelm him, and soon he drills even more holes in order to observe Penny's every move. At EMI's Bombay facility, Harrison recorded a series of ragas for the *Wonderwall Music* soundtrack, while also preparing the instrumental track for a new composition titled "The Inner Light," which was later released as the B-side of the Beatles' chart-topping single "Lady Madonna." For the soundtrack, Harrison recruited a host of superb Indian classical musicians, including sarod virtuoso Aashish Khan, santoor player Shivkumar Sharma, and tabla masters Shankar Ghosh and Mahapurush Misra. By this point in his career, Harrison was wholly enthralled with Indian music, drawing upon it as a means for navigating a future solo career to explore his unrequited artistic passions. As Harrison remarked to *Musician* magazine years later, composing the soundtrack for *Wonderwall* afforded him with a much-needed entrée into a creative world outside of the Beatles. "I was getting so into Indian music by then," Harrison observed, "that I decided to use the assignment as an excuse for a musical anthology to help spread the word."[11]

As producer, Harrison discovered that he could spread the musical word across multiple genres at an even more accelerated clip via the Beatles' Apple enterprise. In this still relatively unfamiliar role, Harrison worked on behalf of a variety of artists during the months after *Wonderwall Music*'s November 1968 release, grooming ace prospects like Billy Preston, Doris Troy, and Jackie Lomax for their Apple debuts. In Preston's case, Harrison was well-acquainted with the American keyboardist's boundless talent, and he was determined to create a space for him on the world music stage. Recording during the spring months of 1969, *That's the Way God Planned It* showcased Preston's unique mixture of gospel, R&B, and soul-oriented rock. For the LP, Harrison mustered a veritable supergroup of top-drawer players in support of Preston,

chipping in his own efforts on guitar along with Eric Clapton, Keith Richards on bass, and Cream's Ginger Baker on drums. Harrison pulled out all of the stops during the album's production, delivering for Preston one of the finest Apple debut releases during the label's short history. For his part, Preston couldn't help revealing his gratefulness in the liner notes for *That's the Way God Planned It*. In so doing, he revealed his own faith in the Beatles' utopian dreams for Apple as a democratizing force: "Apple is the company for all people that know where it's at and love peace, love joy, and all mankind. I am very grateful to be a part of it. It won't be long before we change the whole system that holds and keeps the artist's mind messed up. All thanks must be given to the fab Beatles. People should realize that what they have gone through has not been in vain and they are using it to the best of their ability."[12]

While they would not enjoy Preston's level of success with *That's the Way God Planned It* (the LP's spiritual title track became an international hit), Doris Troy and Jackie Lomax were given Harrison's full efforts to make them stars in their own right. A thirty-two-year-old African American R&B singer, Troy had come to be known as "Mama Soul" after scoring a Top 10 US hit with "Just One Look" in 1963. Having moved to London to take advantage of the UK's affinity for soul, Troy was looking for new avenues via which to energize her flagging career. In November 1968, she hit the jackpot, landing a gig as the vocal arranger for the Rolling Stones' gospel chorus for "You Can't Always Get What You Want." For Troy, the time was nigh to make an album and grow her reputation beyond American shores. As a longtime fan of Troy, Harrison seemed like the perfect producer to transform her fortunes, and he promptly signed her to an Apple contract after meeting the soul singer during the sessions for *That's the Way God Planned It*. Harrison was so taken with Troy's talents that he promptly

installed her in a private office at the Beatles' Savile Row building, complete with her own piano, so that she could fully activate her songwriter muse. As with Preston's album, Harrison lent his musicianship to Troy's project, while recruiting a vaunted support band that included Starr on drums, along with Clapton, Peter Frampton, and Stephen Stills on guitar, longtime Beatles insider Klaus Voormann on bass, and members of the Delaney and Bonnie and Friends band.

In contrast with Preston's album, Troy's LP made few commercial waves, although Harrison was deeply satisfied by his experience working outside of the Beatles' universe, where he had felt so often marginalized as a junior partner. As the Fab Four toiled separately in 1969, Harrison threw himself into Jackie Lomax's latest effort, an album titled *Is This What You Want?* Lomax had been a longtime fixture in the Beatles' world, having at one time been a Liverpool mainstay, the front man for the Merseybeat band the Undertakers, and a member of Epstein's stable of artists. After the manager's untimely death in August 1967, Lomax's recording career fell into the Beatles' hands. Harrison, in particular, was keen on working with Lomax, with whom he produced a single, the Harrison-penned "Sour Milk Sea," released in August 1968 as part of Apple's inaugural quartet of 45 RPM singles. A critical smash, albeit largely a commercial thud, "Sour Milk Sea" featured Harrison pulling out all the stops yet again and a backing band that included Harrison and Clapton on guitar, ace session man Nicky Hopkins on piano, and McCartney and Starr providing the low end on bass and drums.

When it came to recording Lomax's Apple LP debut, Harrison spared no expense, traveling with the singer to Los Angeles, where they took advantage of the talents of the West Coast music industry's famous Wrecking Crew in support of Lomax's latest batch

of songs. Perhaps even more significantly, working in LA brought Harrison into the orbit of Bernie Krause, the Moog synthesizer pioneer who contributed to the sessions for *Is This What You Want?* In 1966, Krause had signed on as West Coast sales representative for the strange new instrument's inventor Robert Moog. Working with his partner Paul Beaver, Krause spent a year trying to drum up Hollywood studio interest in the Moog's sonic potential. His breakthrough finally came in June 1967, when Krause made a much-publicized splash with the invention by exhibiting the synthesizer at the Monterey International Pop Festival. Indeed, it was at Monterey—in sunny California, no less, with the Who and the Jimi Hendrix Experience topping the bill—that Krause and Beaver finally gained a toehold in the music industry. The Beatles had long been rumored to appear at the festival, but they ultimately declined, rightly observing that their music had become far too complex for live performance given the technology of the day. Demonstrating the Moog in their booth at the fest, Krause and Beaver succeeded in capturing the attention of bands like the Doors, the Byrds, and the Rolling Stones.

In short order, the duo emerged as a hot commodity in music circles, landing a recording contract of their own and subsequently releasing a double album, *The Nonesuch Guide to Electronic Music*. In the ensuing months, a spate of albums prominently featured the Moog, often with Krause and Beaver themselves playing the novel instrument, including the Doors' *Strange Days*, the Byrds' *Notorious Byrd Brothers*, the Monkees' *Pisces, Aquarius, Capricorn, and Jones*, and Simon and Garfunkel's *Bookends*, among others. But the electronic instrument finally enjoyed international headlines in 1968 with the release of Wendy Carlos's *Switched-On Bach*, a classical album produced by Rachel Elkind and comprising Moog-synthesized versions of compositions by Johann

Sebastian Bach. As Carlos later remarked, recording the Moog in a studio setting required painstaking effort, as the monophonic instrument could only be activated by playing one note at a time. "You had to release the note before you could make the next note start, which meant you had to play with a detached feeling on the keyboard, which was really very disturbing in making music," said Carlos.[13]

With the enormous commercial success of Carlos's LP, the Moog swiftly became a household name, but the instrument was not ready for mass consumption. The synthesizer had originally emerged via company founder and inventor Moog's interest in eclipsing the sonic limitations of the vacuum tube Theremin, which could emit only a single sine wave tone. Hungry for a more complex electronic instrument, Moog had begun trying his hand at building transistorized sound machines by the early 1960s, and slowly but surely the instrument that would bear his name was born. By the mid-1960s, his prototype operated via a series of standardized modules, or blocks, that were powered by oscillators and activated by a keyboard, thus enabling the player to enjoy pitch control—a game-changing feature of Moog's device. While technological advancements in integrated circuitry allowed Moog to manufacture a more compact keyboard, installing and operating one of the synthesizers was not easy during this era. In most cases, hours of setup time were required—and often at the hands of highly skilled professionals like Krause and Beaver, who not only guided the user in installing and operating the instrument but also handled pitfalls, such as the Moog's notorious pitch instability, which resulted when the device inevitably heated up during extended use. Its oscillators began to drift out of tune. Indeed, they were so unreliable that they often needed to be retuned for each new take.

This meant that licensed sales reps like Krause were in high demand during this early period in the instrument's penetration into the world's recording studios. Having only recently wrapped up work on *The White Album*, Harrison joined Lomax in Los Angeles in October 1968 to work on *Is This What You Want?* On the evening of November 11, Krause joined them at LA's Sound Records Studio, where he played the Moog III on several of Lomax's recordings with Harrison sitting behind the console. The session proved to be a meticulous exercise, with Krause carefully superimposing the monophonic instrument onto a range of Lomax recordings, including the title track, "I Fall Inside Your Eyes," "Baby You're a Lover," "How Can You Say Goodbye," and "Little Yellow Pills." Observing from his place in the booth, Harrison was mesmerized by the device, later entreating Krause to stay with him at the studio into the wee hours of the morning and demonstrate the Moog III's capabilities. With the tape rolling, Krause exhibited the synthesizer's wide array of sonic bells and whistles for Harrison. Over the course of their session together, Krause programmed the device to mimic a host of different sounds, including a static rush of white noise, gunshots and firecrackers, a gale-force wind, a siren, a vacuum cleaner, a series of Morse code–like blips, the high whine of a dentist's drill, and the whir of a race car. For Harrison— who had ushered the sitar to the forefront of Western music—the Moog represented yet another opportunity to lead the vanguard of an exotic form of instrumentation, no matter how mechanized. Before he left the West Coast, the Quiet Beatle promptly ordered one of the synthesizers for delivery at his Esher home, Kinfauns, in the new year.

As it happened, Harrison wouldn't receive his new electronic toy until mid-February, when he finally took possession of his Moog III after his hospital stay for tonsillitis. Not missing a beat, he hired

Krause to set up the intricate, cumbersome device in his home studio and provide him with some rudimentary music lessons. Indeed, for Harrison, operating the Moog was a daunting task. "I had to have mine made specially because Mr. Moog had only just invented it," Harrison later recalled. "It was enormous, with hundreds of jackplugs and two keyboards. But it was one thing having one, and another trying to make it work. There wasn't an instruction manual, and even if there had been it would probably have been a couple of thousand pages long. I don't think even Mr. Moog knew how to get music out of it; it was more of a technical thing." Harrison's synthesizer marked the ninety-fifth instrument sold by Robert Moog's company—and only the third to be installed in the United Kingdom. For $8,000, Harrison received the deluxe model, which consisted of two five-octave keyboards, a ribbon controller, ten oscillators, a white-noise generator, three ADSR (Attack-Decay-Sustain-Release) envelope generators for creating the instrument's tonality, voltage-controlled filters and amplifiers, and a four-channel mixer, among other gadgetry. Things were going along swimmingly between the two colleagues until Harrison made the error, later seen in retrospect, of playing Krause the latest mix of "No Time or Space," a recording that had been slated for a May release on *Electronic Sound*, Harrison's second solo LP. Krause was thunderstruck to discover that the twenty-five-minute track was largely composed of his Moog demonstration back in LA in November. Unsurprisingly, Krause protested vehemently, contending that some of the elements in "No Time or Space" were destined for inclusion on his own upcoming LP, with Paul Beaver. As events would show, Harrison was not persuaded by Krause's objections.[14]

Given its origins as an unstructured demo, Harrison's—or, perhaps more accurately, Krause's—"No Time or Space" featured

scant little music in the way of form or melody. The album's companion piece, entitled "Under the Mersey Wall" and borrowed from the name of a *Liverpool Echo* newspaper column, was a considerably more pleasing demonstration of the Moog's sonic capabilities. Now that he had a Moog III of his own, Harrison treated the instrument, still almost exclusively known for its novelty, as a conventional instrument in his music-making arsenal. With "Under the Mersey Wall," he "stuck to melodic and musical noises and largely steered clear of the more gimmicky and grating effects," John C. Winn astutely observed in his book *That Magic Feeling*. "It's still nothing to write home about, and when George can be heard clearing his throat at 12:15 in the recording, it comes as a welcome human relief to all the impersonal automatonic clamor." As for Krause, the American Moog pioneer was still smarting over Harrison's overt plagiarism and subsequently pursued legal action against the Beatle. When it was released that May on Zapple— Apple's experimental record label—*Electronic Sound* carried the phrase "assisted by Bernie Krause" as its only acknowledgment, save for the album cover itself, which featured Harrison's crude painting of Krause demonstrating the Moog back in LA before the duo became warring parties.[15]

After its release, *Electronic Sound* was quickly forgotten. Harrison rarely mentioned the LP, doing little in the way of promotion at the time, save for a Derek Taylor–penned press release. Lomax was another matter. While Harrison had poured plenty of resources into making his fellow Liverpudlian into a bona fide hitmaker, Lomax was never destined, it seemed, for success. His inability to make a dent in the charts flummoxed Harrison, who saw Lomax as the second coming of Jim Morrison. As *Mersey Beat* founder Bill Harry has observed, Lomax's dearth of commercial success "completely baffled the Beatles because Jackie had one of the rare and

distinctive voices which have the potential of turning its owner into a superstar." For Harrison, the Moog synthesizer proved to be the most significant takeaway from his West Coast lark with Lomax. As the months wore on, Harrison toiled with the synthesizer, attempting to develop a working facility with the instrument. During one of Lennon's visits to Harrison's Surrey home, John was flabbergasted by the sound of the device and remarked at the time, "It's like living with HAL out of *2001*." For his part, Harrison was determined to master the intricacies of the synthesizer, from its baffling array of components to its pesky oscillators. One way or another, he would make the Moog his own.[16]

Reeling from the unhappy events of May 9 at Olympic Sound, when McCartney's bandmates had unsuccessfully pressured him to sign a management contract with Allen Klein, the Beatles managed to right their foundering ship long enough to assemble for a photo shoot a week later. As it turned out, two photo sessions were required to get the job done. In early May—before Lennon, Harrison, and Starr had stormed out of Olympic—the Beatles had gathered in Manchester Square at EMI House with photographer Angus McBean to shoot the cover art for *Get Back, Don't Let Me Down, and 12 Other Songs*. Years earlier, for the Beatles' first album, *Please Please Me*, Martin had known that he wanted McBean's work to grace the cover, given the portrait photographer's long-standing professional relationship with Cliff Richard and the Shadows. On March 5, 1963, McBean had met Martin, Brian Epstein, and the group at Manchester Square to hold the photo session. As it happened, the photograph that was eventually selected for the cover shot was taken by McBean when he first arrived at EMI House. "As I went into the door I was in the staircase well," he remembered years later. "Someone looked over the banister—I asked if the boys were in the building, and the answer

was yes. 'Well,' I said, 'get them to look over, and I will take them from here.'" As Martin and Epstein looked on, the Beatles posed partway up the stairwell, gazing downward for all time. "I only had my ordinary portrait lens," said McBean, "so to get the picture, I had to lie flat on my back in the entrance. I took some shots and I said, 'That'll do.'"[17]

With McBean in tow in May 1969, the Beatles restaged the exercise more than six years later, but their first attempt at capturing an updated photo failed. McBean realized that a new porch had been constructed and that it would be impossible for him to shoot the photo from the same angle that he had used back in 1963. With EMI promising to remove the porch so that McBean could work from the appropriate angle, the Beatles set a new date of Tuesday, May 13, for the photo shoot. Still smarting from the blowup back at Olympic, the bandmates shrugged it off and approximated their March 1963 poses on the EMI House stairwell. In retrospect, it was a clever idea—a means of bookending their career, as well as underscoring their intent to return, with the *Get Back* project, to the unadulterated rock and roll that brought them fame and fortune in the first place. The difference in the Beatles' appearance over the years couldn't have been any more striking. Gone were the comparatively innocent days of early 1963, with the wide-eyed, clean-shaven, matching suit–wearing Beatles smiling brightly for McBean. Those fresh faces had been replaced by a world-weary, longer-haired Fab Four, with a mustachioed Starr and bearded Lennon framing the shot. Only McCartney, still boyish and sporting his locks in nearly the same fashion as in 1963, hearkened back to those bygone days when the Beatles were just beginning their journey to superstardom.

McBean was struck by the sight of the bedraggled group at the top of the stairwell in 1969. He fondly remembered the 1963 photo

shoot, "[when] I asked John Lennon how long they would stay as a group, and he [had] said, 'Oh, about six years, I suppose—who ever heard of a bald Beatle?'" McBean observed that six years later they were far from bald, being "very hairy indeed." On May 13, as McBean prepared to take the photo, he would later recall, "Ringo Starr was so late that the staff of EMI was streaming down the stairs. I got the camera fixed up and John, fascinated by photography, came and lay down beside me to look at my view-finder. I can still hear the screams of the EMI girls as they realized who they were stepping over to get out the door!" While the bandmates' physical appearances may have shifted dramatically, their fans' continuing frenzy suggested that Beatlemania was alive and well—even in those post-touring days, when the Beatles no longer crisscrossed the globe as they had done, in mind-numbing fashion, a few years earlier.[18]

With the photo shoot completed to McBean's satisfaction, Martin and Johns continued their work readying *Get Back* for its expected release. A few days later, Lennon and McCartney's bid to obtain control of Northern Songs was dealt yet another blow when ATV sealed its agreement with Dick James, which left Lord Grade in the driver's seat as far as any deal with the Beatles was concerned. Lennon and McCartney were shell-shocked by this development. According to Apple's Peter Brown, "To John and Paul, Northern Songs wasn't just a collection of compositions, it was like a child, creative flesh and blood, and selling it to their business antagonist Sir Lew Grade was like putting that child into an orphanage." By this point, the songwriters' most formidable obstacle turned out to be Lord Grade himself. A consummate businessman, he implicitly understood the value of the Beatles' holding, once remarking that "the songs in Northern will live on forever." Perhaps even more troubling for Lennon and McCartney, Lord Grade was well aware

that their publishing contract with Northern Songs held the rights to all of their songwriting output until 1973.[19]

With their production team holed up at Olympic, the bandmates went their separate ways, retreating on holiday to their four corners. The McCartneys left first, traveling to Corfu for an extended stay in the Mediterranean, while George and Pattie Harrison journeyed to Sardinia after the Quiet Beatle completed work on *Electronic Sound*. Meanwhile, Ringo and Maureen Starkey boarded the *Queen Elizabeth 2* on their way to vacation stays in New York City and later the Bahamas. The festive occasion had been organized by the producers of *The Magic Christian* as a means for rewarding the cast and crew. Along with the Starkeys, the luxury cruise included Ringo's costar Peter Sellers, director Joe McGrath, producer Denis O'Dell, and Apple press officer Derek Taylor. In the Bahamas, the Starkeys met up with Lennon and Ono, who had planned to make the trip to the United States until John was denied a visa because of his recent drug conviction (he'd pled guilty to cannabis possession in the wake of Norman Pilcher's London raid in late 1968). After spending a few days in the tropics, the Lennons made their way to Montreal for their latest Bed-In for Peace.

Once ensconced on his Greek island hideaway with wife Linda and stepdaughter Heather, McCartney turned quickly back to his music. As he whiled away the days under the Mediterranean sun, McCartney began refining a relatively new song titled "Every Night," which he had begun back in January during the *Get Back* sessions. In the song's chorus, "Every Night" held more than a passing resemblance to "You Never Give Me Your Money," a new composition that the Beatles had attempted recording on May 6, with Martin and Johns working the session at Olympic. McCartney had composed the song back in March when he was visiting his new in-laws in New York City with Linda. Wrestling with the

Beatles' financial entanglements—and the very real and present issue of determining who would manage the band's unraveling financial affairs—he had composed "You Never Give Me Your Money" as a kind of personal therapy about the "funny paper" at the heart of global commerce.

Years later, McCartney would recall that "this was me directly lambasting Allen Klein's attitude to us: no money, just funny paper, all promises and it never works out. It's basically a song about no faith in the person," he added, noting that "John saw the humor in it." Apparently Harrison too understood the irony completely. "That's what we get," he remarked at the time. "We get bits of paper saying how much is earned and what this and that is, but we never actually get it in pounds, shillings, and pence. We've all got a big house and a car and an office, but to actually get the money we've earned seems impossible." It was a sentiment that had plagued the Beatles since their earliest days of stardom. McCartney recalled, "We used to ask, 'Am I a millionaire yet?' and they used to say cryptic things like, 'On paper you are.' And we'd say, 'Well, what does that mean? Am I or aren't I? Are there more than a million of those green things in my bank yet?' and they'd say, 'Well, it's not actually in a bank. We think you are [a millionaire].' It was actually very difficult to get anything out of these people, and the accountants never made you feel successful."[20]

Working a thirteen-hour stint at Olympic on May 6, the Beatles recorded thirty-six takes of the basic track for "You Never Give Me Your Money." Even at this relatively early stage in the life of the song, "You Never Give Me Your Money" was a complex affair, with several different component parts comprising its structure. As with *The White Album*'s "Happiness Is a Warm Gun," "You Never Give Me Your Money" acts as a "through-composed song," which denotes a multipart musical composition that is continuous and

non-repetitive. By this point, McCartney had been refining the song for several weeks. Martin's protégé Chris Thomas recalled a day in late April 1969 when McCartney sat at the Studio 3 piano "playing this whole thing which lasted about 15 minutes, 'it goes into this and into that.'" For the recording of "You Never Give Me Your Money," McCartney sang lead and played piano, with John playing his Casino, Harrison playing his Leslie-amplified Fender Strat, and Starr working his Ludwig Hollywoods. At this juncture, "You Never Give Me Your Money" had a distorted, organic feel. That evening, they recorded thirty-six takes of the backing track, which Martin and Johns spread out liberally across Olympic's eight-track soundscape: with Harrison's Leslie-amplified guitar on track one, McCartney's piano on track two, Starr's drums on track three, McCartney's guide vocal on track four, and Lennon's rhythm guitar on track six. Having selected Take 30 as the best, the Beatles intentionally left plenty of real estate available for continuing work on the song at a later date. For Harrison, the distinctive structure inherent in "You Never Give Me Your Money" made it a joy to perform. As he later remarked, "It does two verses of one tune, and then the bridge is almost like a different song altogether, so it's quite melodic."[21]

At Martin's urging, the Beatles had begun considering the idea of recording a pop opera, a concept that was coming increasingly into vogue among the group's peers, as evinced by works from the Who ("A Quick One, While He's Away"), Frank Zappa and the Mothers of Invention (*Absolutely Free*), and the Small Faces ("Happiness Stan"), among others. McCartney had been particularly inspired by Keith West's "Excerpt from a Teenage Opera," which had landed a Top 5 UK hit back in 1967. Produced by Mark Wirtz and engineered by Emerick, West's "Excerpt" was known as "Grocer Jack," in reference to the song's main character, a grocer who toils in a

small English town, suffering the scorn of the townspeople, who take his presence for granted. In spite of his neighbors' jeers, he wills himself to work, thinking, "Get on your feet / Without you, Jack, the town can't eat." Things come to a head when his unexpected death leaves the village in a lurch, suddenly forcing them to fend for themselves in his glaring absence. Both a cautionary and sentimentalized tale, "Grocer Jack" concludes with the heartbreaking chorus of the village children, who had loved the fallen grocer even as their parents had derided him.

For McCartney, West's storytelling was intoxicating, and he was eager for the Beatles to try their hand at a form of extended songwriting of their own. To McCartney's mind, it was similar to the moment, also in 1967, when he had read an interview with the Who's Pete Townshend in *Melody Maker* in which the guitarist boasted of having created "the raunchiest, loudest, most ridiculous rock 'n' roll record you've ever heard" in "I Can See for Miles." With his competitive energies raging, McCartney duly composed *The White Album*'s "Helter Skelter." During the same month in which the Beatles first tried their hand at recording "You Never Give Me Your Money," the Who upped the ante even further with the release of *Tommy*, the album that would come to define the rock opera as a musical form. With the notion of producing an extended suite of their own, the Beatles were not acting as trendsetters, which was typically their wont, but rather, as trend-followers. But for McCartney, the idea of besting the field with the Beatles' own "huge medley" or "the long one," as the evolving musical suite came to be known among EMI staffers, was tempting. For his part, Martin welcomed the opportunity to expand the Beatles' generic considerations and assist McCartney in his latest bout of one-upmanship. "I wanted to get John and Paul to think more seriously about their music," Martin later recalled. "There

would be nothing wrong with making a complete movement of several songs, and having quotes back from other songs in different keys. And even running one song into another contrapuntally, but thinking of those songs in a formal classical way." To this end, Martin pointedly "tried to instruct them in the art of classical music, and explain to them what sonata form was. Paul was all for experimenting like that."[22]

And at the time, apparently so was Lennon. As the Beatles took a break in June to go on holiday and, just as important, accrue new material, Lennon could barely contain his excitement during an interview with the *NME*. "Paul and I are now working on a kind of song montage that we might do as one piece on one side," he remarked. "We've got about two weeks to finish the whole thing, so we're really working on it." In McCartney's memory, the idea of concocting a medley made perfect sense, given the significant backlog of material that they had accrued by the spring of 1969. "We did it this way because John and I had a number of songs, which were great as they were, but we'd finished them," he later recalled. "It often happens that you write the first verse of a song and then you've said it all, and can't be bothered to write a second verse, repeating or giving a variation. So, I said to John, 'Have you got any bits and pieces, which we can make into one long track?' And he had, and we made a piece that makes sense all the way through."[23]

In mid-June, McCartney returned to London and telephoned Martin, who reeled in surprise when Paul announced that the Beatles were ready to go back in the studio again. Martin was thoroughly aware of the bandmates' blowup back at Olympic in May, and this time he had thought that the group was once and truly kaput. To his mind, his efforts with Johns to wrap up production on the *Get Back* LP and the subsequent cover photo shoot were

likely to be the subpar finishing touches on an otherwise unparalleled career in recording artistry. Not missing a beat, Martin rounded up Emerick and block-booked EMI Studios 2 and 3 for July and August. As the Beatles set their sights on Tuesday, July 1, the symphonic suite served as a rallying point for the bandmates, who were eager to see their good works across the winter and spring come to fruition. But Martin, ever cautious, could clearly read the writing on the wall. From his vantage point, the Beatles seemed to be quickly exhausting their chances for resuscitating their partnership. He knew that, come July, they needed to find a way to put their ongoing rancor behind them before it was too late—before something truly irrevocable happened—and make one last stab at greatness.[24]

4

"The Long One"

For Martin, the ability to corral so much studio time on the Beatles' behalf was one of the last remaining vestiges of his previous career as A&R head at Parlophone, the EMI subsidiary that had signed the band in May 1962. In September 1965, Martin had gone into business for himself, founding AIR and striking out on his own as a freelance producer. Martin had become fed up with EMI's pecuniary ways and was still smarting over the record conglomerate's steadfast refusal to build a royalty schedule into his contract. He had felt EMI's penny-pinching most particularly in early 1964, when he hadn't received a holiday bonus after a year in which his records had held the top spot for an astounding thirty-seven out of fifty-two weeks. EMI denied him a bonus since Martin was management, and the bonuses were reserved for staff-level employees.

By that point, enough was enough for the normally staid producer, who vowed to leave EMI as soon as his contract expired. In his exit agreement, Martin negotiated a deal in which AIR would receive a royalty of 7 percent of retail sales of their clients' EMI records. Things became even more dicey when it came to AIR's production of EMI artists such as the Hollies and Cilla Black. In such cases, AIR would receive a producer's royalty amounting to

2 percent of retail sales. But the real prize, of course, was the Beatles, for whom Martin had produced every record since their industry debut in October 1962. In the UK alone, this amounted to nine number one singles and five chart-topping LPs, and Martin and the Beatles were still just getting started on their pop juggernaut. EMI took the position that Martin deserved only a meager residual on the biggest act that the world had ever seen, reasoning that the Beatles' incubation had occurred under EMI's auspices and virtually neglecting Martin's key role. Thus matters stood at the bitter end of his exit negotiations. EMI's managing director L. G. Wood informed the beleaguered producer that his UK royalty on Beatles records would be computed as 1 percent of the wholesale price of each record sold, which amounted to 0.5 percent retail. In the States—with its larger pop music marketplace—EMI proved to be even less generous, agreeing only to compensate Martin and AIR with 5 percent of the pressing fees that EMI gleaned from its American licensees.

Happy to have rid himself, for the most part, of the record conglomerate's miserly ways, Martin threw his weight around EMI Studios as best he could—a feat that became much easier when it came to the Beatles, who had delivered a series of landmark LPs during Martin's AIR years, an embarrassment of riches that included *Rubber Soul, Revolver, Sgt. Pepper,* and *The White Album.* "One of the things about being the Beatle producer in those days: it didn't give me a great deal of money, but it did give me a great deal of clout," Martin later remarked. "I was able to say, 'Well, look, we want to do this.' And everybody would say, 'Yes, sir! Yes, sir! Three bags full, sir!' Or almost." "Almost" was right, when it came to Martin and the Beatles. Since the advent of AIR, Martin had continued to lead the band to incredible commercial heights, netting eleven more chart-topping singles (including May 1969's

"The Ballad of John and Yoko") and four number one LPs dur-
ing the life of his EMI exit deal. Given the vast rewards emanat-
ing from their partnership, EMI had little trouble granting Martin
and the group virtually unlimited studio time at Abbey Road. And
why not? From EMI's perspective, studio hours represented a sunk
cost. Indeed, studio time was cheap for the EMI Group, which
owned the studios at Abbey Road outright. Hence, the Beatles' in-
ordinately long hours in the studio were never an issue for the re-
cord conglomerate but rather an internal accounting transaction.
"They didn't balk at our spending all that time," Martin observed
at the time. And besides, "they knew that we were doing something
worthwhile."[1]

But when it came to operating budgets, the record conglomerate
was, rather predictably from Martin's vantage point, far less gener-
ous. Having worked at EMI Studios since 1950, the Beatles' pro-
ducer understood the organization's parsimony. While EMI was
free and easy with studio time, the opposite was true when it came
to expenses associated with their recording artistry. In February
1967, Martin had employed a half-orchestra for "A Day in the Life,"
when Lennon and McCartney clearly wanted a full complement of
musicians to perform on the recording. For Martin, the notion of
booking that many players was prohibitively expensive in EMI's
cost-conscious purview. He simply couldn't justify the cost to the
EMI brass. "You're talking about 90 musicians!" he complained to
the bandmates in the studio control room. "This is EMI, not Rock-
efeller!'" In the final accounting, the half-orchestra cost £367 on a
final budget for *Sgt. Pepper* that came to some £25,000. All in all,
it was a miniscule investment on behalf of an album that defined
a generation, selling 250,000 copies in the first week alone in the
UK, while notching 2.5 million copies sold within three months of
its release in the States.[2]

Years later, Martin couldn't help dressing himself down for being so cheap, EMI's tightfisted ways be damned, when it came to the Beatles. "Thus spake the well-trained corporate lackey still lurking somewhere inside me," he later wrote, even going so far as to disparage himself as a "cheeseparer." Still, by the summer of 1969, Martin had come to appreciate the high cost of building, much less maintaining, a state-of-the-art studio. With AIR still in its relative infancy, he took his biggest professional gamble yet. For the balance of his career, Martin had bemoaned the state of British recording studios, which, to his mind, were either overly puritanical in their approach to making sonic art or woefully outdated in terms of incorporating the latest technologies. Having spent the past several years observing the Beatles' growing frustrations with EMI Studios, as well as Magic Alex's recent shenanigans related to building out Apple Studio, Martin was ready to roll the dice on outfitting studio space of his own. Having rented space in Central London's bustling Oxford Circus, the producer was pulling out all the stops in terms of much-needed soundproofing (the Central Line rumbled directly beneath the building's basement) and stocking up on the latest and greatest studio gear. By midsummer 1969, the recording equipment alone was estimated to cost £110,000. For a while, AIR's financial situation was beginning to look a lot like Apple's during this period. As Martin and his AIR partners prepared to break ground on the studio that would come to be known as AIR Oxford Street, he had to balance the dream—building out a studio that world-class artists like the Beatles deserved—and the prospect of imminent bankruptcy. "We had to strip our company to the bone, and were in what the jargon calls a 'serious cash-flow situation' for a while," he later wrote. "The money was going out far more quickly than it was coming in."[3]

For Martin, July 1 couldn't arrive soon enough. The veteran producer was eager to get back into the studio with his most valuable commodity and equally excited about writing a new chapter and finally putting January's *Get Back* sessions behind them. Things began that afternoon in routine fashion, as for any Beatles album over the preceding several years, with McCartney arriving first as usual, given the close proximity of his Cavendish Avenue home. As sessions went, it was a short one by the Beatles' standards, running just four and a half hours. Joining Martin in the Studio 2 control booth were Phil McDonald in the engineer's chair and Chris Blair serving as his tape operator. Emerick was absent—catching a much-earned breather after engineering Mary Hopkin's *Postcard* for McCartney and Jackie Lomax's *Is This What You Want?* for Harrison—as were the rest of the Beatles themselves, who intended to join McCartney the next day.

Blair had been hurriedly pressed into service as McDonald's assistant, given the lack of available personnel at the height of summer, and was unnerved about the prospect of working with the Beatles. He later recalled, "Allen Stagg, then studio manager, called me to his office to ask if I might like to help out. He said that he wouldn't pressurize me into doing it." Stagg's caution on Blair's behalf reflected a schism that had developed over the years between EMI studio personnel and the Beatles. For the majority of EMI's engineers and tape operators, working with the band meant long, tedious hours in the studio and, worse, there was a growing sense at Abbey Road that the group subscribed to a hierarchy that separated themselves as artists from the control room staff. Longtime EMI staffer Richard Langham later admitted to carrying a clipboard with him as he strolled the corridors of 3 Abbey Road and said he was always on the lookout for one of the bandmates, who might suddenly try to rope him into one of the Beatles' sessions.

That's when Langham would hold up his clipboard, signaling that he was already engaged in duties elsewhere. More often than not, the ruse worked out for Langham, who was spared the interpersonal tensions of another twelve-hour overnight session with the Beatles.[4]

With Martin up in the booth, the July 1 session began with McCartney revisiting the notion of compiling a mini rock opera for the Beatles' new LP. Working with the May 6 backing track for "You Never Give Me Your Money," McCartney took several passes at perfecting his lead vocal for the multipart song, which was already slated to be the first track in the "huge medley," the same song cycle about which Lennon had shown such excitement earlier that same summer. It could hardly have been lost on McCartney and Martin that "You Never Give Me Your Money" made for an especially fitting overture for the band's still evolving medley, given the place that fiscal matters held in the group's malaise. For Lennon, the song was equally poignant given his own long-held suspicions and outright distrust regarding the financial class that ruled the world.

But as the session came to a close that evening, McCartney learned the awful news that Lennon wouldn't be joining them in the studio anytime soon. Some six hundred miles to the north of EMI Studios, Lennon had been tooling around the narrow roads of Scotland with Yoko by his side and their children—John's six-year-old son Julian and Yoko's five-year-old daughter Kyoko—in the rear of their Austin Maxi hatchback. The newly married couple had been visiting Lennon's relatives in the far north when John lost control of the car and drove off a steep embankment near Golspie. Lennon and Ono had planned to visit the glacial bay nestled in the Scottish Highlands at the Kyle of Tongue. Knowing the precarious nature of the roadways, Lennon's cousin Stanley Parkes

had cautioned him about driving in the Highlands. "Remember," Parkes told him, "you're on single-track roads up here. Be very, very careful." In truth, Lennon had no business being behind the wheel under any conditions. He had scarcely driven an automobile of any kind since February 1965, when he took and passed his driving test during a session break and belatedly earned his license at age twenty-five. As it happened, Lennon, Ono, and their children were lucky to have escaped with their lives that day in the Highlands. Yoko, who was two months pregnant at the time, crushed several vertebrae and received a concussion in the accident, while all four of the car's occupants suffered cuts and bruises. Lennon's injuries required seventeen stitches in his face, Ono needed fourteen to close up the gash in her forehead, and the couple resigned themselves to spending the next several days in Lawson Memorial Hospital in Golspie.[5]

At the time, Lennon predictably made light of the accident, signing a postcard to Derek Taylor as "Jack McCripple" and informing a gaggle of reporters that "if you're going to have a car crash, try to arrange for it to happen in the Highlands." But Lennon had been stupefied by the extent of his and his family's injuries and practically gave up driving on the spot. It was a harrowing event, to be sure, and one that would have far-reaching implications. With Lennon lying in a hospital bed up in Scotland, the other Beatles went to work on the new LP. As Emerick later recalled, "No one was sure how John would react [to the Beatles proceeding in his absence], but we got on with the work anyway. There seemed to be an assumption that he would go along with it."[6]

First up on July 2 was McCartney's "Her Majesty," a song that he recorded solo on his Martin D-28 acoustic guitar. "Her Majesty" had been in circulation since the fall of 1968, later seeing action

during the January 1969 *Get Back* sessions. Years later, McCartney recalled composing "Her Majesty" in his Scottish home near the Mull of Kintyre. "It was quite funny because it's basically monarchist, with a mildly disrespectful tone, but it's very tongue-in-cheek. It's almost like a love song to the Queen." As it happened, McCartney had first written about the queen some seventeen years earlier. In 1953, a precocious ten-year-old McCartney was feted along with sixty other Liverpool schoolchildren for his essay about Queen Elizabeth as part of a Coronation Day competition. In his prize-winning entry, young Paul celebrated the power of peace by comparing the crowning of the new queen with the violent onset of William the Conqueror's reign in 1066. "On the Coronation Day of our lovely young queen, Queen Elizabeth II, no rioting nor killing will take place," McCartney wrote, "because present-day royalty rules us with affection rather than force." Twelve years later, McCartney and the other Beatles would meet the queen in the flesh when they accepted their MBE medals [Most Excellent Order of the British Empire] on October 26, 1965. As McCartney commented at the time, "She's lovely. She was very friendly. She was just like a mum to us."[7]

With Martin working the control booth with McDonald and Blair, McCartney captured the simple tune in an economical three takes. Martin recorded the Beatle performing the song live with his own accompaniment and distributed the vocal and guitar over two of the eight available tracks. The real challenge that afternoon fell on Blair, who was still nervous about his temporary assignment with the Beatles. After completing work on "Her Majesty," Blair's "mind went completely blank." He recalled that "Paul sat down and did 'Her Majesty,' and I couldn't for the life of me think how to spell 'Majesty' on the tape box. I rang upstairs, all around the building, asking people how to spell 'Majesty'!"[8]

After listening to the playback, McCartney selected "Her Majesty" for possible inclusion in the "huge medley." By this point he had been joined by Harrison and Starr in Studio 2, where they attempted two more McCartney compositions that had been slated for the Beatles' miniature opera, "Golden Slumbers" and "Carry That Weight." The former song found its origins in McCartney's recent visit to Rembrandt, his father Jim's home near Liverpool on Wirral Peninsula. Jim McCartney had remarried in the years since Mary McCartney's untimely death in October 1956, and the elder McCartney's new family included wife Angela and stepdaughter Ruth. During his visit to Rembrandt, Paul discovered the sheet music for Thomas Dekker's "Golden Slumbers" on the piano. He was instantly smitten with the Elizabethan poet and dramatist's lyrics. "I liked the words so much," he later recalled. "I thought it was very restful, a very beautiful lullaby, but I couldn't read the melody, not being able to read music. So I just took the words and wrote my own music. I didn't know at the time it was 400 years old." Originally published as an interlude in Act IV, Scene II of Dekker's 1603 play *Patient Grissil*, "Golden Slumbers" began life as a cradlesong, only to be repurposed by McCartney as a dramatic swell for the still unformed medley. In the play text, Dekker's lyrics evoke the rocking of a newborn to the sweet, somnambulant sounds of a lullaby:

> Golden slumbers kiss your eyes,
> Smiles awake you when you rise;
> Sleep, pretty wantons, do not cry,
> And I will sing a lullaby,
> Rock them, rock them, lullaby.[9]

In McCartney's hands, Dekker's words are embroidered into a rock song of a very different vintage, yet the lyrics' essential meaning

holds fast. No longer a cradlesong, "Golden Slumbers" acts as a salve for the painful realities of interpersonal strife, adulthood, and loss. "Once there was a way to get back homeward," McCartney sings. "Once there was a way to get back home." For McCartney, borrowing the lyrics from a poet who had been dead since the 1630s was a minor offense. Like so many of our greatest artists, the Beatles routinely refashioned the work of others. As McCartney famously observed, "We were the biggest nickers in town. Plagiarists extraordinaires." In the band's early days, they had borrowed liberally from Chuck Berry (the lyrics from "Sweet Little Sixteen" had inspired "I Saw Her Standing There," and they lifted the walking-bass line from a whole raft of Berry tunes) and Bobby Parker (whose "Watch Your Step" was echoed in the Beatles' "I Feel Fine" and "Day Tripper"). More recently, they had refashioned Humphrey Lyttelton's "Bad Penny Blues" as the piano intro for "Lady Madonna," and Lennon pinched his fiery guitar opening for "Revolution" from Pee Wee Crayton's 1954 hit single "Do Unto Others."[10]

When he debuted "Golden Slumbers" for his bandmates during the January 1969 *Get Back* sessions, McCartney joked that the song reminded him of the balladry of Frank Sinatra and that it "should be ready for a *Songs for Swinging Lovers* album." After describing it as "an old English love song," he observed, "I really should write a fairy tale." Working in this vein, he began singing "once upon a time, there lived a king." But by the time he would commit the song to tape some six months later, McCartney had jettisoned any fairy-tale pretensions and recorded "Golden Slumbers" strictly as a lullaby. During the July 2 session at Abbey Road, with Starr working the skins of his Ludwig Hollywoods and Harrison plying his Fender VI bass, "Golden Slumbers" was captured in fifteen takes, with Take 13 selected as the best. Playing the piano melody that he devised for his (mostly) borrowed lyrics—McCartney couldn't

read notation even remotely well enough to attempt the tune as written on Ruth's sheet music—he effected a passionate lead vocal for "Golden Slumbers," breaking into a full-on growl for the chorus. As he later recalled, "I remember trying to get a very strong vocal on it, because it was such a gentle theme, so I worked on the strength of the vocal on it, and ended up quite pleased with it."[11]

Even at this relatively early date in the life of the song, "Golden Slumbers" had already been slated for the medley—and, just as significantly, as the first half of a track that also included "Carry That Weight," another of the many compositions that McCartney had debuted during the January *Get Back* sessions. Even as early as January 9, the composer had been imagining the songs as two halves of a larger story, albeit a comedic one at this point. For a brief period, "Carry That Weight" had been considered for Starr's possible vocal contribution to the project—indeed, nearly all of the Beatles' studio LPs include a lead vocal from Ringo. When McCartney debuted "Carry That Weight" for Starr back in January at Twickenham, he was especially chatty as he attempted to fan the drummer's interest in singing the song, even going so far as to liken "Carry That Weight" to "Act Naturally," the Buck Owens cover version that Starr had earlier contributed to the *Help!* album (1965). "It's like a story," McCartney told Ringo, "a bit like 'Act Naturally,' where a tag line keeps coming up, you know, 'so and so and so and so,' but all he said was 'act naturally.'" At this juncture in the song's gestation, "Carry That Weight" possessed a dance-hall mien, sporting a bouncy, faster tempo in keeping with the song's original comedic overtones. As McCartney informed Starr, "There was a verse about a drunkard who got drunk, got in trouble with the wife, got drunk, so and so and so and so, and 'woke up the next morning with a weight upon my head and found it was my head!' It's sort of the normal kind of troubles that everyone has.

It's one of those songs where you've got everything and you've got everything going great but, you know, 'This morning, one of my eggs broke.' It's just so trivial." At this point, Starr suggested "broke a mirror," to which McCartney countered, "My right shoe is a bit tight," as if to underscore the pettiness of the subject's workaday struggles in "Carry That Weight."[12]

By July 2, the song was no longer trifling comedy but, rather, cut from very similar cloth as "You Never Give Me Your Money" and "Golden Slumbers," compositions that pointedly framed carefree youth against the thorny tableau of growing into adulthood. These songs evoked a world of competing lifestyles and ambitions, in which lifelong friends must reckon with their differences even as those same forces threaten to break up their relationships. The previously light mood of "Carry That Weight" had been replaced by heaviness that matched the weight of the group's unresolved business squabbles and rampant substance abuse. As McCartney observed at the time, "There was what my Aunty Jin would have called a bad atmosphere—'Oh, I can feel the atmosphere in this house, love.' . . . 'Heavy' was a very operative word at the time—'Heavy, man'—but now it actually felt heavy. That's what 'Carry That Weight' was about: not the light, rather easy-going heaviness, albeit witty and sometimes cruel, but with an edge you could exist within and which always had a place for you to be. In this heaviness, there was no place to be. It was serious, paranoid heaviness, and it was just very uncomfortable." Years later, McCartney would put an even finer spin on the portents of "Carry That Weight," remarking, "I'm generally quite upbeat, but at certain times things get to me so much that I just can't be upbeat anymore, and that was one of the times. We were taking so much acid and doing so much drugs and all this Klein shit was going on and getting crazier and crazier and crazier. 'Carry that weight a long time': like forever! That's what I meant." As

for Klein, McCartney still hadn't signed Klein's management contract at the heart of the Beatles' clash of wills two months earlier.[13]

During the July 2 session, McCartney established a guide vocal for "Carry That Weight"—just as he had done with "Golden Slumbers"—a feat that had been rendered much more efficient thanks to the separation afforded by eight-track technology and the TG console. As he had earlier done with "You Never Give Me Your Money," McCartney would be able to refine his lead vocals for "Golden Slumbers" and "Carry That Weight" at a later date and still have enough recording space left over to accommodate harmonies and yet-to-be-imagined instrumental superimpositions. The consensus was that Take 15 of "Carry That Weight" was the band's best. The next day, July 3, Martin supervised an editing session with McDonald and Blair in the Studio 2 control room, joining Take 13 of "Golden Slumbers" and Take 15 of "Carry That Weight" to create a seamless whole and afford McCartney, Harrison, and Starr with a fresh piece with which to work. To effect the link between the two songs, Starr rapped out a nifty beat on his Hollywood tom-toms.

As Lennon convalesced up north with Ono, his bandmates carried on. That evening, McCartney revisited his lead vocals for both songs, while Harrison provided an inventive guitar lick as a transition from the chorus of "Carry That Weight" to the song's heartrending middle eight. Paul, George, and Ringo sang the lyrics in unison, belting out the lyrics of the chorus with all the attendant gusto and gravity that they could muster. But it would be the middle eight—arguably McCartney's most revealing lyrical effusion on tape—where the sound of their voices reached their dramatic zenith:

> I never give you my pillow
> I only send you my invitations

And in the middle of the celebrations
I break down.

By explicitly using the melody of "You Never Give Me Your Money," the middle eight in "Carry That Weight" lays the bandmates' turmoil bare, with McCartney even going so far as to admit his own culpability. When it really mattered—when he might have provided his mates with comfort—he had given them the cold shoulder. In short, he had failed at being their friend. It would be a burden that the singer was destined to carry for a long time: to echo McCartney's own words, "like forever!"

By the conclusion of the July 3 session, the news of Brian Jones's death at age twenty-seven had reached the Beatles at EMI Studios. The Fab Four had enjoyed a close relationship with the estranged Rolling Stones guitarist. They had known him since the early 1960s, at the onset of the Stones' fame, and he had participated in Beatles recording sessions. Earlier that day, Jones's body had been found at the bottom of his swimming pool at Cotchford Farm. The coroner would later rule Jones's passing as "death by misadventure," given the accumulation of drugs and alcohol in his bloodstream. Years later, Mick Jagger would admit, "I wasn't understanding enough about his drug addiction. No one seemed to know much about drug addiction. Things like LSD were all new. No one knew the harm. People thought cocaine was good for you." Meanwhile, with Lennon still recovering from his injuries in Scotland, the other Beatles and Martin held a comparatively brief session in Studio 2 on the afternoon of Friday, July 4. By this point, "Carry That Weight" featured Starr's drums on track one, Harrison's bass on track two, McCartney's piano on track three, McCartney's lead vocals on track four, the three Beatles singing in harmony on track five, and, on track six, Harrison's Leslie-amplified lead guitar. Harrison

brought "Carry That Weight" to a close with a descending guitar riff that he had earlier deployed in the service of Cream's "Badge," which he had cowritten with Eric Clapton the preceding autumn. At this point, Martin had two remaining tracks at his disposal, affording plenty of space for a future orchestral overdub.[14]

The first part of that July 4 session had been devoted to, of all things, a tennis match. As engineer Dave Harries later recalled, when the Beatles arrived at the studio that afternoon, the production team had been following BBC Radio 2's live broadcast of Wimbledon, with Great Britain's Ann Jones vying for the women's championship against Billie Jean King, the American defending champion. "We were sitting there listening to the final before the Beatles came in," said Harries. "We had it coming through the mixing console. Then they came in and we thought, 'Oh, blimey, that's it,' especially when they pulled faces and went 'Uggghhh.' But they said we could carry on listening for a while and then, a few minutes later, one of them asked how Ann Jones was getting on, so we put it through on the studio speakers so that they could listen, too!" And so it was that portions of the radio broadcast found their way onto the outtakes from the band's recordings that day, as Jones bested King 3–6, 6–3, 6–2 in a seventy-one-minute, three-set match. That weekend, the news would be dominated by the Rolling Stones' free concert in London's Hyde Park, where the band performed a fourteen-song set as a memorial to Brian Jones. To prepare for the event, the Stones rehearsed at the Beatles' basement studio on Savile Row. McCartney was in attendance during the Saturday concert, which attracted nearly half a million fans to Central London. While the event had been previously planned to serve as a debut for Mick Taylor as Jones's replacement, the Stones opted to honor the late guitarist's memory instead. "We turned it into a memorial for Brian," Keith Richards later wrote. "We wanted

to see him off in grand style. The ups and downs with the guy are one thing, but when his time's over, release the doves, or in this case the sackfuls of white butterflies."[15]

Monday, July 7, proved to be one of the Beatles' most convivial sessions as Harrison unveiled his latest composition, "Here Comes the Sun," to the delight of his bandmates. With songs like *The White Album*'s "While My Guitar Gently Weeps," and more recently "Something," Harrison had finally proven himself a songwriter of the highest order. For Lennon, "Something" had been a revelation. As he later recalled, "Paul and I really carved up the empire between us, because we were the singers. George didn't even used to sing when we brought him into the group. He was a guitarist. And for the first few years he didn't sing on stage. We maybe let him do one number, like we would with Ringo." By the time Harrison started his life as a working songwriter, "there was an embarrassing period where his songs weren't that good," Lennon added, "and nobody wanted to say anything, but we all worked on them—like we did on Ringo's. I mean, we put more work into those songs than we did on some of our stuff. So he just wasn't in the same league for a long time—that's not putting him down; he just hadn't had the practice as a writer that we'd had."[16]

There is little doubt that Harrison acutely recognized his middling place in the Beatles' songwriting pecking order, yet he remained undeterred in his resolve to go toe-to-toe with the composers of "She Loves You," "I Want to Hold Your Hand," "Eleanor Rigby," and countless other gems. "I wasn't Lennon, or I wasn't McCartney," George remarked, "I was me. And the only reason I started to write songs was because I thought, 'Well, if they can write them, I can write them.'" As recently as the spring of 1967, he had endured the dispiriting experience of having one of his compositions, "Only a Northern Song," rejected by Martin, who felt

that it wasn't up to snuff for inclusion on *Sgt. Pepper*. In a moment of great triumph, Harrison returned with a vengeance, recording the superior "Within You, Without You" for *Sgt. Pepper*. With "Here Comes the Sun," Harrison would succeed in elevating his status again. During the January 1969 *Get Back* sessions, he had observed Lennon plying away on "Sun King," a new composition that featured the lyrics "here comes the sun." That April, Harrison deployed that germ of an idea in fine style as he strolled around the garden at Hurtwood Edge, Eric Clapton's country estate. Years later, Clapton would fondly remember the experience of observing his friend's creative energy in full bloom. "It was a beautiful spring morning, and we were sitting at the top of a big field at the bottom of the garden," he recalled. "We had our guitars and were just strumming away when he started singing 'de da de de, it's been a long cold lonely winter,' and bit by bit he fleshed it out, until it was time for lunch."[17]

As with such recent McCartney compositions as "You Never Give Me Your Money" and "Carry That Weight," Harrison's song had a connection with the band's fiscal crises. "'Here Comes the Sun' was written at the time when Apple was getting like school, where we had to go and be businessmen: 'Sign this' and 'sign that,'" Harrison later recalled. "Anyway, it seems as if winter in England goes on forever, by the time spring comes you really deserve it. So one day I decided I was going to slag off Apple and I went over to Eric Clapton's house. The relief of not having to go see all those dopey accountants was wonderful, and I walked around the garden with one of Eric's acoustic guitars and wrote 'Here Comes the Sun.'"[18]

Harrison completed the song during his May vacation with wife Pattie in Sardinia, putting the finishing touches on the lyrics, which he had scrawled on his personal stationery, replete with

a Hindu drawing and spiritual quotations. In order to provide a mnemonic device to remind him of his scat lyrics, he described his refrain as "scoobie doobie," while referring to his guitar part during the bridge as "son of 'Badge,'" in reference to the descending guitar figure in his Cream composition with Clapton. Harrison illustrated his lyrics with a sketch of a smiling, radiant sun. As for the song's endearing refrain, Harrison was likely drawing on the Diamond's 1957 doo-wop hit "Little Darlin'" for his inspiration.

With McDonald and Kurlander joining him up in the booth, Martin commenced the session for "Here Comes the Sun" on the afternoon of July 7. The genial atmosphere that day continued from start to finish. When the first take resulted in a false start, Harrison playfully remarked, "One of me best beginnings that!" "Here Comes the Sun" was not as simple as it sounded, shifting across a complexity of different time signatures in quick succession, including 4/4 time during the verses, punctuated by an intricate 11/8 + 15/8 sequence. For the recording, the bandmates concocted a basic rhythm track that featured Harrison singing a guide vocal and playing the song's distinctive melody on his Gibson J-200 acoustic guitar, McCartney on bass, and Starr—who was celebrating his twenty-ninth birthday—on the drums. After Martin and the Beatles selected Take 13 as the best of the lot, Harrison devoted the remainder of the session to refining his guitar part. With his capo on the seventh fret, Harrison brought the basic track for "Here Comes the Sun" to fruition, perfecting the song's gentle acoustic introduction in the process.[19]

On Tuesday, July 8, work on "Here Comes the Sun" continued. For his part, Martin was excited by the evolution of Harrison's latest composition. "I think there was a great deal of invention," Martin later recalled. "I mean, George's 'Here Comes the Sun' was the first time he'd really come through with a brilliant composition, and musical ideas, you know, the multiple odd rhythms that came through. They really became commercial for the first time

on that one." That afternoon, Harrison superimposed a new lead vocal onto "Here Comes the Sun" in place of the previous day's guide vocal. At this point, Harrison and McCartney layered the song with exquisite backing vocals, double-tracking their voices, which served to enhance the richness of their harmonies. Given that the band's vocals and instrumentation had consumed all eight of the 3M machine's available tracks, Martin and his production team concluded the eight-hour session with a tape reduction mixdown. Harrison was already imagining future adornments, including a planned orchestral arrangement from Martin.[20]

Then the group's day of reckoning arrived. On the afternoon of Wednesday, July 9, the Beatles once again became four, with Lennon, bruised and clearly the worse for wear, having made his return with Yoko and the children from Scotland. As McDonald later recalled, "We were all waiting for them to arrive, Paul, George [Harrison], and Ringo downstairs and us upstairs. They didn't know what state he would be in. There was a definite 'vibe': they were almost afraid of Lennon before he arrived, because they didn't know what he would be like. I got the feeling that the three of them were a little bit scared of him. When he did come in it was a relief, and they got together fairly well. John was a powerful figure, especially with Yoko—a double strength." For the other Beatles, it must have been quite a sight, with Yoko wearing a tiara to hide the wound on her forehead from the car wreck. Given her high-risk pregnancy, Yoko was under her physician's orders for constant bed rest, so John had a double bed shipped into EMI Studios from Harrods and a microphone positioned within easy reach to allow her to be in continuous communication with her husband. Not long afterward, Martin's partner from AIR and one-time Beatles engineer Ron Richards stopped by the studio for a visit. He was flabbergasted by the sight of Yoko lounging in the bed. "I popped into one

of the later sessions in Number 3," he later recalled, "and there was Yoko in this blooming double-bed. I couldn't believe it! John was sitting at an organ, playing, and I went up to him and said, 'What the bloody hell is all this?' and he was very touchy about it, so I kept quiet and walked out."[21]

Up first during Lennon's first session back was McCartney's "Maxwell's Silver Hammer," yet another leftover from the January *Get Back* sessions. In truth, the composition's origins went back much further. In January 1966, McCartney had listened to a production of Alfred Jarry's play *Ubu Cocu* on BBC radio while driving to Liverpool. "It was the best radio play I had ever heard in my life," McCartney later recalled, "and the best production, and *Ubu* was so brilliantly played. It was just a sensation. That was one of the big things of the period for me." After his experience listening to the play, McCartney immersed himself in Jarry's "pataphysics," a branch of metaphysics in which every occurrence throughout the universe, no matter how mundane or routine, is treated as an extraordinary and hence meaningful event. In "Maxwell's Silver Hammer," this phenomenon is illustrated through Maxwell's unprovoked, largely motive-free, killing spree. McCartney penned the first verse of the song in Rishikesh during the Beatles' sojourn in India in spring 1968, when Lennon and McCartney's shared belief in a karmic philosophy evolved under the tutelage of Maharishi Mahesh Yogi. In their conception, a form of instant karma lingers out there somewhere for folks who commit malfeasance. As Apple employee Tony King later recalled, Lennon "said that the idea behind the song was that the minute you do something that's not right, Maxwell's silver hammer will come down on your head." According to McCartney, "'Maxwell's Silver Hammer' was my analogy for when something goes wrong out of the blue, as it so often does, as I was beginning to find out at that time in my life. I

wanted something symbolic of that, so to me it was some fictitious character called Maxwell with a silver hammer. I don't know why it was silver, it just sounded better than 'Maxwell's Hammer.' It was needed for scanning." Later commenting on the lyrics, Harrison couldn't help but notice that the instant karma that Maxwell delivers invariably arrives in the form of homicide. "It's sort of sick," Harrison later remarked during a *Melody Maker* interview. "The guy keeps killing everybody!"[22]

While "Maxwell's Silver Hammer" didn't see any action during the *White Album* sessions, the song had received early and regular consideration for the *Get Back* album. Under Glyn Johns's supervision, McCartney debuted the song during the second day of rehearsals at Twickenham, leading the band through numerous iterations with Lennon and Harrison on guitar, Starr on drums, and McCartney rounding out the instrumentation on bass and guide vocal. By that afternoon, McCartney had already taken to describing "Maxwell's Silver Hammer" as the "corny one." At Harrison's suggestion, McCartney began performing a piano accompaniment, with George taking over on bass. As the *Get Back* sessions trudged forward, McCartney regularly toyed with the arrangement, leading the band through dozens of rehearsals as he ad-libbed additional lyrics and continued to refine the composition. On January 7, he dispatched Mal Evans to acquire an anvil, instructing the roadie to pound the iron block with a hammer to punctuate the song's "Bang, bang, Maxwell's silver hammer!" chorus. On January 9, work on "Maxwell's Silver Hammer" had come to a standstill when Harrison briefly quit the band.

Work resumed on "Maxwell's Silver Hammer" during the July 9 session with Martin in the control booth—and Lennon and Ono looking on from the newly installed bed. At this point, they began fashioning a basic rhythm track with McCartney on piano

and guide vocal, Harrison on bass, and Starr on drums. As the bandmates worked their way through sixteen takes, Lennon didn't budge as McCartney picked up where they had left off back in January. After the fifth take, McCartney began imagining future musical stylings for the song, signaling that yet more refinements would be necessary. "It was good, you know," he remarked to the others. "It had nice bits in it. It would be nice to have the nice bits and the other bits." As the session came to a close, McCartney and Harrison rehearsed a series of electric guitar passages to give "Maxwell's Silver Hammer" a pointedly country-and-western feel. The next day, Thursday, July 10, work continued on the song, with Lennon sitting out the session as he lounged with Ono on their bed, occasionally disappearing to take phone calls in a studio anteroom. During the nine-hour session, the remaining Beatles added several overdubs, including a new piano part from McCartney, Martin playing Hammond organ, and Starr banging the anvil. Meanwhile, Harrison provided a Leslie-amplified guitar part, and later McCartney refined his lead vocal before improvising a set of harmonies with Harrison, singing a scat vocal in unison ("doo doo da doo doo") before chiming in with "Maxwell must go free." All three Beatles came together to sing the song's plaintive conclusion, "silver hammer man." As for the anvil, the one Evans had procured back in January was jettisoned. "There was a proper blacksmith's anvil brought to the studio for Ringo to hit," Emerick later recalled. "They had it rented from a theatrical agency."[23]

At this juncture, the bandmates believed that "Maxwell's Silver Hammer" was finished, as Martin and his production team dutifully carried out a series of stereo remixes to conclude the session. While he had worked like a trouper on behalf of McCartney's composition, Harrison astutely recognized—even at this date—the polarizing effect that the song would exert on listeners. "'Maxwell's

Silver Hammer' is something of Paul's which we'd spend a hell of a lot of time on," he later observed, "and it is one of those instant whistle-type of tunes which, I suppose, some people will hate and some people will really love." Not surprisingly, "Maxwell's Silver Hammer" wasn't really finished—McCartney added new vocal superimposition during the Friday session, while Harrison chipped in with a new Leslie-amplified guitar part—and the song would linger in various states of production well into August. For his part, Lennon was disgusted with McCartney having devoted so much attention to "Maxwell's Silver Hammer" in the studio. "He did everything to make it into a single and it never was and it never could've been," Lennon later asserted. "But he put guitar licks on it and he had somebody hitting iron pieces and we spent more money on that song than any of them in the whole album." The group put in as much time and effort as their music demanded—even with songs like "Maxwell's Silver Hammer" for which most of them held a growing disdain. As Derek Taylor later observed, while the band may have suffered difficult interpersonal challenges at times, "The Beatles never debauched their art in the studio."[24]

With work on "Maxwell's Silver Hammer" temporarily having ceased, the Beatles returned to Harrison's "Something," for which Harrison recorded a new lead vocal. At this juncture, "Something" included an instrumental coda that sprawled for some two and a half minutes. After a reduction mix, the song had been reshaped considerably from its earlier dimensions and scope, with Martin and his team trimming it from nearly eight minutes in length to 5:32. By midnight, the July 11 session came to a close after McCartney overdubbed a fresh bass part for "You Never Give Me Your Money." But a new cold war was on, as Lennon lay dormant, still suffering from his injuries earlier that month and having grown impatient with "Maxwell's Silver Hammer."

After taking an extended weekend, the Beatles returned to work on Tuesday, July 15. That day Lennon rejoined his mates, if only briefly, to record the group's splendid harmony vocals that precede the "one sweet dream" section of "You Never Give Me Your Money." Singing in harmony, they adorned the song's ethereal conclusion, chanting "One, two, three, four, five, six, seven / All good children go to heaven." While McCartney played the chimes at strategic junctures throughout the song, Harrison double-tracked his organic, sizzling electric guitar riffs that act as bridges between its movements. As a result, the introduction to the "huge medley" had begun to take on its own dramatic energy, and the band had established a powerful overture for the song cycle to come. By the next afternoon, Lennon had disappeared again, leaving his bandmates to continue their work on Harrison's "Here Comes the Sun" and "Something" in Studio 3 without him. By this juncture, Lennon's mood swings and absenteeism—the ups and downs of his erratic, unpredictable behavior—were likely the result of his protracted heroin use with Ono. As Barry Miles later recalled, "The other Beatles had to walk on eggshells just to avoid one of his explosive rages. Whereas in the old days they could have tackled him about the strain that Yoko's presence put on recording and had an old-fashioned set-to about it, now it was impossible because John was in such an unpredictable state and so obviously in pain." For "Here Comes the Sun," Harrison contributed a harmonium overdub during the July 15 session, while the bandmates and Martin devoted considerable time to performing a series of intricate hand claps that the composer had devised to punctuate his song's complicated time signatures. Later that day, the group returned to "Something," for which Harrison recorded a new lead vocal along with McCartney's enthusiastic harmonies.[25]

Working a nine-hour day in Studios 2 and 3 on July 17, the Beatles, once again without Lennon, returned to "Oh! Darling" and "Octopus's Garden." By this point, McCartney had adopted a regimen specifically designed to hone a distinctive vocal style for "Oh! Darling." "Perhaps my main memory of the *Abbey Road* sessions is of Paul coming into studio three at two o'clock or 2:30 each afternoon, on his own, to do the vocal," Alan Parsons later recalled. "Paul came in several days running to do the lead vocal on 'Oh! Darling.' He'd come in, sing it and say, 'No, that's not it, I'll try it again tomorrow.' He only tried it once per day, I suppose he wanted to capture a certain rawness which could only be done once before the voice changed. I remember him saying, 'five years ago I could have done this in a flash,' referring, I suppose, to the days of 'Long Tall Sally' and 'Kansas City.'"[26]

With McCartney's daily pass at "Oh! Darling" in the can, the group turned their attentions to "Octopus's Garden." With the basic track having been completed back in the spring, the bandmates were ready to overlay a series of overdubs onto Starr's child-like song. Up first were McCartney and Harrison's harmonies, after which McCartney superimposed a piano part on the track. As with "Yellow Submarine" back in June 1966, "Octopus's Garden" was fertile ground for a series of sound effects to amplify the song's playful ambience. In contrast with the 1966 sessions for the *Revolver* LP, though, Martin and the Beatles now had access to the wonders of eight-track recording. Working in the booth, Martin captured the sound of McCartney and Harrison singing in an inordinately high pitch, while Phil McDonald created an underwater effect using an oscillator and limiter. In so doing, Martin and his team worked to establish a make-believe world under the sea. As with "Yellow Submarine," Starr suggested that they record the sounds of blowing bubbles in a glass of water, with engineer Alan

Brown placing the microphone close to the glass in order to bring the effect to fruition.

Working in Studio 3 that Friday, the Beatles, except Lennon, concluded their highly productive week with McCartney and Starr taking new attempts at their lead vocals for "Oh! Darling" and "Octopus's Garden," respectively. That Sunday, the Beatles— as with the world—were transfixed by the majesty and grandeur of the Apollo moon landing. Years later, Emerick recalled the excitement of the moment, having left EMI Studios just in time to catch the moon landing. "I raced home late that night after the session ended so I could watch Neil Armstrong's historic first step on my newly acquired color TV," he wrote. "To my disappointment, the broadcast from the moon was in black and white." But as luck would have it, soon the group would be in for some magic of their own. To the bandmates' relief, on Monday, July 21, Lennon returned to the fold in a moment of great triumph. His voice may have been a little rough—he hadn't produced a lead vocal since "Give Peace a Chance" on May 30—but his palpable enthusiasm more than made up for it. In his possession that day was "Come Together," his first new composition since mid-April's "The Ballad of John and Yoko."[27]

And what a song it was. As with so many of the band's recent compositions, "Come Together" had been slowly evolving over a period of months. Lennon's latest song found its origins in the Montreal Bed-In, when Timothy Leary asked Lennon to compose a song based on the slogan for the counterculture guru's 1970 California gubernatorial campaign, "Come Together—Join the Party!" Leary had originally drawn his slogan from the *I Ching*, the Chinese book of changes. "There was obviously a double-meaning there," said Leary, referring to the slogan's overt sexual *entendre*. "It was come together and join the party," he added, "not a political

party, but a celebration of life." Lennon began composing "Come Together" almost immediately, taking up his acoustic guitar and transforming Leary's words into song. In its earliest manifestations, which Lennon captured in a demo during his Montreal stay, "Come Together" riffed on Leary's concept, with Lennon clearly taking up the counterculture guru's sexual *and* political overtones in earnest:

> Come together right now,
> Don't come tomorrow,
> Don't come alone,
> Come together right now over me,
> All that I can tell you is you gotta be free.

With the demo in hand, Leary promptly began pushing his cause back in California, where he succeeded in winning a place for Lennon's primitive tape on alternative radio stations. As far as Leary was concerned, "Come Together" had been written purely to support his nascent political ambitions. As events would later demonstrate, he was mistaken.[28]

During the composition of "Come Together," Lennon had also clearly been influenced by Chuck Berry's 1956 hit, "You Can't Catch Me," in which the pioneering rock-and-roller sings, "Here come a flattop, he was movin' up with me." The Beatles had improvised a version of "You Can't Catch Me" on January 14 during the *Get Back* sessions. After revising the lyrics for "Come Together" as "Here come ol' flattop, he come groovin' up slowly," Lennon believed that he was off to the races. But as McCartney observed at the time, "Come Together" wasn't quite ready. As far as he was concerned, the "plagiarists extraordinaires" were at it again. In fact, even with Lennon's subtle change in lyrics, "Come Together"

sounded far too much like Berry's original tune for McCartney's taste—which was saying a lot. As McCartney later recalled, "John came in with an up-tempo song that sounded exactly like Chuck Berry's 'You Can't Catch Me,' even down to the 'flat-top' lyric. I said, 'Let's slow it down with a swampy bass-and-drums vibe.' I came up with a bass line and it all flowed from there." Working together in the studio, the band transformed Lennon's composition into a grooving, slow-burn of a tune. Rehearsed with the tape running, the mid-tempo, bluesy "Come Together" was captured in eight takes, with Lennon on lead vocals, Harrison on electric guitar, McCartney's bass, and Starr's drums, on which Ringo concocted a distinctive tom-tom shuffle.[29]

As for Leary, Lennon quickly realized that "Come Together" "would have been no good to him—you couldn't have a campaign song like that. Leary attacked me years later, saying I ripped him off. I didn't. It's just that it turned into 'Come Together.' What am I going to do, give it to him? It was a funky record." As it happened, Leary first heard the Beatles' version of the song on the radio during his prison stay in December 1969 after being charged with marijuana possession. The drug bust brought his gubernatorial campaign to a sudden halt. In contrast with Lennon's recollections, Leary remembered feeling surprised about the transformation of "Come Together" from a political campaign slogan into a bluesy Beatles tune. "Although the new version was certainly a musical and lyrical improvement on my campaign song, I was a bit miffed that Lennon had passed me over this way," Leary later recalled. "When I sent a mild protest to John, he replied with typical Lennon charm and wit that he was a tailor and I was a customer who had ordered a suit and never returned. So he sold it to someone else."[30]

And with lyrics consisting of so much "gobbledygook," in Lennon's words, "Come Together" certainly wasn't the makings of a

campaign theme. In retrospect, "Come Together" can be understood as the songwriter's attempt at détente, to reunite himself and his bandmates through the power of music. Music theorist Walter Everett interprets the song as Lennon's composite rendering of the individual Beatles' personae: "The gobbledygook may be heard as a disguise for Lennon's portrayal of the band members, one per verse: George as the long-haired holy roller, Paul as the good-looking player of Muddy Waters licks, and Lennon himself through images of the Walrus, Ono, and Bag Productions and a 'spinal cracker' reference to his car accident, but Ringo is harder to make out so clearly." But for all of the song's inherent funkiness and lyrical flair, Lennon never drifted too far away from heroin's clarion call, clearly singing "shoot me" during the drum breaks.[31]

For the Beatles, the "Come Together" session proved to be an instance of sheer and much-needed joy. The performances speak for themselves, with Lennon turning in a soulful, masterful lead vocal as Harrison found a groove on his Gibson Les Paul Standard. The Beatles' rhythm section was fine, with McCartney playing distinctive looping bass notes on his Rickenbacker, while Starr perfected his slick tom-tom roll for the song's opening. On the whole, the session was loose and effortless, with Lennon good-naturedly ad-libbing "got to get some bobo" and "Eartha Kitt, man!" After weeks of uncertainty and disarray, Lennon had returned with a vengeance, and his bandmates responded in kind with some of their most inspired playing in months—and arguably since the waning days of *The White Album*. July 21 also marked Emerick's full-time return to the stable. He had visited the sessions throughout the production of the Beatles' new LP, but he had only recently been able to conclude his outstanding non-Beatles professional obligations. In addition to working at Apple Studio to undo Magic

Alex's basement fiasco, he had worked on the Wallace Collection's _Laughing Cavalier_ album and the Koobas' eponymous release, which featured the minor hit "Daydream," a belated psychedelic infusion of the highest order.[32]

Working in the Studio 3 booth with Martin, McDonald, and Kurlander, Emerick was back in his element. He had even come around to the notion of working with the newfangled solid-state desk, which he had initially disdained. He later admitted, "The new sonic texture actually suited the music on the album—softer and rounder. It's subtle, but I'm convinced that the sound of that new console and tape machine overtly influenced the performance and the music." For Emerick, recent songs like "Here Comes the Sun" and "Come Together" were cases in point. "With the luxury of eight tracks, each song was built up with layered overdubs, so the tonal quality of the backing track directly affected the sound we would craft for each overdub. Because the rhythm tracks were coming back off tape a little less forcefully, the overdubs—vocals, solos, and the like—were performed with less attitude. The end result was a kinder, gentler-sounding record—one that is sonically different from every other Beatles album." Interestingly, the "live" sound of "Come Together" was initially captured on four-track tape, with all four Beatles arrayed across the sound palette. Having selected Take 6 as the best, the production team copied the song to the 3M eight-track machine to provide additional space for overdubs, as well as the opportunity to manipulate the EQ of the individual tracks at their leisure. Working on Tuesday, July 22, Lennon superimposed a new lead vocal, while Harrison added a rhythm guitar part. But the highlight was McCartney's inspired electric piano performance. Years later, McCartney would cherish his fond memories of playing the Fender Rhodes electric piano: "Whenever [John] did praise any of us, it was great praise, indeed, because he didn't dish it out

much," McCartney recalled. "If ever you got a speck of it, a crumb of it, you were quite grateful. With 'Come Together,' for instance, he wanted a piano lick to be very swampy and smoky, and I played it that way and he liked it a lot. I was quite pleased with that."[33]

Suddenly the impasse was over. Whether it had its roots in John and Yoko's car accident or the group's ongoing managerial stalemate or Lennon's inability to stomach yet another session devoted to "Maxwell's Silver Hammer," the Beatles had found their way out of their interpersonal morass yet again. With "Come Together," the bandmates had managed to right their ship in a matter of hours. Playing off of Lennon's renewed energy, the others had responded in kind. As always, it was the music that lived at the heart of their inspiration. "I think it shows on the record when we were excited," Starr later recalled. "The track's exciting, and it all comes together. It doesn't matter what we go through as individuals on the bullshit level. When it gets to the music, you can see that it's really cool, and we had all put in 1,000 percent." With the unexpected triumph of "Come Together," the band had found its way back. And just in the nick of time.[34]

Figure 1

EMI Studios, September 1969. Purchased by the Gramophone Company in 1929
and renamed EMI Studios, the facility officially opened its doors in November
1931. After the worldwide success of the Beatles' *Abbey Road* album in the late
1960s, the building was rebranded as Abbey Road Studios. Courtesy of Ronald
Kunze.

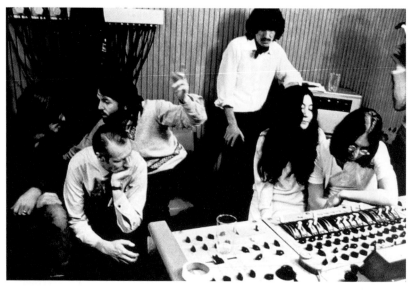

Figure 2

Apple Studio, January 1969. Producer George Martin, Yoko Ono, and the Beatles in the Apple Studio control booth during the January 1969 sessions for the *Get Back* album project. Courtesy of the Everett Collection.

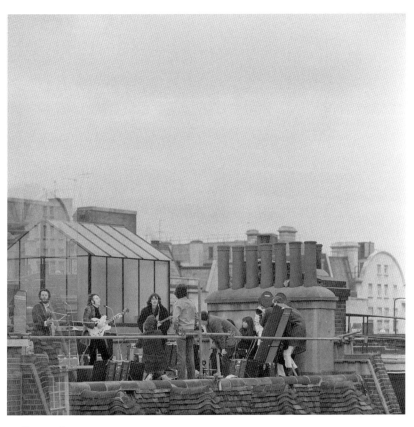

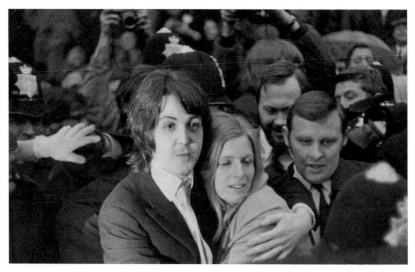

FIGURE 4
Paul and Linda, March 12, 1969. Paul McCartney and Linda Eastman arrive at the Marylebone Register Office to exchange their nuptial vows. The couple first met at London's Bag O'Nails Club in May 1967. Courtesy of Getty Images.

Figure 5
John Lennon, Yoko Ono, and children, Scotland, June 27, 1969. Lennon and Ono
pose with his six-year-old son Julian (*left*) and her five-year-old daughter Kyoko
in Durness, Scotland, a few days before their automobile accident in the High-
lands on July 1. Courtesy of Getty Images.

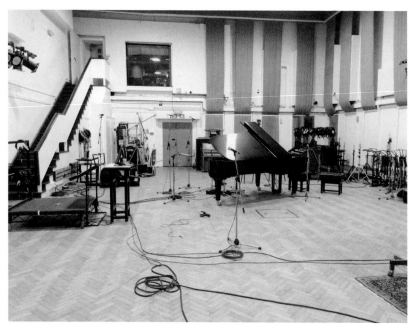

FIGURE 6
Studio 2. Affectionately known as Number 2 at Abbey Road Studios, Studio 2 features a twenty-eight-foot ceiling, a second-floor control booth, and some twenty-two hundred square feet on the studio floor. The Beatles recorded most of their music here. Courtesy of Jasper Dent.

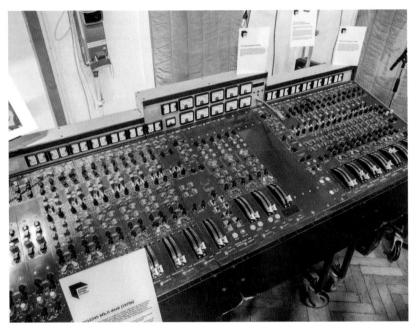

FIGURE 7

EMI TG12345. The solid-state, transistor-powered EMI TG12345 Mk2 console, six and a half feet wide—two feet wider than the REDD console it replaced. The Mk1 prototype of the eight-track mixing desk was installed at EMI Studios in late 1968. Courtesy of Keith Ainsworth.

FIGURE 8

"Mrs. Mills." Named in honor of music hall pianist Gladys Mills, the Steinway Vertegrand tack piano in EMI's Studio 2 is featured on a number of Beatles recordings, including *Abbey Road*'s "You Never Give Me Your Money," for which it was treated with George Martin's innovative "wind-up" piano technique. Courtesy of Keith Ainsworth.

FIGURE 9

Abbey Road cover. Released in the UK on September 26, 1969, *Abbey Road* was the Beatles' last-recorded studio album. As of 2017, the LP had sold more than forty-three million copies worldwide. Publicity photo.

Figure 10

Let It Be. Released in the UK on May 8, 1970, *Let It Be* served as the soundtrack for Michael Lindsay-Hogg's documentary by the same name. Originally part of the Beatles' *Get Back* project in January 1969, *Let It Be* was mixed by several different producers, including Glyn Johns, George Martin, and Phil Spector, whose controversial post-production work involved unauthorized orchestral and choral overdubs. Publicity photo.

Figure 11
Abbey Road Studios logo. Artist Alan Brown's vintage design serves as one of the facility's most recognizable logos. It was commissioned by Ken Townsend as part of his rebranding effort as EMI Studios transitioned to Abbey Road Studios. Courtesy of Abbey Road Studios. With special thanks to Alan Brown.

FIGURE 12
Ken Townsend, Abbey Road Studios garden, August 2018. Having begun his career with EMI in 1950, Townsend was appointed general manager of EMI Studios in 1974, later earned an MBE, and retired as chairman of the Studio Group after forty-five years of service. Photo by Kenneth Womack.

5

The Wind-Up Piano and Mrs. Mills

The goodwill generated by the "Come Together" sessions would carry over as the band returned to the ambitious song cycle that would comprise much of *Abbey Road*'s second side. This time Lennon contributed a number of song-sketches to what had morphed into McCartney and Martin's shared vision in the days after John and Yoko's automobile accident.

On Wednesday, July 23, McCartney recorded his latest lead vocal for "Oh! Darling" in Studio 3. Some nine hours later—during a playback session of the album's recordings so far—he would select it as the best take of the song, finally putting "Oh! Darling" to bed. Much of the rest of the session had been devoted to recording a conclusion for the huge medley. At this point, the bandmates referred to the song as "Ending" and slated it to be positioned after "Golden Slumbers" and "Carry That Weight." From the outset, a drum solo by Starr was determined to be the new song's centerpiece. As McCartney later recalled, "We finally persuaded Ringo to play a drum solo, which he'd never wanted to do." In truth, Ringo used to regularly play solos during his early days as a professional drummer—in the days when he was still known as Ritchie Starkey. As a member of Rory Storm and the Hurricanes, he had quickly emerged as one of the group's most popular musicians, and his

image was enhanced by the many rings that adorned his fingers. Before long, he became known as "Rings," which morphed into "Ringo." Likewise, Starkey was abbreviated into "Starr," and a stage name was born for the ages. Eventually the band turned the spotlight occasionally on their drummer, who sang a song or played an extended drum solo during a feature that became known as "Starr Time."[1]

In his touring days with the Beatles, Starr had pointedly refused to engage in such theatrics. From McCartney's perspective, his lack of interest in solos also originated from a gnawing sense that his drumming wasn't up to snuff. "I think Ringo was always paranoid that he wasn't a great drummer because he never used to solo," McCartney said. "He hated those guys who went on and on, incessantly banging while the band goes off and has a cup of tea or something." Not surprisingly, it was McCartney in particular who had been pressuring Starr to play an extended solo on a Beatles recording. He was especially bothered when "other drummers would say that although they liked his style, Ringo wasn't technically a very good drummer. It was a bit condescending and I think we let it go too far. I think his feel and soul and the way he was rock solid with his tempo was a great attribute. I always say if you can leave a drummer and turn your back on him, then you're very lucky. You could just tell Ringo how it went and leave him; there was always this great noise and very steady tempo coming from behind you." In the end, it was Martin who convinced Starr to play a drum solo. But Starr never stopped lamenting the practice of showcasing drummers on rock recordings. "Solos have never interested me. That drum solo is still the only one I've done," he later recalled. "I was opposed to it: 'I don't want to do no bloody solo!'"[2]

With Starr having reluctantly agreed to perform a solo on a Beatles track, Emerick prepared for the July 23 session for "Ending"

by placing a dozen microphones around Ringo's kit. The engineer also devoted two of the recording's eight available tracks—as opposed to a single track, as was their usual practice—in order to afford the solo with even greater prominence. In this way, Starr's solo for "Ending" was the only time that his drums were recorded in true stereo. In so doing, Emerick made it possible for listeners to experience every thump and throb of the drummer's rousing, pounding drum solo. With McCartney on bass, Lennon and Harrison on electric guitars, and Starr, of course, on drums, the Beatles recorded seven takes of "Ending" that day, with the final take ultimately being selected as the best. Much of the session was devoted to rehearsing the song, with Lennon counting off each new iteration. During the seventh take, Starr's drum solo clocked in at sixteen seconds. At this point in the life of the song, "Ending" timed out at a swift 1:20, and the guitars can be heard during the mix throughout Starr's solo.

As for the "rumble" itself—as McCartney later took to describing it—Starr's solo was laden with energy and gusto. The drummer later admitted that he drew his inspiration from Iron Butterfly's "In-a-Gadda-Da-Vida," the epic seventeen-minute psychedelic rock anthem that became a surprise US hit, in its heavily edited form, in the summer of 1968. Borrowing the distinctive bass drum sound from Ron Bushy's Iron Butterfly solo, Starr finally brought the solo in for a landing during the Wednesday session. Even so, he couldn't help being frustrated by Martin and McCartney having goaded him into performing the bit in the first place. "As I was playing it," Starr remarked at the time, Martin "counted it because we needed a time. It was the most ridiculous thing. I was going, 'Dum, dum—one, two, three, four . . . ,' and I had to come off at that strange place because it was 13 bars long. Anyway, I did it, and it's out of the way. I'm pleased now that we've got one down."[3]

When the band returned to the studio the following day, they turned to a pair of Lennon compositions, including "Here Comes the Sun King"—later abbreviated to "Sun King"—which had seen its debut during the January 1969 *Get Back* sessions. The musical germ for "Sun King" had been born during the composition of Lennon's "Don't Let Me Down," his high-octane, bluesy love song for Ono. During the *Get Back* sessions, Lennon pointedly dropped the "pull-off chords" that he had been deploying during the chorus of "Don't Let Me Down," adopting a more traditional strumming style of guitar playing instead. The "pull-off" technique is created when a guitarist lightly pulls on a fretted string that is already ringing, which results in a distinctive resonation. Still enamored with the notion of playing pull-off chords, Lennon began toying with a new composition at Twickenham, and "Sun King" began to take shape. Always a voracious reader, Lennon was familiar with the story of Louis XIV, the "Sun King," whose seventy-two-year reign (1643–1715) notched a high-water mark in French history, as he ruled over a protracted era of great social and economic expansion. Lennon may have even been familiar with Nancy Mitford's recent best-selling biography *The Sun King* (1966), an illustrated history of Louis XIV's remarkable life and times. Originally entitled "Los Paranoias," "Sun King" bore more than a passing resemblance to Fleetwood Mac's dreamy instrumental hit "Albatross." As Harrison later recalled, the band actually played a few bars of the recent chart-topper as a means of inspiration: "At the time, 'Albatross' was out, with all the reverb on guitar. So we said, 'Let's be Fleetwood Mac doing "Albatross," just to get going. It never really sounded like Fleetwood Mac." Fleetwood Mac had likewise borrowed: founding member Peter Green later admitted to having lifted his song's melody directly from an Eric Clapton guitar solo and simply playing it slower than the original. As for the lyrics of "Sun King," Lennon

effected his own wistful ambience—"Everybody's laughing / Everybody's happy"—only to devolve into a bizarre admixture of Italian, Spanish, and Portuguese phrases.[4]

The second song, "Mean Mr. Mustard," had been rotating in the band's orbit since their spring 1968 sojourn in India. Lennon's inspiration for the song came from a newspaper story about an eccentric miser who lived on the streets of London and sought out increasingly creative ways to hide his secret wealth in order to avoid spending it. A demo for "Mean Mr. Mustard" had originally been recorded in May 1968 at Harrison's home studio in Esher for possible inclusion on *The White Album*. During a January 8, 1969, rehearsal of "Mean Mr. Mustard" for the *Get Back* project, Lennon ad-libbed a new version of the song, which involved a chorus in which he sang, "Mean Mr. Mustard, he's such a dirty bastard." During one extended verse, Lennon improvised a host of nonsensical lyrics for the evolving composition:

> Man, I'm coming, gonna do you no harm.
> He's wearing pink pajamas 'cause he comes from a farm.
> He's gotta get some 'cause no one gets so happy coming home.
> Well, everyplace you go is low, everyplace you go is low.
> Everyplace you go is low, everyplace you go is low, low, low.

Several months later, Lennon revisited "Mean Mr. Mustard" yet again. Seizing the opportunity to contribute to the huge medley, Lennon proposed that his unfinished songs be captured as a single track. In so doing, they would not only serve the purposes of the musical suite but also share in the unfolding character studies that the medley was beginning to accrue. As with "Golden Slumbers" and "Carry That Weight," Lennon's plan called for "Sun King" and "Mean Mr. Mustard" to be recorded without interruption. By this

point, Lennon had slated "Polythene Pam," yet another unfinished composition, for inclusion in the huge medley. To accommodate this song, he deftly altered the lyrics of "Mean Mr. Mustard" to establish a sense of narrative coherence. As he later remarked, "In 'Mean Mr. Mustard,' I said 'his sister Pam'—originally it was 'his sister Shirley' in the lyric. I changed it to Pam to make it sound like it had something to do with it."[5]

Work commenced on "Sun King" and "Mean Mr. Mustard" during a seven-hour session in Studio 2 on Thursday, July 24. With Martin up in the booth with his production team—which now included the regular trio of Emerick, McDonald, and Kurlander—the Beatles performed the song pair as a single recording. As Emerick later observed, "there is a slight gap between the two songs," so they could have easily captured each song as an individual recording, but at Lennon's direction they opted to render them as a single work. "Knowing in advance that they would be sequenced in that order, John made the decision to play through both of them in one go, which made it a little more of a challenge to the band's musicianship."[6]

As was typical, the Beatles began the session by establishing a basic track that included Lennon's guide vocal and rhythm guitar, Harrison's lead guitar, McCartney's bass, and Starr's drums. At one point, the convivial session broke into a jam session, albeit a far more precise and well-played version than the frequent fits and stops during the *Get Back* days, when they often suspended their work on new compositions in favor of rock and roll oldies. For the moment, they seemed to have regained the fervor and attack of "(You're So Square) Baby, I Don't Care," their Elvis Presley jam during the *White Album* sessions. On this day, they erupted into a trio of Gene Vincent tunes, including "Be-Bop-a-Lula," "Who Slapped John?" and "Ain't She Sweet," a throwback from

the Beatles' Hamburg days. They likely hadn't performed the latter tune since June 1961, when they recorded it as "The Beat Brothers," Tony "The Teacher" Sheridan's backing band, which was produced by German orchestra leader Bert Kaempfert at Friedrich-Ebert-Halle studio and featured Lennon on vocals, along with McCartney, Harrison, and Pete Best on drums. In the July 1969 version, Lennon performed "Ain't She Sweet" with a perceptibly gravelly voice and took comical liberties with the lyrics (he may have simply forgotten them), at one point singing "I ask you very hydrofollicky." At the end of the recording, Lennon thanked his mates, remarking that "I hope you liked that trip, boys."[7]

By the wee hours of the morning, the group had recorded a remarkable thirty-five takes of "Sun King" / "Mean Mr. Mustard," albeit with several false starts along the way. Even with the song's basic track in place, they had managed to afford the recordings with a variety of nuance, including Harrison and Lennon's heavy tremolo on their electric guitars for "Sun King" and McCartney's distortion pedal on his bass for "Mean Mr. Mustard." For his gentle drum work on "Sun King," Starr deployed his brushes, capturing the "Albatross"-like ambience that had originally inspired Lennon to compose the song. For his part, Emerick was impressed with the band's cohesiveness over the past days. To him, the atmosphere seemed like a far cry from the previous summer, when he had left the Beatles' team in disgust. "They pulled it off," he later wrote. "It really was a group effort, and all four Beatles played with energy and enthusiasm, each making his own unique contribution to the sound and arrangement."[8]

Working a twelve-hour session on Friday, July 25, the Beatles perfected "Sun King" / "Mean Mr. Mustard," recording a series of overdubs in order to bring the songs to life, while also adding further superimpositions to "Come Together" and trying their

hand at a pair of new songs for the huge medley, Lennon's "Poly-
thene Pam" and McCartney's "She Came in Through the Bath-
room Window." Having selected Take 35 of "Sun King" / "Mean
Mr. Mustard" as the best, the band added several overdubs to "Sun
King," including supplemental percussion in the form of Len-
non's maracas and Starr's bongos. For his part, Martin chipped in
with a smooth Lowrey organ flourish. The session for "Sun King"
was rounded out with the Beatles' descent into the Romance lan-
guages, which Lennon and McCartney morphed into a series of
intentionally nonsensical phrases such as "mundo paparazzi mi
amore chicka ferdi para sol." As Lennon remarked at the time, "We
just started joking, you know, singing 'quando para mucho.' So we
just made up—Paul knew a few Spanish words from school, you
know. So we just strung any Spanish words that sounded vaguely
like something. And of course we got 'chicka ferdi' in. That's a Liv-
erpool expression. . . . It doesn't mean anything to me but [childish
taunting] 'na-na, na-na-na!'" Observing from his place in the con-
trol booth, Emerick couldn't help but smile as the old friends col-
laborated on "Sun King" and "Mean Mr. Mustard," later remarking
that "the vibe was so good that, this time around, Paul was invited
by John to participate in both songs, which seemed to lift his spir-
its greatly. They even disappeared behind the screens at one point
for a puff on a joint, just the two of them, and when they came out
they had a fit of giggles as they sang the pseudo-Spanish gibber-
ish at the end of 'Here Comes the Sun King'; in fact, they found it
impossible to get through a take without dissolving into laughter."[9]

In the end, they were pleased with their fusion of Romance lan-
guages and childish phrases, although—as Lennon later noted—
they neglected to include any reference to the song's original title,
"Los Paranoias," which held personal significance to Lennon and
McCartney. The phrase was clearly in the air for the songwriting

partners. At the tail end of the *White Album* sessions, McCartney performed an impromptu version of "Step Inside Love," the song he had penned as the theme for Cilla Black's network television program, before launching into a chorus of "Los paranoias, come on and enjoy us!" But when it came to the final pass at "Sun King," they failed to mention the phrase altogether. As Lennon observed, "The one we missed, we could have had 'paranoia,' you know. Forgot all about it. We used to call ourselves 'Los Paranoias' ['The Paranoids']," referring nostalgically to his days back in Gambier Terrace with McCartney and painter cum bassist Stu Sutcliffe. It was early 1960, and they were desperate to land a name for their evolving band. "We had about ten a week," said McCartney. And for a moment at least, they were Los Paranoias before becoming the Beatles for all time.[10]

During the mixing phase, Martin and Emerick made shrewd use of the TG console's capabilities, gently panning the stereo picture from right to left during the "Everybody's laughing / Everybody's happy" section. The new mixing desk afforded them with the requisite pan control or cross-channel phasing to move and distribute the sound signal across the spectrum. After completing work on "Sun King," they turned their attentions to "Mean Mr. Mustard." Wiping one of the rhythm guitar tracks from the mix, Martin and Emerick supervised Lennon's overdubs of piano and tambourine. Later they mixed Lennon's lead vocals and McCartney's harmonies, which they treated with ADT to afford them with greater texture and nuance. After superimposing harmony vocals onto "Come Together," the Beatles rounded out the week with a whopping thirty-nine takes of Lennon's "Polythene Pam" and McCartney's "She Came in Through the Bathroom Window," which were recorded for the medley as a single song, like "Golden Slumbers" and "Carry That Weight" (and "Sun King" and "Mean Mr. Mustard").

Written a year earlier in Rishikesh, "Polythene Pam" had little to do with the Beatles' extended excursion to study Transcendental Meditation at the Maharishi's feet. Rather, the song clearly offered a throwback to the group's salad days as a Liverpool beat band, when they cavorted with the lunchtime crowd of groupies—or "scrubbers," in Scouser-speak. "That's another half a song I wrote in India about a kinky girl in a polythene bag," Lennon remarked at the time. In the songwriter's memory, "Pam" was "a mythical Liverpool scrubber dressed up in her jackboots and kilt." In this instance, Lennon had made very little effort to disguise his protagonist, a Cavern Club regular named Pat Dawson (née Hodgett), whom the Beatles referred to as Polythene Pat because of her well-known penchant for eating plastic. As Dawson later recalled, "I started going to see the Beatles in 1961 when I was 14, and I got quite friendly with them. If they were playing out of town they'd give me a lift back home in their van. It was about the same time that I started getting called Polythene Pat. It's embarrassing really. I just used to eat polythene all the time. I'd tie it in knots and then eat it. Sometimes I even used to burn it and then eat it when it got cold. Then I had a friend who got a job in a polythene bag factory, which was wonderful because it meant I had a constant supply."[11]

But the story behind "Polythene Pam" didn't end there. In addition to Dawson's peculiar delectation in eating plastic, Lennon's song referenced something the Beatles had experienced during their summer 1963 UK tour. On August 8, 1963, the group passed through the Channel Islands, playing a show that evening at Guernsey's Candie Gardens. Years later, Lennon recalled that "Polythene Pam" was "me, remembering a little event I had with a woman in Jersey [*sic*], an island off the French coast. A poet, England's answer to Allen Ginsberg, a beatnik that looked like a beatnik, who gave us our first exposure, who was from Liverpool,

took me to this apartment of his in Jersey. This was so long ago. This is all triggering these amazing memories. So this poet took me to his place, and I had a girl and he had one he wanted me to meet. He said she dressed up in polythene, which she did. In polythene bags. She didn't wear jack boots and kilts—I just sort of elaborated—and no, she didn't really look like a man. There was nothing much to it. It was kind of perverted sex in a polythene bag. But it provided something to write a song about."[12]

As it turned out, the Beatles' brief stay in the Channel Islands wasn't the first time that they had come into the orbit of the poet Lennon recalled. In the summer of 1960, British beat poet Royston Ellis played a minor, albeit impactful role in the course of the early Beatles' history. The poet earned national notoriety after being described in the *Daily Mirror* as "a weirdie from weirdsville." During an interview from that period, Ellis fanned the flames of his incipient fame by suggesting that "no self-respecting teenager should marry a virgin," later recounting that "that remark alone generated fees to keep me comfortable for a year." Having published a collection of verse titled *Jiving to Gyp*, Ellis had been touring the UK, where he often enlisted jazz and pop combos to perform while he read his poetry. In so doing, he made the acquaintance of a number of present and future rock luminaries, including Cliff Richard's backing band the Shadows, Led Zeppelin's Jimmy Page, and the Beatles, who at that juncture were a five-piece outfit with Sutcliffe on bass and a revolving lineup of drummers that included Tommy Moore, Norman Chapman, and others.[13]

Ellis first met the Beatles after being invited to read his work at the University of Liverpool. Known at the time as the "King of the Beatniks," the bearded poet also recited his verse at Liverpool's Jacaranda Club, which the bandmates frequented during that era. "I was quite a star for them at that time," Ellis later recalled, "because

I had come up from London and that was a world they didn't really know about. I stayed with them for about a week in their flat at Gambier Terrace during that 1960 visit. John was fascinated by the fact that I was a poet and that led to deep conversations." During their time together, the more worldly Ellis treated the group to their first drug experience, via a Benzedrine inhaler. Thinking back on the experience, Lennon recalled, "Everybody talked their mouths off for a night and thought, 'Wow, what's this?'" Years later, Ellis would take credit for the group changing the spelling of their name from "Beetles" to "Beatles" and being one of the inspirations for the band's 1966 chart-topping single "Paperback Writer."[14]

By the time of his 1963 encounter with the band, Ellis had left the nascent British beatnik scene behind, traveling hither and yon across the globe. His meeting with the Beatles was purely a matter of chance, as the poet had taken a seasonal job on Guernsey as a ferry engineer. After the group's performance that evening at Candie Gardens, Ellis enjoyed a reunion of sorts with Lennon, who had rented a garret apartment for the occasion. Decades later, McCartney recalled the events of the night as Lennon had related them to him: "John, being Royston's friend, went out to dinner with him and got pissed and stuff and they ended up back at his apartment with a girl who dressed herself in polythene for John's amusement, so it was a little kinky scene," said McCartney. "She was a real character." As for Ellis, he could scarcely recall the girl's name, although he later remembered that their erotic intentions fell short of his expectations:

> We'd read all these things about leather and we didn't have any leather, but I had my oilskins and we had some polythene bags from somewhere. We all dressed up in them and wore them in bed. John stayed the night with us in the same bed. I don't think anything very exciting happened and we all wondered what the fun was in

being "kinky." It was probably more my idea than John's. It could have all happened because in a poetry booklet of mine, which I had dedicated to the Beatles, there was a poem with the lines: "I long to have sex between black leather sheets, and ride shivering motorcycles between your thighs." I can't really remember everything that happened. At the time, it meant nothing to me. It was just one event during a very eventful time of my life.

As if the song's origins could be even more convoluted, Tony Bramwell later suggested a different impetus for the creation of "Polythene Pam." To his mind, Lennon was likely influenced by "an old 'bag lady' who used to hang around the Knightsbridge end of Hyde Park, close to the army barracks. She had all her possessions in plastic bags and slept in the park. I'm sure that she had something to do with the song."[15]

For Lennon and the Beatles, "Polythene Pam"—with the song's overtly sexual overtones—offered an intriguing counterbalance to the miserly character in "Mean Mr. Mustard." As with the recordings of "Golden Slumbers" / "Carry That Weight" and "Sun King" / "Mean Mr. Mustard," the group decided to capture "Polythene Pam" as part of a pair—in this case with McCartney's "She Came in Through the Bathroom Window." The latter song, which went under the working title of "Bathroom Window," had been inspired by a May 1968 burglary of McCartney's Cavendish Avenue home. The theft had been carried out by several members of the Apple Scruffs while McCartney had been away. Harrison had coined the term "Apple Scruffs" to denote the dedicated female fans who kept vigil outside of the Apple Corps offices on Savile Row, as well as EMI Studios and McCartney's nearby home in St. John's Wood. This coterie of close-knit women were fiercely loyal to their idols and also, for the most part, to each other. The regulars penned meticulous notes in their journals about everything that occurred

under their watch—often down to the minute particulars of the Beatles' wardrobes.[16]

Having been victimized in several instances by thieves bent on obtaining memorabilia, McCartney had been accustomed to the invasive nature of his celebrity. Yet this burglary felt especially disturbing to him, given the loss of a much-cherished photograph of his father, Jim Mac. For McCartney, the incident was also an intensely personal violation given the degree to which the bandmates had come to trust the Apple Scruffs. As it happened, the burglary occurred when Lennon and McCartney had traveled to the States to announce the formation of Apple Corps. It was instigated by several members of the Apple Scruffs, including Diane Ashley, who later recalled, "We were bored, he was out, and so we decided to pay him a visit." As the smallest person in the group, Diane was tasked with climbing a ladder and making her way inside to let the others into McCartney's home. "I'm in the bathroom!" Diane announced, as Carol Bedford clambered up the ladder after her. Having gained entrance inside McCartney's home, the Apple Scruffs rifled through the Beatle's photographs and clothing, including a pair of his blue jeans, which they later took turns wearing in order to feel closer to their idol. Margo Bird, McCartney's dog walker, later recalled the incident, remarking that the Apple Scruffs "rummaged around and took some clothes. People didn't usually take anything of real value, but I think this time a lot of photographs and negatives were taken. There were really two groups of Apple Scruffs—those who would break in and those who would just wait outside with cameras and autograph books." With Margo's assistance, McCartney was able to retrieve the purloined photograph of his father.[17]

Bedford remembered McCartney telling her, "I've written a song about the girls who broke in." Ashley was surprised that he

had chosen to memorialize the burglary in a Beatles song. "I didn't believe it at first because he'd hated it so much when we broke in. But then I suppose anything can inspire a song, can't it? I know that all his neighbors rang him when they saw we'd got in, and I'm sure that gave rise to the lines 'Sunday's on the phone to Monday / Tuesday's on the phone to me.'"[18]

The origins of another lyric in the song were pure happenstance. In November 1968, after the Beatles had completed work on *The White Album*, McCartney traveled to New York City to ferry his future wife Linda and her five-year-old daughter Heather back to England to live with him. On their taxi ride to the airport, the trio was driven by a cabbie whose identification panel listed him as "Eugene Quits, New York City Police Dept." With this found object in hand, the songwriter penned the phrase, "And so I quit the police department / And got myself a steady job." For McCartney, "this was the great thing about the randomness of it all. If I hadn't been in this guy's cab, or if it had been someone else driving, the song would have been different. Also, I had a guitar there, so I could solidify it into something straight away." The song's bizarre verbal tapestry was not lost on Harrison, who later remarked that "She Came in Through the Bathroom Window" was "a very strange song of Paul's with terrific lyrics, but it's hard to explain what they're all about!"[19]

After its lengthy gestation period, McCartney debuted the song for the band on January 6, 1969, at Twickenham. That day, they conducted seven rehearsals of "She Came in Through the Bathroom Window," with McCartney leading Lennon and Harrison through the chord changes on their electric guitars. Over the next several days, they rehearsed the song several more times, finally landing on an arrangement that featured McCartney on bass and lead vocals, Lennon on piano, Harrison playing his Leslie-amplified

Fender Telecaster with a wah-wah pedal, and Starr on drums. By this juncture, Lennon had concocted a sunny backing vocal, while punctuating each new rehearsal of the song with comic overtones, including attempting the lead vocal himself using an overwrought Cockney accent as McCartney offered a playful call-and-response, singing "a bloody spoon, a bloody spoon, a bloody silver spoon." In a later verse, the duo pushed the lyrics to their limits, with Lennon ad-libbing sarcastic responses to McCartney's straight lines:

> *McCartney:* And so I quit the police department.
>
> *Lennon:* Get a job, cop!
>
> *McCartney:* And got myself a proper job.
>
> *Lennon:* Bloody 'bout time, too, if you ask me!
>
> *McCartney:* And though she tried her best to help me.
>
> *Lennon:* You bloody need it too!

The Beatles resumed work on "She Came in Through the Bathroom Window" at Apple Studio on January 21, when they ran through five different rehearsals of the song. The instrumentation had shifted slightly, with Lennon playing the Fender Rhodes electric piano to McCartney's great delight. Before the month was out, the Beatles conducted several additional rehearsals of the song, including five iterations on the day before the rooftop concert on January 30. At this point, it seemed likely that the song might be included on the ill-fated *Get Back* LP, but McCartney inexplicably shelved it. "She Came in Through the Bathroom Window" might very well have remained in limbo had it not been for the advent of the huge medley. Suddenly McCartney could imagine a new life for the song, which, like Lennon's "Polythene Pam," was far too brief by the Beatles' standards to exist on its own.

When it came time to record "Polythene Pam" and "She Came in Through the Bathroom Window," the songs were well-known quantities for the bandmates, who easily fell into a groove in the studio, completing the basic track during the marathon session on July 25. Strumming away on his twelve-string Framus "Hootenanny," Lennon intentionally used a thick Liverpudlian accent to connote the character's northern origins and coarse demeanor. "Well, you should see Polythene Pam," Lennon sang, spitting the words out with a nasty, guttural delivery. "She's so good looking, but she looks like a man." Lennon effected an acoustic guitar part in the style of the Who's "Pinball Wizard" (which had peaked at number four on the British charts in the spring of 1969), playing his Hootenanny with a series of impassioned, hard stabs. In addition to Lennon's guitar and vocal, the basic track was rounded out with McCartney's bass, Harrison's lead guitar, and Starr's drums. For his guitar solo, Harrison flirted with a D/A/E chord sequence before the group executed one of the medley's most exciting moments. At the conclusion of the solo section, the trio of guitarists perform a "walk down" or downward scale with an E/D/C#/B sequence before landing on A, which was the key of "She Came in Through the Bathroom Window." As musicologist Scott Freiman has observed, "It's a really important point in the medley since 'You Never Give Me Your Money' was in A minor/A major, and the Beatles have been playing in the key of E since then. That walk down makes the first chord of 'Bathroom' feel like a resolution." Caught up in the exhilaration of the transition, Lennon can be heard speaking to Beatles roadie Mal Evans off-mic, erupting in a raucous laugh, and then shouting "Oh, look out!" before McCartney belts out the first line of the song: "She came in through the bathroom window / protected by a silver spoon." Continuing the instrumentation of "Polythene Pam," the basic track for "She

Came in Through the Bathroom Window" featured McCartney's bass (and guide vocal), Lennon's twelve-string acoustic, Harrison's lead guitar, and Starr's drums.[20]

Before adjourning the long session, Lennon and McCartney overdubbed new lead vocals onto the songs—both of which would be treated with ADT during postproduction—while McCartney and Starr tightened up the low end with fresh passes at their bass and drum parts. Starr had been particularly eager to rerecord his drum work after Lennon had maligned his playing as having "sounded like Dave Clark." The samba beat in "Polythene Pam" had been giving him fits all day. Toward the end of recording "Polythene Pam" and "She Came in Through the Bathroom Window," Lennon had grown ever more impatient with Starr failing to capture the right beat, saying, "Sod it, let's just put one down anyway." At one point, Starr implored him to lead the Beatles through another take: "Why don't we just record the backing track again? I think I've got a part you'll like now." But Lennon simply wasn't having it. "I'm not playing the bloody song again, Ring. If you want to redo the drums, go ahead and overdub them." Working with McCartney and Emerick, the Beatles' drummer did just that. As Emerick recalled, "Fortunately we were working in eight-track, so I was able to record the new drum track without erasing the old one. It took many hours to do, but Ringo eventually pulled it off, managing to play the new drum part from start to finish without losing the beat—and those were the days before we had click tracks, so his only reference was the original drum track, which we fed to him through headphones."[21]

All in all, Lennon's frustration with Starr had been a minor bump in what had proven to be an incredible day of music-making during a period that was often vexatious. As Phil McDonald later recalled, "People would be walking out, banging instruments down,

not turning up on time and keeping the others waiting three or four hours, then blaming each other for not having rehearsed or not having played their bit right." Yet even though relations among the Beatles were "getting fairly dodgy" at times, their music grew even more profound and affecting, as McCartney would later point out, "even though this undercurrent was going on." For Emerick in particular, the July 25 session seemed like a magnificent return to form for the Beatles. He later wrote, "John was actually in a pretty good mood throughout the entire session. I could see that he was a bit looser, a little more recovered from his injuries, and a lot less worried about Yoko, who was no longer lying in the bed, though it remained, unmade, in a corner of the studio, a mute reminder of the weirdness we'd had to deal with over the past weeks." By this point, Ono wasn't the only Beatle wife to make regular appearances in the studio, having been joined on several occasions by Linda McCartney. Eight months pregnant with the couple's first child, Linda would occasionally join Ono on the Harrods bed, where the two observed their husbands together as they whiled away the hours at EMI Studios. The dark clouds associated with the Lennons' automobile accident were not entirely gone. John and Yoko still suffered from residual pain, and their heroin addiction was in full swing. At one point, American actor Dan Richter, a friend of Ono's, had made his way inside EMI Studios to provide Yoko with the Lennons' latest fix. As Richter later recalled, "It felt weird to be sitting on the bed talking to Yoko while the Beatles were working across the studio. I couldn't help thinking that those guys were making rock and roll history, while I was sitting on this bed in the middle of the Abbey Road studio, handing Yoko a small white packet."[22]

By Monday, July 28, Lennon's mood seemed to have further improved over the weekend, and the group began working on

overdubs for "Polythene Pam" / "She Came in Through the Bathroom Window." Working a six-hour session in Studio 3, the group carried out numerous superimpositions, including new lead vocals from Lennon and McCartney, as well as additional acoustic and electric guitar parts. Working the TG and the 3M tape machine in tandem, the Beatles and their production team were clearly taking full advantage of the expanded sound palette, easily wiping and recording new instrumentation and fulfilling their every creative whim in the process. At one point, Lennon added acoustic and electric piano parts to both songs, only to opt to have them deleted from the mix by the end of the month. The overdubs were rife with additional percussion too, with everyone chipping in with a range of instruments, including maracas, tambourine, and cowbell.

By far the most exciting percussion superimposition that day belonged to Starr, who adorned "She Came in Through the Bathroom Window" with the sound of an orchestral whip (or clapper) to punctuate the verses. After the group went home that evening, Martin and his production team made their way to the Studio 2 control room to carry out a reduction mix to create new real estate for future overdubs. For his part, Emerick was aglow with the band's progress that month, having seen them go from disarray to a working rock and roll band again. "For all of the kerfuffle, they were fun tracks to record," Emerick later recalled. "The ensemble playing was superb. Sitting up in the Studio 2 control room, I commented to George Martin that it sounded like old-style Beatles, like the four of them playing together as a band circa 1963." And while Martin certainly agreed with the high quality of the group's performance, he wasn't fooled. "You're right," Martin replied. "You'd never guess that the four of them actually can't stand each other."[23]

The next evening, Tuesday, July 29, the Beatles worked another session in Studio 3, with Lennon adorning "Come Together" with

a guitar flourish during the song's central climax, while also plying additional overdubs onto "Sun King" and "Mean Mr. Mustard." The superimpositions included new vocals from Lennon, who also added a piano part to "Mean Mr. Mustard," while Martin sharpened up his Lowrey organ on "Sun King." Starr rounded out the day with a tambourine overdub. But the big story would unfold on Wednesday, July 30, when the Beatles and their production team finally got to hear how the huge medley was shaping up in the studio. By day's end, they intended to edit a trial version of the suite in order to hear how it was (or wasn't) progressing. Working for much of the day in the Studio 2 control room, Martin, Emerick, MacDonald, and Kurlander were tasked with creating a rough stereo remix for all of the songs slated for inclusion in the medley, then editing and crossfading them into a seamless, albeit still rough, whole. To accomplish a crossfade, studio personnel edit a given set of recordings by fading one segment down, while fading another one up in order to accomplish a smooth overlap. In film-making a similar technique is described as a "dissolve."[24]

But as it happened, Martin and his production team couldn't begin the editing process yet. The Beatles still had a number of creative ideas that they wanted to capture on tape. Working in Studio 3, Lennon and Harrison added new electric guitar parts to "Come Together." Turning to "Polythene Pam" / "She Came in Through the Bathroom Window," they recorded additional vocals, percussion, and yet more guitars. McCartney appended new vocals for "You Never Give Me Your Money" and "Golden Slumbers" / "Carry That Weight." By ten-thirty that evening—after having spent some seven hours toiling away on the songs slated for the medley—the bandmates were ready to turn things over to their production team. Over the next four hours, Martin and his production team carefully shaped the suite. Through editing and crossfading the

constituent songs together, they hoped to see if the medley was indeed coming to fruition, while also revealing any of the suite's shortcomings so that the Beatles could take yet another pass at improving it. At this point, "The End" was still unfinished, lacking vocals of any sort, and "You Never Give Me Your Money" transitioned into "Sun King" by virtue of an organ note. After treating the songs to stereo remixes, Martin and his team assembled the medley with a running order that included "You Never Give Me Your Money," "Sun King," "Mean Mr. Mustard," "Her Majesty," "Polythene Pam," "She Came in Through the Bathroom Window," "Golden Slumbers," "Carry That Weight," and "The End." Altogether, the medley clocked in at 15:30, a bit longer than the Who's "A Quick One, While He's Away" but economical in comparison to recent releases by Zappa and the Small Faces.

When the editing process was complete, the long medley was an unqualified success. Well, almost. Even at that early date, the Beatles and their production team were impressed with the results. "You Never Give Me Your Money" kicked off the medley in fine style, with plenty of emotional highs and lows to follow, including the sheer beauty and grace of "Sun King," the absurdist comedy of "Mean Mr. Mustard," the spirit and excitement inherent in the song cycle ranging through "Polythene Pam" and "She Came in Through the Bathroom Window," the dramatic, heartrending flourishes of "Golden Slumbers" and "Carry That Weight," and the power pop conclusion of "The End." But to McCartney's ears in particular, "Her Majesty" stuck out like a sore thumb between "Mean Mr. Mustard" and "Polythene Pam." Not only did it stymie the musical energy that the Beatles had accrued by that juncture, the acoustic simplicity of McCartney singing along with his Martin D-28 sounded out of place in the midst of so many compositions featuring the bandmates at full strength. Sitting there in

the control room, he knew that it had to go, that "Her Majesty" needed to be stricken from the medley. It simply didn't belong. As Kurlander later recalled, "We did all the remixes and crossfades to overlap the songs," and Paul said, "I don't like 'Her Majesty,' throw it away." Kurlander dutifully excised the song, accidentally including the last note of "Mean Mr. Mustard," which he neglected to edit out, given that it was only a rough mix, after all.[25]

That was only the beginning of the saga of "Her Majesty." The very next day, "Her Majesty" experienced a bizarre resurrection when Malcolm Davies prepared a playback lacquer of the medley at Apple Studio, with Mal Evans returning the lacquer to EMI later that same day for the Beatles' inspection. Although Kurlander wanted to adhere to McCartney's wishes and dispose of "Her Majesty," he also knew that "I'd been told never to throw anything away, so after he left I picked it up off the floor, put about 20 seconds of red leader tape before it, and stuck it onto the end of the edit tape." By the time that the young tape op returned to Abbey Road for his next shift the following afternoon, he was surprised to discover that "Her Majesty" was back in the mix, albeit with a very different placement than when he had gone home the previous evening. When the Beatles listened to the lacquer, they clearly had liked hearing "Her Majesty" at the end of the medley. "The Beatles always picked up on accidental things," said Kurlander. "It came as a nice little surprise there at the end." But with "Her Majesty" having experienced a new life at the end of the medley, the song cycle still wasn't quite finished.[26] During the July 31 session, McCartney decided that "You Never Give Me Your Money" wasn't there yet— especially the song's third verse ("Out of college, money spent"), with its tempo change in contrast with the plaintive early stanzas. Indeed, there were at least two major problems from McCartney's perspective: the shift among the constituent subsections of "You

Never Give Me Your Money," which McCartney found to be jarring in its current state, and the organ transition piece that linked "You Never Give Me Your Money" with "Sun King," which seemed slipshod and unimaginative compared to the other transitions in the rough mix. To solve the problem in the latter case, McCartney turned to the "wind-up" piano technique, a long-standing implement in the Beatles' production toolbox.

The "wind-up" piano had been Martin's brainchild, dating back to the late 1950s, when the Parlophone A&R head had righted the fortunes of the label with a series of hit comedy records. In addition to Peter Sellers, one of Martin's favorite funny men was the diminutive Charlie Drake, a British comedian who found fame as the star of the BBC's *Drake's Progress* television program. In 1958, Drake recorded a spoof of "Volare (Nel Blu Dipinto Di Blu)," which Martin enhanced with a varispeed recording technique, in which he captured the song's backing vocals at half speed, only to play them back at full speed. This afforded the harmonies with a comedic feel befitting Drake's novelty track.

Varispeed—or "frequency control," as studio personnel referred to it during the 1950s and 1960s—wasn't originally conceived as a tool of recording artistry. It had been designed as a means for speed correction to counteract the frequent power outages at EMI Studios. In such inopportune moments, studio recordings were often affected by nonstandard tape speeds and sudden pitch shifts that engineers could overcome via varispeed technology. As the notion of recording artistry developed during the 1960s and beyond, frequency control began to take on creative uses. As Parsons observed, frequency control was deployed "to produce small pitch shifts for effect and slowing down or speeding up entire songs." It was also activated in conjunction with "ADT and the chorusing effect," which "would be produced by 'wobbling' the oscillator slightly." In so doing,

pioneering engineers like Emerick and Parsons worked the tools of their trade in increasingly innovative ways.[27]

Drake's "Volare" would not be the last time that Martin tried his hand at concocting such rudimentary studio effects. During this same period, varispeed recording would enjoy renown of a much different sort after the Chipmunks novelty act scored a seasonal smash hit with "The Chipmunk Song (Christmas Don't Be Late)." Chipmunks creator Ross Bagdasarian Sr. deployed varispeed to create the illusion of three chipmunks—the fictive Alvin, Simon, and Theodore—singing their trademark high-pitched vocals. (Bagdasarian would be rewarded with three Grammys for his efforts.) By the time Martin had the pleasure of meeting the Beatles in June 1962, he had mastered varispeed recording, having deployed it on numerous comedy records. He soon realized that the technique often led to unique sonic qualities when coupled with acoustic musical instruments, especially the piano. In such instances, Martin discovered that his varispeeded notes bristled with the noise of the tiny hammers striking the piano strings as they were being recorded at half speed. To Martin's ears, the resulting effect sounded like the music emanating from the wind-up music boxes of yore.

By the summer of 1969, the Beatles were devotees of the wind-up technique, with Martin's varispeed having graced numerous tracks over the years, including *Please Please Me*'s "Misery" and the title track from *A Hard Day's Night*, among others. In arguably the most striking example of his handiwork, Martin wiped a Hammond organ solo from *Rubber Soul*'s "In My Life" and replaced it with a varispeeded piano part. Martin later recalled, "the only way I could do it [in such instances] was to slow the tape down to half speed, which allowed me to play the notes nice and slowly, at a pace I could manage." As Martin reckoned, "it is a fact

of physics that if you slow the tape down to half speed, then the frequencies are halved, and the sound drops down an octave lower exactly. I duly played the notes an octave down, recording them at that speed, then on playback speeded the tape back up to normal." To his great delight, "Eureka! It worked!" With "In My Life," his simple, Bach-infused piano, after being treated with varispeed, took on the sound of a Baroque harpsichord.[28]

At the time, Martin felt like the wind-up piano was essentially a kind of parlor trick. Working with the REDD.51 and later the TG, he could activate half-speed recording by simply throwing a switch on the tape deck from recording at 30 ips (inches per second) to 15 ips. In the case of "In My Life," he later explained, varispeed mimicked "a harpsichord sound by shortening the attack of everything, but also because I couldn't play it at real speed anyway. So I played it on piano at exactly half normal speed, and down an octave. When you bring the tape back to normal speed again, it sounds pretty brilliant. It's a means of tricking everybody into thinking you can do something really well." Martin often deployed the wind-up piano for strategic effect. During the British Invasion era, for example, he resorted to his trusty wind-up piano technique to camouflage pop singer Billy J. Kramer's vocals, which were often detestable to Martin's ears. "Where there was any offending phrase from the Kramer tonsils," he later recalled, "I put in a bit of this piano and mixed it a bit louder." For Matt Monro's James Bond theme "From Russia with Love," Martin deployed his varispeed wind-up piano effect to mimic the sound of balalaikas echoing in the background of Monro's vocals. As he further honed the technique during his later years with the Beatles, Martin used it as a means for establishing setting and ambience, as witnessed by the barrelhouse piano solo in *Sgt. Pepper*'s "Lovely Rita" and the honky-tonk pretensions in *The White Album*'s "Rocky Raccoon."[29]

When it came to refining "You Never Give Me Your Money," Mc-Cartney had concocted a solution for the "Out of college, money spent" section of his through-composed song. During the July 31 session in Studio 3, he hit upon the idea of superimposing a boogie-woogie piano to inject the song with some much-needed energy after the lingering quietude of the opening stanzas. Popularized by Albert Ammons during the 1930s and 1940s, the boogie-woogie style found its musical roots in a jazzy form of twelve-bar blues. As with Martin's dilemma involving "In My Life" back in October 1965, McCartney knew full well that he couldn't play the complex piano solo up to tempo—certainly not with the clarity and character that he demanded for a Beatles record. To capture the boogie-woogie sound, Martin and McCartney prepared to deploy the wind-up piano technique again.

For his instrument on the "You Never Give Me Your Money" piano overdub, McCartney opted to play the Steinway Vertegrand tack piano in Studio 2, which had a much mellower sound than the Challen jangle piano in Studio 3 that he had played on "Old Brown Shoe" back in April. Known as "Mrs. Mills," Studio 2's tack piano had a long and colorful history at EMI Studios. Named in honor of Gladys Mills, a music hall pianist who enjoyed playing the Vertegrand during her frequent visits to Abbey Road in the 1960s and 1970s, the 1905 piano had been purchased by EMI in 1953 for £404. At the time, engineer Stuart Eltham instructed a Steinway technician to imbue the instrument with an "older" sound by hardening the hammers with lacquer, thus simulating the bright feel of a tack piano. To further enhance the effect, EMI staffers kept the piano slightly out of tune to give the sound of an old-time saloon piano. Gladys Mills had made her name recording sing-along records and party tunes at the height of the music hall revival. Her career blossomed in 1961, when at age forty-three she released her

debut single, "Mrs. Mills Medley," which became a Top 20 British hit and made her a household name. Over the years, her repertoire featured a raft of cover versions, including Carol Channing's "Diamonds Are a Girl's Best Friend," Louis Armstrong's "Hello, Dolly!" and, of particular note, the Beatles' "Yellow Submarine."

By the summer of 1969, the "Mrs. Mills" piano had appeared on numerous Beatles songs, including "She's a Woman," "I Want to Tell You," "Lady Madonna," "Penny Lane," and "With a Little Help from My Friends." During the July 31 session, McCartney and Martin wasted little time in capturing the wind-up piano technique for "You Never Give Me Your Money." Playing an octave below the "Out of college" section, which the Beatles had performed in E minor, McCartney fashioned a rumbling boogie-woogie piano part on "Mrs. Mills." Up in the booth, Martin dutifully ran the tape machine at half speed. When Martin and his production team employed varispeed, the technique performed exactly as expected, and the "Out of college" section took on the bright, jazzy feel of a boogie-woogie piano played full tilt. Later that evening, McCartney and Starr made further refinements to the medley, trying their hands at the timpani to afford the low end of "Golden Slumbers" / "Carry That Weight" with a much-needed dramatic flourish.

But McCartney couldn't shake his nagging instinct about the organ note acting as transition between "You Never Give Me Your Money" and "Sun King." To his ears, it didn't have the subtlety and grace befitting a medley by rock's masters. After all, as he had said many times before, "We're a big act, the Beatles."[30]

No, the organ note simply wouldn't do.

6

Virtuosi

As July came to a close, Emerick had come to enjoy the routine
of working with Martin and the Beatles again. Gone, for the
most part, were the arguments and bad blood that had prompted
him to escape the *White Album* sessions. The engineer had even
come to appreciate the capabilities of the TG console especially in
terms of the solid-state sound that it produced. For Emerick, "The
new recording console, that specific one, gave the original rhythm
tracks a certain texture that wasn't as aggressive and upfront and
hard as the tube desk would have given us. And that sound was
well-suited to a lot of the songs they brought in for the album. In
addition, because the original rhythm tracks were sort of more
subdued, the overdubs were a little softer and less harsh as well.
Everything sat together a little easier in the mix." Emerick reasoned
that it was the solid-state machine that afforded the album with
clearer and warmer tones—especially on the low end, where the
TG console significantly curtailed the distortion produced by the
REDD mixing consoles of old.[1]

The warmth and beauty of the Beatles' sounds, as captured on
the TG console, reached their apex with "Because," a composition
that Lennon shared with his bandmates during an eight-hour ses-
sion in Studio 2 on Friday, August 1. Lennon had been inspired to

write "Because" after hearing Ono, a classically trained musician, play the first movement of Beethoven's Piano Sonata No. 14 in C Sharp Minor ("Moonlight Sonata"). In one of his most innovative reinventions of a "found object," Lennon completed his new composition after reversing the direction of the arpeggios that provided the accompaniment to Beethoven's melody and adorning them with suitably introspective lyrics. As Lennon later recalled, "I was lying on the sofa in our house, listening to Yoko play Beethoven's 'Moonlight Sonata' on the piano. Suddenly, I said, 'Can you play those chords backward?' She did, and I wrote 'Because' around them. The song sounds like 'Moonlight Sonata,' too. The lyrics are clear, no bullshit, no imagery, no obscure references."[2]

The "plagiarists extraordinaires" were at it again, borrowing without compunction from the pinnacle of classical music artistry. As Steve Turner has astutely observed, "There was a touch of irony in the idea of a Beatle borrowing from Beethoven because there was a common perception at the time that rock 'n' roll was antithetical to classical music and that no one could genuinely appreciate both." Turner noted, "It also probably didn't help that the Beatles had recorded Chuck Berry's 'Roll Over Beethoven,' an irreverent piece of advice to classical composers asking them to make way for rock 'n' roll." But for Lennon, the idea of pinching an idea from Beethoven held a special significance. Under Ono's tutelage, he had come to revere Beethoven, Western music's most vaunted composer, as "one with whom he felt kinship," as Turner pointed out. "By 1969, he was no longer trying to be the artistic equal of Elvis or the Rolling Stones, but of Picasso, Van Gogh, Dylan Thomas, and Beethoven." In the case of "Because," McCartney later observed, "I wouldn't mind betting Yoko was in on the writing of that. It's rather her kind of writing: wind, sky, and earth are recurring. It's

straight out of [Ono's book] *Grapefruit*, and John was heavily influenced by her at the time."³

During the August 1 evening session, the Beatles captured "Because" in twenty-three takes, with Lennon providing a guide vocal and electric guitar part, McCartney playing bass, and Martin working a Baldwin spinet electric harpsichord, which was no easy feat given the song's C-sharp key signature, distinguishing "Because" as the only Beatles composition to be played in that rarified key. As Emerick later recalled, the idea for the keyboard part had come from the Beatles' producer: "John had written the song on guitar, gently picking individual notes rather than playing chords, but he felt that something more was needed. 'Why don't I double your line exactly on harpsichord?' George [Martin] suggested, and Lennon quickly agreed. 'Yeah, great, that will help make it a little more classical-like, too.'" For purposes of recording the basic rhythm track, Starr played a gentle beat on his hi-hat that was projected into the other musician's headphones to provide a tempo. "Because I'm not renowned as the greatest time-keeper when I'm playing," Martin later recalled, "Ringo was our drum machine."⁴

Meanwhile, McCartney was up in the control booth, acting as the Beatles' de facto producer while Martin labored at the keyboard. As Emerick later recalled, McCartney "was pushing them too hard that night, having them do take after take, playing way past their peak. When the exhausted trio finally came up to the control room to have a listen, they realized that they had laid down a perfectly good take an hour before. John didn't say anything, but he shot an embarrassed Paul a dirty look. Fortunately, they seemed too tired to make an issue out of it." The moment clearly wasn't lost on McCartney, who later remarked that "on *Abbey Road* I was beginning to get too producery for everyone. George Martin was the actual producer, and I was beginning to be too definite. George

[Harrison] and Ringo turned around and said: 'Look, piss off! We're grown-ups and we can do it without you fine.' For people like me who don't realize when they're being very overbearing, it comes as a great surprise to be told. So I completely clammed up and backed off—'right, okay, they're right, I'm a turd.' So a day or so went by and the session started to flag a bit and eventually Ringo turned 'round to me and said: 'Come on . . . produce!' You couldn't have it both ways. You either had to have me doing what I did, which, let's face it, I hadn't done too bad, or I was going to back off and become paranoid myself, which was what happened." With the basic rhythm track for "Because" complete, the band was well on their way to realizing Lennon's new song. But the best, as so often with the Beatles and their recording, was yet to come.[5]

On Monday, August 4, the Beatles returned to "Because," effecting the same kind of three-part harmony that they had perfected with "This Boy" in 1963, and later, in 1965, with "Yes It Is" and *Rubber Soul*'s "Nowhere Man." In singing three-part harmony, Lennon, McCartney, and Harrison could revel again in the music of their youth, especially their vocal idols, the Everly Brothers. While Martin had clearly assisted the band's principal singers in improving their vocal chops, they were naturally gifted singers who had performed together for many years by the time they came into the producer's orbit in 1962. "I didn't teach them to sing harmony, because they were already good at that," Martin later wrote. "They had cut their teeth in Liverpool and most importantly in Hamburg, when they had performed for hours on end each night in a very rough and demanding environment, organizing a repertoire for themselves by including American records in the act. They tried out the harmonies they heard on records and became quite good at it, to the point where they were able to sing naturally in three-part harmony once the song was established."[6]

"Because" may stand as the bandmates' most exquisite multi-part vocal effort, and it received a vital assist from the TG console, which allowed Martin and Emerick to spread out the vocals with great separation, hence finer vocal resolution. For the three-part vocal that adorned "Because," Lennon took the mid-range lead vocal part, Harrison sang the somewhat lower harmony, and Mc-Cartney rounded out the trio by singing in falsetto. Designating two tracks for the harmonies, "we put down one set of voices with John, Paul, and George singing in harmony and we then designed two more sets of trios to go on top," Martin remembered. "So we finished up with nine voices, nine sounds, that's all but it worked. It was very simple." Only it wasn't that simple. Recording the delicate vocals proved to be a painstaking process, even if the song itself benefits from the aura of ease and simplicity that it radiates. Martin later admitted that to capture the vocals, he was "literally telling them what notes to sing" in order to bring off the recording. At the time, Harrison described "Because" as "a bit like 'If I Needed Someone'—you know, the basic riff going through it is somewhat the same, but it's actually quite a simple tune. It's a three-part harmony thing which John, Paul, and myself all sing together." For Harrison, "Because" distinguished itself as his favorite song on the LP "because it's so damn simple. The lyrics are uncomplicated, but the harmony was actually pretty difficult to sing. We had to really learn it, but I think it's one of the tunes that will definitely impress most people."[7]

Later that evening, after work on "Because" had wrapped up for the night, Harrison worked in the Studio 3 control room with Mc-Donald and Parsons to produce rough stereo remixes of "Something" and "Here Comes the Sun." For Harrison, listening to the playbacks was a revelation. Even at this stage, the songs were masterfully performed and recorded, but, to his ears, they weren't quite

right just yet. Meanwhile, Martin was given an acetate of "Something" to consult when composing an orchestral backing track for Harrison's majestic song. By this juncture, it was clear that Martin's skills as an arranger would be in great demand for several songs on the new LP, including some of the cuts on the huge medley, such as "Golden Slumbers" and "Carry That Weight." To accommodate the classical musicians, Martin had already booked cavernous Studio 1 for an afternoon session on August 15 to record the orchestral overdubs.

For the Beatles, Tuesday, August 5, proved to be a banner day among the recording sessions devoted to the new album. For McCartney, the afternoon session resulted in a solution to his discontent with the existing transition between "You Never Give Me Your Money" and "Sun King." Over the previous weekend, he had begun experimenting with the tape loops at his Cavendish Avenue home. Since the mid-1960s, recording tape loops had emerged as one of McCartney's favorite pastimes. "I used to experiment with them when I had an afternoon off, which was quite often," he later recalled. "We'd be playing in the evening, we'd be doing a radio show or something, and there was often quite a bit of time when I was just in the house on my own so I had a lot of time for this. I wasn't in a routine. . . . So I would sit around all day, creating little tapes." McCartney had become particularly taken with the idea of running the tape backward, later graduating to creating imaginative tape loops by splicing bits of tape into pieces and randomly joining them together using a bottle of glue that he had picked up at Abbey Road.[8]

When he arrived for the August 5 session, McCartney brought along a plastic bag containing a dozen pieces of monophonic tape. Working in the Studio 3 control room with Martin and his production team, McCartney transferred the best of the lot onto

four-track tape. He was especially pleased with a series of sounds of birds and chirping crickets that he merged with jingly bells. Crossfading the shimmering tape loops between "You Never Give Me Your Money" and "Sun King" served as a vital transition from the high-energy conclusion of the first into the slower, mellower tones of the latter. McCartney had some tape loops in mind for potential use on "Here Comes the Sun," but they went unused.

That same day, the staff of EMI Studios experienced a moment of great excitement as Harrison supervised the installation of his Moog equipment in the facility, moving it from his home. For the task of programming the complex instrument, Martin hired as a consultant his longtime friend and colleague Mike Vickers, the multi-instrumentalist from the Manfred Mann band and the studio conductor for "All You Need Is Love." At the behest of Chris Thomas, Martin had earlier purchased a Moog synthesizer for AIR. When the instrument arrived in the UK, Thomas was understandably mystified, like Harrison, by its lack of an instruction manual—the Moog only came with a schematic—and Vickers assisted Martin's protégé in learning how to program and play the instrument. Hence Vickers was a natural choice to help acclimate the Beatles to the inner workings of the Moog. As Kurlander later recalled, "The Moog was set up in Room 43, and the sound was fed from there by a mono cable to whichever control room we were in. All four Beatles—but particularly George—expressed great interest in it, trying out different things." For studio personnel, the new instrument created a tremendous buzz. Alan Parsons remembered, "Everybody was fascinated by it. We were all crowding around to have a look."[9]

Emerick credited Harrison with importing new sounds into the studio with the Moog, "just as he had done back in the *Revolver* days when he introduced Indian instruments to Beatles records."

As with Kurlander and Parsons, Emerick was flummoxed by the sight of the thing: "It was a foreboding black object the size of a bookcase, littered with dozens of knobs, switches, and patch cords," he later recalled. "Mal grunted and sweated as he dragged the thing in, packed up in eight huge boxes. The Moog people had given a demo at EMI some months prior, so I wasn't altogether unfamiliar with the device, but it took forever to set up and get just a single sound out of it. Harrison sure loved twiddling those knobs. I have no idea if he knew what he was doing, but he certainly enjoyed playing with it."[10]

By the evening of August 5, Vickers had succeeded in setting up the Moog to Harrison's satisfaction. Without missing a beat, the Quiet Beatle turned his attentions back to "Because," for which he fashioned a contemplative backdrop echoing Martin's harpsichord part. EMI staffer Nick Webb was duly impressed with the Beatles' deployment of the new instrument, later remarking, "I think the Beatles used the Moog with great subtlety. Others in a similar situation would probably have gone completely over the top with it. It's there, on the record, but not obtrusively. Perhaps they weren't sure it was going to catch on!" To execute the overdub, Martin and his production team fed the signal from the Moog from room 43 into the Studio 2 control room, where they carried out the superimposition of Harrison's keyboard part onto the two vacant tracks in the recording.

With "Because" completed, the Beatles returned to "The End," which still went under the working title of "Ending." As part of the song's introductory riffs, McCartney overdubbed a fiery vocal, singing "Oh, yeah! All right! Are you gonna be in my dreams tonight?" as a preface to Starr's magnificent drum solo. Afterward, Lennon, McCartney, and Harrison harmonized a series of vocals for the song—singing "love you" repeatedly across the middle section—before McCartney closed out the track with

a moment of sheer brilliance, a lyrical flourish of his own making. He would later remark, "Shakespeare ended his acts with a rhyming couplet so that the audience would know they were over. I wanted it to end with a little meaningful couplet, so I followed the Bard and wrote a couplet." Singing "and in the end, the love you take is equal to the love you make," McCartney succeeded in concluding the medley with "a cosmic, philosophical line," in Lennon's words. And with that, the Beatles seemed to have brought "The End" to fruition, save for a planned orchestral overdub.[11]

The next day, Wednesday, August 6, the Beatles were at it again. By this point, they were regularly working in separate studios in the complex—not because of any ongoing animus but because the LP was quickly coming together. Working "on heat" again, they wanted to take advantage of the onrush of creative energy and complete their latest batch of songs. EMI staffer Tony Clark worked the band's sessions during the first three weeks of August, and he later recalled that "they kept two studios running and I would be asked to sit in Studio 2 or 3—usually 3—just to be there, at the Beatles' beck and call, whenever someone wanted to come in and do an overdub. At this stage of the album, I don't think I saw the four of them together." Working in Studio 3, Harrison overdubbed several electric guitar licks onto "Here Comes the Sun," including various solo efforts that would be deleted from the final mix.[12]

Meanwhile, McCartney worked in room 43, where he fashioned a Moog part for "Maxwell's Silver Hammer." As with the preceding day's efforts on "Because," the instrument's signal was fed into the Studio 2 control room, where Martin and his production team supervised the overdub. Working the session that day in room 43, Parsons was impressed with how quickly McCartney learned how to manipulate the new instrument. As Parsons later

remarked, "Paul used the Moog for the solo in 'Maxwell's Silver Hammer,' but the notes were not from the keyboard. He did that with a continuous ribbon-slide thing, just moving his finger up and down on an endless ribbon. It's very difficult to find the right notes, rather like a violin, but Paul picked it up straight away. He can pick up anything musical in a couple of days." Sitting in the control room, Martin too was fascinated with McCartney's ability to work the Moog, although he remained suspicious of artificial sounds. "I suppose we were still influenced by real sounds and we were still trying to get sounds that were like instruments we knew more than synthetic sounds," he later observed, "but nevertheless, there was a floaty mystical thing about the sound on 'Maxwell's Silver Hammer.'"[13]

By Thursday, August 7, the Beatles, it seems, had fallen into a routine, albeit a productive one. With work on the new LP coming briskly to a close, the bandmates continued to work in different studios simultaneously to carry out overdubs and apply an array of other finishing touches. General goodwill in the group continued, but things could turn on a dime with them. That afternoon, tensions seem to have materialized out of thin air, starting when the Beatles were sitting in the Studio 2 control booth with Martin, Emerick, and Kurlander, listening to playbacks of "Come Together" during a remixing session. As Kurlander looked on with the others, they could see Ono down in the studio below, where she slowly rose out of bed and tiptoed across the room to Harrison's Leslie speaker cabinet. As they watched, Yoko picked up one of the guitarist's digestive biscuits from where he stored them atop the cabinet and began slowly unwrapping it. "That bitch!" Harrison yelled. "She's just taken one of my biscuits!" At that point, Emerick later recalled, "Lennon began shouting back at him, but there was little he could say to defend his wife (who, oblivious,

was happily munching away in the studio), because he shared the same attitude toward food. Actually, I think the argument was not so much about the biscuits, but about the bed, which they had all come to deeply resent." Although he tried desperately to stay out of the Beatles' fray, even the normally staid Martin had become chagrined by the bed's awkward and continuing presence in the studio.[14]

But what Kurlander would remember most about that day was how the tempest so quickly blew over. A short time later, the Beatles seemed to have forgotten all about the explosion in the Studio 2 control room. Working in Studio 3, Harrison and Lennon put aside their differences to perform a fusillade of guitar solos for the rock and roll revue that concluded the medley. The idea for the three-way guitar duel emerged when the Beatles realized that there were still several unused bars in "The End." As Emerick later recalled, it was Harrison who piped up with a solution:

> "Well, a guitar solo is the obvious thing," said George Harrison.
> "Yes, but this time you should let *me* play it," said John jokingly. He loved playing lead guitar—he'd often mess about doing lead parts during rehearsals—but he knew that he didn't have the finesse of either George or Paul, so he rarely did so on record. Everyone laughed, including John, but we could see that he was at least half-serious.
> "I know!" he said mischievously, unwilling to let it go. "Why don't we all play the solo? We can take turns and trade licks."

And that's exactly how it happened. With McCartney on his Fender Esquire, Harrison on Lucy, his Gibson Les Paul Standard, and Lennon on his Epiphone Casino, each guitarist succeeded in improvising a two-bar solo for the ages. To capture the moment, the Beatles' engineer instructed Mal Evans to set up the guitarists' trio of amplifiers in a row on the studio floor. There was no need to achieve separation, given that the individual solos would be recorded live on a single track. As Martin, Emerick, and Starr looked

on from the booth, the bandmates captured the solos in one take. As Emerick later recalled: "John, Paul, and George looked like they had gone back in time, like they were kids again, playing together for the sheer enjoyment of it. More than anything, they reminded me of gunslingers, with their guitars strapped on, looks of steely-eyed resolve, determined to outdo one another. Yet there was no animosity, no tension at all—you could tell that they were simply having fun." After they had completed the take, the three Beatles stood on the studio floor, beaming at each other like old friends, flush with the accomplishment that they had just pulled off in spite of everything. As with Kurlander, Starr had been thunderstruck by the virtuosic performance. "Out of the ashes of all that madness," said Starr, "that last section is one of the finest pieces we put together."[15]

The next day, August 8, the Beatles arrived early at the studio to finally resolve the lingering matter of their new album's cover art. Since early summer, the title had been a running issue among the group, with several names being bandied about, including *Four in the Bar*, *All Good Children Go to Heaven*, and the absurd *Billy's Left Foot*. One of the strongest contenders had been to name the album *Everest* in honor of the brand of cigarettes that Emerick smoked. "We were stuck for an album title," McCartney later recalled, "and the album didn't appear to have any obvious concept, except that it had all been done in the studio and it had been done by us. And Geoff Emerick used to have these packets of Everest cigarettes always sitting by him, and we thought, 'That's good. It's big and it's expansive.'" The bandmates ultimately balked at the idea when they realized that they didn't want to go to the enormous trouble of journeying to Tibet to shoot the album's cover art. Besides, McCartney added, "You can't name an album after a ciggie packet!" Suddenly out of options, they turned to the studio from whence

they had made their name. "Fuck it," Starr reportedly said. "Let's just step outside and name it *Abbey Road.*" And that's exactly what they did. Working with designer John Kosh, an artist friend of the Lennons, McCartney sketched out the LP's cover art. On the morning of August 8, the Beatles gathered outside the stately gates of 3 Abbey Road for the photo shoot. While the London Metropolitan Police helpfully cleared the area of traffic, photographer Iain Macmillan stood atop a ladder and took the famous cover shot of the bandmates walking single file across the zebra crossing only a few yards from the main entrance to EMI Studios. As McCartney later recalled, "It was a very hot day in August, and I had arrived wearing a suit and sandals. It was so hot that I kicked the sandals off and walked across barefoot for a few takes, and it happened that in the shot he used I had no shoes on, Sandie Shaw style. There's many a person who has gone barefoot, so it didn't seem any big deal for me at all." Lennon would remember, "We were just wishing the photographer would hurry up. Too many people were hanging around. 'It's going to spoil the shot. Let's get out of here. We're meant to be recording, not posing for Beatle pictures'—that's what we were thinking. And, I was muttering, 'Come on, hurry up now, keep in step.'"[16]

With plenty of time to kill before the day's session began at 2:30 p.m., McCartney and Lennon hung out at Paul's Cavendish Avenue home. Meanwhile, Harrison and Mal Evans visited the London Zoo in nearby Regent's Park, while Starr went shopping. Then, working in Studio 2, McCartney and Starr refined their bass and drum parts for "The End." That evening, Lennon and Starr returned to "I Want You," with Ringo perfecting his drum work in the studio and John finally getting his turn at creating sound effects on the Moog synthesizer in room 43. For Lennon, the session resulted in an extensive buildup during the song's closing section,

in which he generated white noise from the Moog. During post-production, Emerick overwhelmed the mix with the sound of un-remitting static in order to satisfy Lennon's desire that the Moog become progressively louder and louder. Meanwhile, McCartney concluded the August 8 sessions in Studio 3, where he superimposed a new lead guitar part and a tambourine onto "Oh! Darling."

By Monday, August 11, the Beatles were determined to make further refinements during the waning days of *Abbey Road*'s production. As Martin worked feverishly to complete the musical arrangements for Friday's mammoth orchestral session in Studio 1, the group made further superimpositions to "Here Comes the Sun," "Oh! Darling," and "I Want You (She's So Heavy)," which had earned its subtitle after Lennon, McCartney, and Harrison built up harmony after harmony singing "she's so heavy," which Emerick duly captured on the available tracks four and seven. After bestowing a series of vocal harmonies on "Oh! Darling," the session was rounded out with Harrison adding yet more guitar parts to "Here Comes the Sun." Over the next few days, the Beatles and their production team carried out long control room sessions in Studio 2 to put the finishing touches on "Because," "Maxwell's Silver Hammer," and "You Never Give Me Your Money." During a twelve-hour session on Thursday, August 14, the remixed versions of "Sun King" / "Mean Mr. Mustard" and "Polythene Pam" / "She Came in Through the Bathroom Window" were merged via a hard edit, in which "Mean Mr. Mustard" and "Polythene Pam" were joined without the slightest hint of a pause between the two songs. Considerable time was spent perfecting the crossfade between "You Never Give Me Your Money" and "Sun King," with McCartney's August 5 tape loops in place. The August 14 session was also marked by a visit from British DJ Kenny Everett, who interviewed Lennon about the Beatles' progress on their new LP. During the

course of the discussion, Lennon divulged the title of the album, while confirming that the band's next LP would be titled *Get Back*, although no release date had been planned. "We got fed up," Lennon admitted to the DJ, "so we just left it."[17]

The next day, Martin supervised the monumental orchestral session for *Abbey Road*, second only in size and scope to the February 1967 session in Studio 1 for "A Day in the Life." Working in that same studio on Friday, August 15, Martin conducted the session musicians, whose music and images were transmitted by closed-circuit television to the Studio 2 control room, where Emerick, McDonald, and Parsons monitored the proceedings. With Studio 1 not yet outfitted with eight-track technology, Martin's production team was forced to capture the orchestral recordings in the Studio 2 control booth, where they had access to the TG console. As engineer Alan Brown later recalled, "It was a mammoth session. We had a large number of lines linking the studios, and we were all walking around the building with walkie-talkies trying to communicate with each other." Up first that day was "Golden Slumbers" / "Carry That Weight," for which Martin had scored arrangements for twelve violins, four violas, four cellos, a string bass, four horns, three trumpets, a trombone, and a bass trombone. By this time, Martin had perfected the art of orchestration as a means not only for complementing the Beatles' compositions but also to bring their creativity to life. "Production and arranging are two different jobs, even though they go hand in hand," he later remarked. "If you can score, if you can orchestrate, it's obviously a tremendous help to realize the production ideas that you have. You know what to write in order to get the right sound in the studio. Similarly, if your production end tells you what you need to write, you're working hand-in-glove with yourself so to speak. And that's where your orchestrating style affects your production style."[18]

With "Golden Slumbers" / "Carry That Weight" under his belt, Martin turned to "The End," which, in terms of sheer cost per second, was the most exorbitant recording of the day. With the same musicians working in Studio 1, Martin conducted the powerful coda for "The End." As the medley thundered to a close, a series of guitar flourishes coalesced with George's orchestration, establishing a sense of an ending amid the warmth of the musicians' harmonics. In contrast with "A Day in the Life," with its climax in a darker hue (with the inherent tension and uncertainty of an E-major chord), Martin's score for "The End" reached the finish line with the comparative serenity of C major. As Brown later observed, "The orchestral overdub for 'The End' was the most elaborate I have ever heard: a 30-piece playing for not too many seconds—and mixed about 40 dBs down. It cost a lot of money: all the musicians have to be paid, fed, and watered; I screw every pound note out of it whenever I play the record!"[19]

After taking a break to arrange the new configurations of musicians and prepare the next set of scores, Martin turned to "Something" and "Here Comes the Sun." The Beatles' producer had concocted a pair of exquisite orchestrations for Harrison's contributions to *Abbey Road*. His arrangement for "Something" called for twelve violins, four violas, four cellos, and a string bass. For the song, Martin had composed a lovely pizzicato section for the bridge, with the violinists plucking their strings to accentuate the singer's romantic abandon. Later, for "Here Comes the Sun," Martin's score called for four violas, four cellos, a string bass, two clarinets, two alto flutes, two flutes, and two piccolos. In this instance, Martin's deft arrangement perfectly complemented Harrison's buoyant, optimistic lead vocals as well as the delicate layers of his acoustic guitar and Moog overdub, the latter of which he would record on the following Tuesday. By the wee

hours of Saturday, August 16, the orchestrations for *Abbey Road* were complete.

But apparently Harrison hadn't been completely satisfied. Earlier in the session, Harrison had taken up Lucy to record a new guitar solo for "Something" in place of the original solo recorded back at Olympic on May 5. With Emerick, McDonald, and Parsons looking on from the Studio 2 control booth—still patched in with the happenings in Studio 1 via closed-circuit TV—Harrison performed his sublime electric guitar solo for the instrumental verse. For the recording, Martin's orchestration was arrayed on tracks three and four, while the guitar solo was edited into track one, which was already composed of Harrison's electric guitar intro and outro sequences. To Emerick's delight, he recalled years later, Harrison "managed to play the intricate solo with ease."[20]

The engineer would marvel at the quality of Harrison's performance on the guitar solo for "Something," observing that the Quiet Beatle deftly infused his solo with the graceful *gamak* embellishments that he had gleaned from Indian classical music. Harrison's solo also portended the slide-guitar sound that would become his trademark in the 1970s. As Emerick noted, it "became his signature sound on *Abbey Road* and on many of his subsequent solo albums. It seemed to me that Harrison's progress as a musician was more linear than that of the other Beatles. He wasn't an especially good player at the beginning of their recording career, but he kept getting better and better until in the end he was quite a formidable guitarist. The fact that he went off on an Indian tangent, getting familiar with music that contains so many different polyrhythms (and so many more notes than are used in Western music), had to have helped his playing, which no longer was European- or American-influenced. For all intents and purposes, his approach

to guitar became Eastern, which gave him a distinct sound that characterized many late-period Beatles recordings."[21]

That very day, August 16, 1969, some fifty-six hundred miles away, the legend-making Woodstock Festival got underway on a dairy farm in the Catskill Mountains in Bethel, New York. Billed as "An Aquarian Exposition: Three Days of Peace and Music," the event featured the likes of Crosby, Stills, Nash, and Young, the Band, the Who, Jefferson Airplane, and Jimi Hendrix, among dozens of other acts, and attracted an audience that eventually blossomed into more than four hundred thousand. Unsurprisingly, considerable attempts had been made by the festival's organizers to include the Beatles. Promoter Michael Lang had made contact with Apple representative Chris O'Dell, and O'Dell seems to have made a half-hearted effort to make it happen. There were clearly barriers to the Beatles' attendance at the event, including the fact that outside of the January 30 rooftop concert, the band hadn't performed live in three years. Then there was the looming matter of Lennon's visa status. In May 1969, the administration of new president Richard M. Nixon had rejected the Beatle's visa application because of his recent drug conviction (not mentioned were his ongoing antiwar efforts). As events transpired, the Beatles in August would be knee-deep in the production of *Abbey Road*.

Over the years, a number of rumors have emerged suggesting that the group offered to send surrogates to Woodstock in their place. Lang is said to have later claimed that Lennon had offered Yoko and the Plastic Ono Band to perform in the Beatles' stead, although the tale was likely apocryphal. According to another rumor, O'Dell had been recommending Apple recording artist James Taylor throughout her discussions with Lang, only to see Taylor's invitation revoked after the Beatles declined to appear at the festival. In his memoirs, Lang reflected on what might

have occurred had the likes of the Beatles or the Rolling Stones appeared at the event: "I was a huge Stones fan, but as with the Beatles, they would dominate the festival and change our message. Woodstock was not intended to be about any one band or group of bands. It was about the people—and the ideas and music interwoven through their lives." But the Beatles—via Harrison—left their mark on the festival anyway. Performing on the first day of Woodstock—in the pouring rain—was Ravi Shankar, the master sitar player and Harrison's idol, who, along with the Beatles, had helped to usher Indian music into the wider Western consciousness. While the Beatles may not have been at Woodstock in person, Richie Havens, Joe Cocker, and Crosby, Stills, Nash, and Young all included Lennon-McCartney compositions in their sets.[22]

By Monday, August 18, the Beatles were in the home stretch with *Abbey Road*. The medley had finally been completed, for the most part, with an overdub for "The End" that featured McCartney's four-second piano track as an introduction to his quasi-Shakespearean couplet. To accomplish the effect, Martin and his production team turned to varispeed to resolve the conflicting keys of the basic track for "The End" and the recently recorded orchestral finale. The original recording of "The End," complete with the fusillade of guitar solos, had been captured on tape slightly below concert pitch. To accommodate the discrepancy, McCartney's piano was treated with varispeed, hence slightly flattened. In so doing, Martin and his production team also ensured that Lennon's final burst of grunge guitar gusto was in time with McCartney's piano.

For Martin, crafting the huge medley had been nothing short of pure joy. With the completion of the *Abbey Road* song cycle he had fully realized his vision of the recording studio as a "magical workshop." For the Beatles' producer, the art of making records

was an inherently visual act—strange as that may seem—and he often likened record production to a kind of impressionist painting. "Drawing is not what one sees, but what one must make others see," Martin later observed, paraphrasing the French impressionist Edgar Degas. "In a way, that's what we do in sound. The recording is not what one hears, but what one must make others hear." During his years in the studio, "gradually, I got hooked," he would write. Addicted to the studio's artistic possibilities, "I didn't want to leave it. It enabled me to be creative. I could do things that I found very enjoyable." For Martin, working in the studio with the Beatles had been a gradual evolution, one that had taken him from the relative simplicity of twin-track recording a four-piece beat band into the seemingly endless possibilities portended by the TG console. With his background in orchestration and arrangement, Martin had been itching to adorn the Beatles' music with orchestral sound since the earliest days of their association. In 1965, he finally landed his opportunity to superimpose a string quartet on "Yesterday," later overdubbing an octet for "Eleanor Rigby" and a half-orchestra to accent the sound of apocalypse in "A Day in the Life." For *Abbey Road*, Martin had finally taken his unparalleled skill at developing pop music arrangements to a new level thanks to eight-track technology, which allowed him to widen the Beatles' music across a greater sound spectrum. The results of Martin's inspired arrangements could now be heard in the dramatic orchestral swells of "Golden Slumbers" / "Carry That Weight" and the pure beauty of "Here Comes the Sun" and "Something." For the Beatles producer, listening to the playbacks of the huge medley was nothing short of a revelation.[23]

As usual, the Beatles weren't quite done. As their progression of albums demonstrated, they were perfectionists. The few errors and miscues extant on their records were left there by design—often as

a kind of creative afterthought, most often involving fumbled lyrics. Take, for example, "feeling two-foot small" in *Help!*'s "You've Got to Hide Your Love Away"; "you're doing the best that I can" in *Sgt. Pepper*'s "Getting Better"; "Desmond stays at home and does his pretty face" in *The White Album*'s "Ob-La-Di, Ob-La-Da"; and McCartney's unedited laughter when he sings "writing 50 times" during "Maxwell's Silver Hammer." Lennon adored such verbal slips, particularly their jarring of the listener's expectations. When he sang "two-foot small" instead of "two-feet tall" during "You've Got to Hide Your Love Away," he reportedly said, "Let's leave that in, actually. All those pseuds will really love it." McCartney left "Her Majesty" in the mix for the huge medley for precisely the same reason: after the bombast and finitude of "The End," the twenty-three-second ditty exploded the reverential conclusion, hence the listener's expectations, before disappearing just as quickly into the ether. McCartney liked the pseudo-accidental nature of "Her Majesty" being included at the tail end of the album, hidden fourteen seconds after the end of "The End": "That was very much how things happened. Really, you know, the whole of our career was like that so it's a fitting end." To his mind, it was the ironic unexpectedness that heightened rather than detracted from the LP's conclusion—much like the abrupt appearance of "Sgt. Pepper's Inner Groove" after the powerful, lingering chord at the end of "A Day in the Life" seemed to have wafted off into the distance. In this way, artists like Lennon and McCartney were scarcely different from James Joyce, the High Modernist himself, who was said to have proclaimed about his labyrinthine novel *Ulysses* (1922), "I've put in so many enigmas and puzzles that it will keep the professors busy for centuries arguing over what I meant, and that's the only way of insuring one's immortality." As for the Beatles, if they too had been seeking immortality for their art, by August 1969—with

such landmark LPs as *Revolver*, *Sgt. Pepper*, and *The White Album* already in their wake—their fate was secure.[24]

On Tuesday, August 19, they were at it again in Studio 2, with most of their attention being devoted to "Something" and "Here Comes the Sun," Harrison's exquisite contributions to the new LP. For the latter song, Harrison labored for hours to perfect an exacting Moog synthesizer edit that brought the original recording and Martin's orchestral arrangement into a delicate harmony. In so doing, the composer elevated "Here Comes the Sun" into a new, unforeseen level of greatness. With Martin and his production team assigning Harrison's Moog performance to the available fourth track, the Beatles' guitarist made several passes at the keyboard part. Years later, Harrison would observe that "when you listen to the sounds on songs like 'Here Comes the Sun,' it does do some good things, but they're all very kind of infant sounds." While his observation may have been true in comparison to the artistic heights of progressive rock's synthetic sounds in the 1970s, "Here Comes the Sun" benefited from the relative minimalism of Harrison's performance, which to some degree masked the complexity of the composition.[25]

"Here Comes the Sun" may have seemed clear and uncluttered in its final form, but it was a complex choreography of instrumentation and tempo shifts. As musicologist Andy Babiuk later remarked, Harrison's dexterous Moog performance comprised a "lovely ribbon-assisted downward slide on the intro, and glorious synth sounds filling the 'sun, sun, sun' middle section." Harrison's experimentation with the synthesizer back at Kinfauns had paid dividends, particularly regarding his dexterity with the Moog's ribbon controller, which Parsons described as "a long strip which induces changes in the sound being played depending on where it is touched and how the player's finger is then moved." With songs

like "Maxwell's Silver Hammer" and "Here Comes the Sun," Parsons observed, the best results seemed to occur when the player worked the ribbon controller "like a violin." With his "Here Comes the Sun" overdub, Harrison demonstrated his facility with the Moog, deploying the instrument for a series of well-timed flourishes throughout the recording. Later that day, August 19, Martin and Emerick carried out a nifty stereo remix for "Here Comes the Sun," panning Harrison's Moog intro from left to right at the song's outset, establishing a dreamy palette for the song's optimistic lyrics.[26]

On Wednesday, August 20, with all four Beatles in attendance, the band's work on the *Abbey Road* album ended exactly where it had begun—with Lennon's "I Want You (She's So Heavy)," the song that had kicked things off back in February at Trident, when Glyn Johns and Billy Preston were still on the scene. At this belated point, "I Want You (She's So Heavy)" still required some sorting out. The recording existed as a bizarre amalgam comprised of the hybridized February mixes at Trident, the April guitar coda that Lennon and Harrison had concocted at EMI, and additional overdubs by Lennon and Starr onto the Trident mix. Lennon's recent white-noise exercise, captured just twelve days earlier, had been superimposed onto the Trident mix. In short, the Beatles and their production team were now confronted with two nearly identical versions of "I Want You (She's So Heavy)." To create the final master, Martin and Emerick supervised a session in which both versions of the song were remixed and then edited the two versions together, with the first 4:37 from the Trident tape being crossfaded onto the final 3:07 from the EMI version, complete with Lennon's turn behind the Moog. For the song's distinctive ending, with its powerful sonic buildup, Lennon offered careful instructions in order to ratchet up the intensity. "Louder! Louder!" he implored

Emerick during the mixing process. "I want the track to build and build and build, and then I want the white noise to completely take over and blot out the music altogether." With only twenty-one seconds remaining of the original recording, "all of a sudden he barked out an order" to the Beatles' engineer, "Cut the tape here!"[27]

And with that, "I Want You (She's So Heavy)" was complete, as were seemingly all of the tracks for *Abbey Road*. All that was left, as far as the Beatles and their production team were concerned, was to define the running order, as well as to compile and band the final master tape. Working in the Studio 2 control room from the dinner hour through just past 1:00 a.m. the following morning, Martin and the band, joined by Emerick, McDonald, and Parsons, set about formatting each side of the album. They had recently been debating whether to situate the medley on side one or side two—in contrast with their perspective back in early May. At one instance, Lennon had even floated the idea of placing all of his songs on side one and all of McCartney's on the other, McDonald later recalled. But with the medley effecting a potentially dramatic climax for the album, there was little point in reversing their original plans. Besides, they now had the bookended highpoints of the sudden, startling conclusion of "I Want You (She's So Heavy)" on side one, balanced with the explosive rock and roll revue of "The End" on the other. The only other matter was a relatively minor one, with the bandmates debating whether to place "Octopus's Garden" before "Oh! Darling" on side one or vice versa. In the end, they opted to go with "Oh! Darling" first. As for the openers for each side, they followed Martin's long-held precept about starting with the strongest material, which *Abbey Road* had in spades. Side one began with "Come Together" and "Something"—a one-two punch, if ever there were one—while side two opened with Harrison's "Here Comes the Sun."

But they weren't finished just yet. On the afternoon of August 21, McCartney was back in the Studio 2 control booth, working with Martin and his production team on yet another stab at the crossfade between "You Never Give Me Your Money" and "Sun King." With the transition now in place to his satisfaction, *Abbey Road* was finally put to bed, it seemed, but on August 25, during the very last postproduction session for the album, McCartney requested that the bouncy intro to "Maxwell's Silver Hammer" be edited out. During this same session in the Studio 2 control booth, McCartney supervised the straight edit of some thirty-six seconds of the guitar duel on "The End," trimming the recording to a comparatively economical 2:05. As Martin looked on, Emerick made a copy of the master tape for *Abbey Road* and then transported the master and the copy to Apple Studio on Savile Row. There Emerick transferred the tapes into the custody of Malcolm Davies, the Apple Records mastering engineer. In this, *Abbey Road* marked the first instance in which a Beatles LP hadn't been cut by Harry Moss. As a longtime disc-cutter, Moss was something of an institution at EMI, and his efforts were memorialized by the initials HTM, which he carved into the runout grooves of the numerous records that he mastered over the years. But with Davies, the Beatles' latest LP was in highly skilled hands. An ex-EMI staffer in his own right, Davies was a veritable master of the cutting-room lathe, having worked in the record conglomerate's employ for more than a decade before taking his current job at Apple. In fact it was Emerick who had recommended the veteran disc-cutter for the job. From Emerick's perspective, when it came to the best mastering engineer in London, "Malcolm Davies is your man."[28]

After finishing their studio work, the Beatles busied themselves with print and radio interviews. With the album slated for release at the end of September, they had plenty of time to kill. And plenty

of time for listening sessions too. As Parsons later recalled, "When the album was finished we were listening to a playback, and Tony Hicks of the Hollies came in and joined us, hearing the LP from start to finish. He said to Paul, 'I think this album is every bit as good as *Pepper*,' but Paul disagreed with him. 'No, I don't think it's as good as *Pepper*, but I do like George's song. I think that's the best. "Something" is the best song George has ever written.'" Lennon readily agreed—as did Allen Klein, who lobbied for the release of "Something" backed with "Come Together" as the album's one and only single. For Harrison, the "Something" single was a signal moment in his career. "They blessed me with a couple of B sides in the past," he remarked at the time. "But this is the first time I've had an A-side. Big deal!" Martin felt that *Sgt. Pepper* had been more innovative, although he admitted to being taken with the variety that the new LP offered, remarking, "One side of *Abbey Road* was very much John—let's rock a little, let it all hang out. The other side was Paul—perhaps even symphonic. The segues were my idea, to have a continuous piece of music. Whenever possible, we would design a song that way."[29]

But as the waiting world would soon discover, *Abbey Road* was more than the sum of its parts, far eclipsing the senses of purpose and design that had gone into its creation. In many ways, the LP represented the Beatles reaching greater heights in musicianship, highlighted, as it was, by the sonic warmth and separation afforded by the TG console. As singers, they were now in full flower, as evinced by Lennon's impassioned vocals for "I Want You (She's So Heavy)" and the sheer beauty of McCartney's work on "Golden Slumbers." And then there was their three-part harmony on "Because," which was every bit as magnificent as "This Boy" from their salad days back in 1963. From Lennon and Harrison's innovative guitar work and McCartney's melodic bass and piano

playing through the group's facile deployment of the Moog and Starr's inspired drumming, their musicianship had never been better. There was no finer example of their evolving artistry than the bandmates' exquisite turns on "The End," which not only took on the proportions of an old-time rock and roll revue but also acted as the perfect vehicle for showcasing their musical prowess and bringing the medley to a splendid close.

With *Abbey Road*, the Beatles had sustained, if not amplified, their place as pop music's reigning virtuosos. Come September 26, when the album finally hit the record stores, the world would know it too.

7

Tittenhurst Park

First, the Beatles had a photo session to attend.

On Friday, August 22, scarcely more than thirty hours since they'd departed EMI Studios after having finally put *Abbey Road* to bed, the group reconvened at Tittenhurst Park, Lennon and Ono's estate in rural Sunningdale near Ascot in Berkshire County. Having vacated the Montagu Square apartment in London that they had borrowed from Starr—Jimi Hendrix would move into the flat soon thereafter—the couple had moved into their new home just eleven days earlier. Lennon had purchased the seventy-two-acre property back in May after the sale of Kenwood, his home with ex-wife Cynthia in Weybridge. Even more regal and grandiose than Kenwood, Tittenhurst Park cost £145,000—a pretty penny at the time—and included a twenty-six-room main house, Victorian-era assembly hall, Tudor cottage, chapel, servants' cottages, and assorted other outbuildings amid neatly kept rolling lawns, gardens, and a cricket pitch. Lennon and Ono would soon make Tittenhurst Park their own by installing, outside a living-room window, their mangled Austin Maxi hatchback. There it would serve as a cautionary sculpture, a reminder of the day they nearly lost their lives in Scotland.

Joining the band and Ono were Apple press officer Derek Taylor, ever-faithful Mal Evans, a heavily pregnant Linda McCartney, and Paul's sheepdog Martha. For the occasion, Taylor had invited twenty-three-year-old American photographer Ethan Russell, who had taken photos of the Beatles during the January *Get Back* sessions, and the *Daily Mail*'s popular sports photographer Monte Fresco. Evans also took photos that day, as did Linda, who was a professional photographer, having published her pictures of rock and roll glitterati in *Town and Country* (as she later would in *Rolling Stone*).

For the Beatles, the event at Tittenhurst Park was the latest of a seemingly endless succession of exercises over the years in which they had posed, at times, around bomb craters, in parks and on beaches, on boats and around steamer trunks, and, more recently, walking along the zebra crossing on stately Abbey Road. "It was just a photo session," Starr later recalled. "I wasn't there thinking, 'Okay, this is the last photo session.'" But for Russell, who had already spent hours photographing the band earlier in the year, "the vibe was strange." As the Beatles posed for him that day, Russell could tell that "they were not a happy group"—especially Harrison. "George was just miserable the whole time," Russell later recalled. As usual, the Beatles were stylishly dressed for the occasion. Harrison donned a wide-brimmed cowboy hat in comparison with the prim black felt one atop Lennon's head. While Starr wore a neo-Paisley scarf for the occasion, McCartney preferred the simplicity of a nondescript dark suit, tieless in contrast with the red kerchief around Harrison's neck. They might almost have been a group of tourists who had meandered into a novelty shop, hoping to have themselves photographed while decked out in the apparel, if not the mythology itself, of the Old West.[1]

The session commenced at the main house, with the Beatles posing for pictures beneath the terrace canopy. For the most part, Russell took the lead that day, with Fresco hanging back as their small assemblage moved from one backdrop to another. After leaving the terrace, the Beatles loitered near the weathered statue of Diana, the goddess of the moon and hunting, who seemed to gaze off into the distance, as Russell and Fresco snapped their pictures. A short while later, the Beatles posed with a pair of donkeys from the stables, under a spread of Weeping Blue Atlas cedar trees, near the estate's assembly hall, with its enigmatic stone busts, and among the four terraced cottages that led back to the main house. For a while, the Beatles stood for the photographers in a paddock of tall grass, a cricket pitch that had long ago lost its purpose, overgrown and languishing from neglect. As woolly Martha rested at her master's feet, Linda shot 16mm film footage with Paul's camera. Years later, McCartney would soberly realize that his wife's moving images would be the last footage of the Beatles. Russell and Fresco rounded out the day with several pictures of the Beatles, accompanied by Yoko and Linda, looking over the balcony. In the end, the band posed inside the main house, where they were arrayed around a large wooden table. As Fresco shot the final picture of the day, McCartney and Starr were captured in the act of waving goodbye, rather fittingly, for his camera.[2]

Russell's photographs would eventually come to define the image of the band's later career. As early as February 1970, one of the photos from the *Abbey Road* publicity shoot would adorn the cover for the Capitol Records compilation *Hey Jude*. Still others would be held back by Taylor for the languishing *Get Back* project, which Glyn Johns was still slaving over in hopes of finally winning its release in the new year. He had already compiled two iterations of the LP's mix for the Beatles' consideration, only to see his work

rejected. He was currently at work on a third iteration and still hoping that he could find a way to present a mix that was palatable to Lennon and McCartney. At this juncture, the only formal release of Johns's efforts had been the chart-topping "Get Back" single (backed with "Don't Let Me Down").

To Johns, *Get Back, Don't Let Me Down, and 12 Other Songs* still held considerable promise—and even as a potential successor to *Abbey Road*. With such unreleased gems as "Let It Be" and "The Long and Winding Road," how could it possibly fail? By October, events would turn in Johns's favor after he was summoned to a West End screening by Allen Klein, who had been shoring up the Beatles' affairs with a vengeance since work on *Abbey Road* had wrapped. In attendance were Klein and Michael Lindsay-Hogg, who screened the raw footage from January. For his part, Klein was unimpressed. As Johns later recalled, "Klein decided that there was too much footage involving other people, and it should concentrate more on the four members of the band. So this meant that there was no interaction between the Beatles and anyone else, which, in my opinion, ruined what had been a much more interesting film, but then I *would* say that," he later admitted, "as it was mostly footage of me that was cut." But one thing was resoundingly clear: McCartney's original idea for a *Get Back* documentary was moving forward, which meant that Johns could well emerge as the producer for the accompanying soundtrack release.[3]

Meanwhile, back in the Beatles' camp, things had become decidedly uncertain during the final weeks leading up to the release of *Abbey Road*. Lennon and Ono were seemingly at a crossroads with their heroin addiction. Shortly before moving to Tittenhurst, a chauffeur witnessed their malaise in all of its awful reality at their Montagu Square flat, recalling that "they were doing heroin and other drugs and neither of them knew whether it was day or

night. The floor was littered with rubbish." After the conclusion of the photo session at Tittenhurst Park, the couple had resolved to kick the habit once and for all. Ono sought out the help of Dan Richter, her supplier, and his wife Jill, who joined John and Yoko at Tittenhurst Park on Monday, August 25. "We were very square people in a way," said Ono. "We wouldn't kick in a hospital because we wouldn't let anybody know. We just went straight cold turkey. The thing is, because we never injected, I don't think we were sort of—well, we were hooked, but I don't think it was a great amount. Still, it was hard. Cold turkey is always hard."[4]

In an effort to memorialize his experience trying to shake his heroin addiction—at one point, he reportedly ordered Ono to tie him to a chair—Lennon composed "Cold Turkey," a song that illustrated the excruciating throes of heroin withdrawal: "My feet are so heavy / So is my head / I wish I was a baby / I wish I was dead." Within days, he played a demo of "Cold Turkey" for Bob Dylan's consideration, hoping that the American singer-songwriter would play piano on the song. The day after Dylan's appearance at the Isle of Wight Festival, he accompanied Harrison on a visit to Tittenhurst Park. As Lennon later recalled, "I was just trying again to put him on piano for 'Cold Turkey' to make a rough take, but his wife was pregnant or something and they left." By this point, Lennon's attempt to go cold turkey had apparently stalled, mere days after the Richters had come to Tittenhurst Park. Years later, Lennon remembered that he and Dylan "were both in shades and both on fucking junk. And all these freaks around us, and Ginsberg, and all those people. I was nervous as shit."[5]

A few days later, Lennon duly proposed "Cold Turkey" as the next Beatles' single, only to be soundly rebuffed. At the time, he shrugged this off as a simple matter of timing. "I offered 'Cold Turkey' to the Beatles, but they weren't ready to record a single," he

remarked during an October interview. "When I wrote it, I went to the other three Beatles and said, 'Hey, lads, I think I've written a new single.' But they all said, 'Ummmm . . . arrrr . . . well,' because it was going to be my project, and so I thought, 'Bugger you, I'll put it out myself.' So I did it as the Plastic Ono Band. I don't care what it goes out as, as long as it goes out." But the more Lennon considered the situation, the more he seethed about the state of affairs in which his desire to record "Cold Turkey"—a highly personal and confessional composition—was so easily dismissed by the other Beatles as the basis for a group project. McCartney and Harrison felt that the song—both in terms of its sound and its meaning—fell outside of the Beatles' style. But Lennon wasn't having it. "On half of the tracks on *Abbey Road*, I'm not even on them," he pointed out. "I'm not even on half of the tracks on the double album. Even way back then, sometimes there might only be two Beatles on a track. It's got to the situation where if you have the name 'Beatles' on it, it sells. So you got to think, 'What are we selling?' Do they buy it because it's worth it, or just because it says 'Beatles'?"[6]

Lennon was determined to find out. On September 11 he returned to EMI Studios to revisit "What's the New Mary Jane?," an unused track from the *White Album* sessions. With Malcolm Davies sitting in the producer's chair in Studio 3 and assisted by Tony Clark and Chris Blair, Lennon carried out three remixes of the madcap, experimental song, which had been recorded back on August 14, 1968, and had featured Lennon on piano and vocals, Harrison on acoustic guitar, Ono on percussion, and Mal Evans playing the handbell and providing assorted sound effects. While the other Beatles had perceived the song as a trifle, Lennon hadn't been able to get it out of his head. "That was me, Yoko, and George sitting on the floor at EMI fooling around. Pretty good, huh?"

he remarked at the time. Suddenly hell-bent on releasing it as a Plastic Ono Band single, Lennon dispatched Davies to create an acetate of "What's the New Mary Jane?" back at Apple so that he could ponder his next move.[7]

But before he could take the concept any further, Lennon was the beneficiary of an unexpected opportunity. The day after the "What's the New Mary Jane?" remixing session, providence made itself known to Lennon in the form of a phone call. As he later recalled, "It was late, about 11 o'clock one Friday night, I was in my office at Apple, when we got a phone call from this guy saying, 'Come to Toronto.' They really were inviting us as King and Queen to preside over the concert and not to play. But I didn't hear that part, and I said, 'Okay. Okay. Just give me time to get a band together.' So I thought, 'Who could I get to come and play with me?' So it all happened like that. We left the next morning." What had begun as an invitation for John and Yoko to preside over the one-day Toronto Rock 'n' Roll Revival Festival, scheduled for Saturday, September 13 at the University of Toronto's Varsity Stadium, had just as quickly morphed into the Plastic Ono Band's inaugural live performance. The festival featured a host of rock and roll greats, including Chuck Berry, Jerry Lee Lewis, Gene Vincent, and Little Richard, with the Doors closing out the event as the headlining act. At Lennon's instruction, Evans hastily rounded up a backing band for Lennon and Ono, which included Eric Clapton on lead guitar, Beatles intimate and Manfred Mann bassist Klaus Voormann, and drummer Alan White. Before settling on Clapton, Lennon had invited Harrison, who declined to join his mate on his spur-of-the-moment North American adventure, feeling that the Plastic Ono Band concept was too "avant-garde" for his taste.[8]

While Lennon was thrilled with the opportunity to play live again, he was simultaneously overcome with dread at the thought

of performing in front of twenty thousand people. By the time they arrived in Toronto, the hastily organized band had just enough time to make a single pass through their set backstage at the Varsity Stadium. Worse yet for Lennon, his heroin addiction had returned with a vengeance. He later recalled being "full of junk": "I just threw up for hours till I went on. I nearly threw up in 'Cold Turkey,'" he added. "And I was throwing up nearly in the number. I could hardly sing any of them. I was full of shit." But Lennon was still energized by the performance. "The buzz was incredible," he said at the time. "I never felt so good in my life. Everybody was with us and leaping up and down doing the peace sign, because they knew most of the numbers anyway." Quite naturally, the Plastic Ono Band's set list included a bevy of cover versions—songs like "Blue Suede Shoes," "Money (That's What I Want)," and "Dizzy Miss Lizzy." In addition to playing "Give Peace a Chance" and the Beatles' "Yer Blues," the group performed "Cold Turkey," which "we'd never done before," said Lennon, "and they dug it like mad." For Lennon, "Cold Turkey" was still so fresh that he didn't even know all of the words. Ono resorted to holding a clipboard in front of her husband so that he could belt out the lyrics.[9]

To Clapton, the concert had been great fun, but in truth it was nothing more than "a glorified jam session." The real story that day had occurred on the plane ride across the Atlantic, when Lennon, Clapton, and the others had congregated in the galley in a breakneck effort to put together their set. As Clapton later recalled, "We picked out chords on the guitar, which you couldn't hear because we had nowhere to plug in, and, of course, Alan didn't have his drums on the plane with him." Without ready access to another fix, Lennon and Clapton were both struggling with bouts of nausea. At some point during the flight, Lennon confided to his makeshift bandmates that he intended to quit the Beatles—and soon. He even

went so far as to ask them to join him in forming a new group. For his part, Clapton didn't take his friend's invitation too seriously, chalking his revelation up to heroin and nerves. Having flown into Toronto in support of his client, Klein was unhappy to discover that Lennon had divulged plans about leaving the group. Klein was in the throes of high-stakes negotiations with Capitol Records, EMI's American subsidiary, to establish a new royalty deal for the Beatles. As North America was easily the Fab Four's most lucrative marketplace, a new long-term agreement with Capitol was a crucial part of Klein's strategy to improve and secure the Beatles' financial position. Not surprisingly, Klein admonished Lennon to cease any further talk about disbandment—at least until he had landed the Capitol deal.[10]

For the next week, Lennon struggled with his feelings. On the one hand, he was restless and believed he was ready to forge a new identity for himself and Ono beyond the long shadow of the Beatles. But on the other, he was fully cognizant of the stakes involved with breaking up the group. They were the biggest act in the world, after all, not to mention the vehicle for realizing his vision. He had founded the band, had sweat blood over their success, and, although he would often wax sardonic about the Beatles' work, he was damned proud of it. While he would occasionally question their level of achievement with the *Abbey Road* LP, he could just as easily be the album's most fervent cheerleader. In mid-July, having emerged from his heroin-induced stupor, he was overwhelmed by his enthusiasm for their project, remarking to the press, "I tell you this next Beatles album is really something. So tell the armchair people to hold their tongues and wait. Just shut up and listen!" During the week after his return from Toronto, Lennon struggled over whether to tell the other Beatles about his inclination to leave the band. "It was not an easy decision," his assistant Anthony

Fawcett later recalled. "I watched him agonize for days over it—irritable, chain-smoking, and impossible to be around, skulking in his bedroom, losing himself in sleep or drugging himself with television."[11]

By Saturday, September 20, Lennon could simply no longer contain himself. With Klein, Ono, and Mal Evans present, the Beatles—sans Harrison, who was visiting his ailing mother, who had been diagnosed with cancer, in Liverpool—assembled at their Savile Row office building to discuss the new agreement with Capitol. With Harrison tapped into the meeting via an open phone line, McCartney ruminated over upcoming opportunities for the group, including playing a series of small gigs and even a potential television special. At each turn, Lennon said, "No, no, no," before telling him, "Well, I think you're daft." And that's when Lennon blurted out that he wanted a "divorce." "What do you mean?" a stunned McCartney asked. "The group's over," Lennon replied. "I'm leaving." At this point, McCartney recalled, "Everyone blanched except John, who colored a little, and said, 'It's rather exciting. It's like I remember telling Cynthia I wanted a divorce.'" For his part, Klein quickly intervened, repeating his admonition about maintaining absolute secrecy about the group's immediate plans, lest the Capitol deal be lost. Lennon acquiesced, later remarking, "Paul and Allen said they were glad that I wasn't going to announce it, like I was going to make an event out of it. I don't know whether Paul said, 'Don't tell anybody,' but he was damned pleased that I wasn't. He said, 'Oh well, that means nothing really happened if you're not going to say anything.'"[12]

While Lennon had made his intentions clear, the others—Harrison, in particular—attributed his words to a moment of unchecked grandstanding. Lennon had been unpredictable for months at this point, and besides, "Everybody had tried to leave" the group at

some point, "so it was nothing new." But to Lennon, "they knew it was for real," even though he shortly gave an interview to *Melody Maker*'s Richard Williams in which he speculated positively about the Beatles' future, commenting that "the trouble is we've got too much material. Now that George is writing a lot, we could put out a double-album every month, but they're so difficult to produce. After *Get Back* is released in January, we'll probably go back into the studio and record another one. It's just a shame that we can't get more albums out faster."[13]

Perhaps Lennon was merely playacting with Williams to preserve the myth of Beatles' unity for the sake of McCartney and Klein and to avoid jeopardizing the new Capitol agreement. Perhaps the ups and downs of his heroin addiction were getting the best of him again. After all, this was the same person who had arrived at a business meeting in May 1968 and announced—in a hallucinogenic-induced haze—that he was Jesus Christ. Or perhaps he was just as flummoxed as he had been prior to the September 20 meeting and didn't really know what he wanted. But Mal Evans knew better, having been with the group since August 1963, when manager Brian Epstein hired the former Cavern Club bouncer to be the band's roadie. Along with Neil Aspinall, Evans had been at the core of the group's inner circle, having traveled the globe with them in close quarters. And the September 20 meeting had shaken him to the core. Like Harrison, he had reasoned that "all of them had left the group at one time or another, starting with Ringo." But when "John came into the office and said, 'the marriage is over! I want a divorce,' . . . that was the final thing. That's what really got to Paul, you know, because I took Paul home and I ended up in the garden crying my eyes out."[14]

In spite of Evans's fears and sense of certainty, the Beatles fell into a kind of détente, with McCartney and Klein maintaining

their veil of secrecy and Lennon pushing forward with his plans for the Plastic Ono Band. Consumed with the idea of releasing "Cold Turkey" as a single, Lennon hurried into EMI Studios on September 25 to capture the basic track. Just twelve days removed from their performance in Toronto, the Plastic Ono Band's personnel had already shifted. Along with Lennon and Ono, Clapton and Voormann were still on board, but White was no longer involved with the project. For the "Cold Turkey" recording, Lennon found a drummer much closer to home in the form of Starr, who was only too happy to share his talents with Lennon. Of all the Beatles, Ringo had been the least conflicted about the band's malaise. Harrison may have wanted out of the band by this juncture, but he doubted Lennon's resolve. McCartney was still hoping that Lennon was being rash and would eventually see the error of his ways. But Starr felt an overwhelming sense of relief, though at first he'd found the possibility of disbandment "traumatic." Starr sensed that the Beatles had been devolving as a working unit for some time. "On a lot of days, even with all the craziness, it really worked," he reasoned. "But instead of working every day, it worked, say, two days a month. There were still good days because we were still really close friends, and then it would split off again into some madness." After Lennon's bombshell during the September 20 meeting, Starr later recalled, he just wandered home. "I sat in the garden for a while wondering what the hell to do with my life."[15]

For Starr apparently, performing with the latest incarnation of the Plastic Ono Band was as good as any other place to start finding out where his life would take him. And so it was that on September 25, he joined Lennon and his other Plastic Ono bandmates in Studio 3. After working through twenty-six takes of "Cold Turkey," the group managed to capture a version of the song to

Lennon's liking. But within a matter of days, he began to doubt the quality of the EMI recording, and so he hastily regrouped the players on September 28 at Trident, where they managed to perform "Cold Turkey" to his satisfaction. The next day, Lennon and Ono returned to EMI Studios, where they mixed the song for release, with Emerick sitting in the engineer's chair. At the 3:25 mark, "Cold Turkey" entered an extended fade-out in which Lennon moaned and screamed as he simulated the terrifying experience of heroin withdrawal.

Slated for a late October release, "Cold Turkey" was a departure for Lennon in more ways than one. The song was easily his most confessional on record at this point—and possibly *ever*—but it was also the first time that one of his compositions hadn't been credited to "Lennon-McCartney." Attributed to Lennon as the sole composer, "Cold Turkey" marked the end of an era. While it had been years, for the most part, since they had been "playing into each other's nose," writing their groundbreaking songs "eyeball to eyeball," their identity as the songwriters putting words to the Beatles' revolutionary sound had been central to their mystique. But with "Cold Turkey," Lennon had given up the ghost. As it turned out, the timing was remarkably apt. On September 25, the same day Lennon began recording "Cold Turkey" at EMI Studios, the long-standing saga regarding the fate of Northern Songs finally concluded. That day, ATV obtained 54 percent of Northern Songs, making it the principal and controlling shareholder of the Lennon-McCartney catalog. John and Paul had failed in the yearlong quest to own their publishing rights. In October, Lennon and McCartney would sell their stock—Lennon's 644,000 shares and McCartney's 751,000—for a cool £3.5 million. It was an impressive sum, to be sure, but a fraction of the value of their songwriting corpus, which was already the most coveted songbook in pop music history.[16]

While the Fab Four and their intimates may have been on ten-terhooks as far as the group's future was concerned, the wider world beyond the bandmates' inner circle eagerly anticipated the imminent appearance of a new Beatles album. On September 26, *Abbey Road* was released in the UK, where it had already received advance orders of more than 190,000 copies. Stateside, where the LP was released on October 1, *Abbey Road* had earned a gold disc from the Recording Industry Association of America, with more than 500,000 units sold before the record was available in stores. Within three weeks, *Abbey Road* topped the *Billboard* charts, and it held the number one slot for eight straight weeks before battling with *Led Zeppelin II*, the much-anticipated sophomore effort from the world's reigning heavy metal band. The Beatles would quickly wrestle the top spot away from Led Zeppelin and capture three additional weeks atop the US charts. Within two months, *Abbey Road* had sold more than four million copies. By June 1970, Klein would report that the LP had become the biggest-selling album in the Beatles' history, having notched yet another million units by that time.

In later years, music historians would marvel at *Abbey Road*'s performance, especially at how the LP had so quickly superseded the mega-sales of such blockbuster Beatles records as *Sgt. Pepper* and *The White Album*. While there were several naysayers in the press—often objecting to the artificial sound that they perceived, likely inherent in the album's use of the TG console—*Abbey Road* enjoyed critical success. Writing in *Melody Maker*, Chris Welch described the LP as "just a natural born gas, entirely free of pre-tension, deep meanings, or symbolism," adding that "while production is simple compared to past intricacies, it is still extremely sophisticated and inventive." Although he took issue with "Max-well's Silver Hammer" and its corny "cod-1920s jokes," The *Sunday*

Times's Derek Jewell described *Abbey Road* as "refreshingly terse and unpretentious," praising it for reaching even "higher peaks" than *The White Album*. In a *Rolling Stone* review, John Mendelsohn described *Abbey Road* as being "breathtakingly recorded" and declared the huge medley as equal to "the whole of *Sgt. Pepper*." Mendelsohn asserted, "That the Beatles can unify seemingly countless musical fragments and lyrical doodlings into a uniformly wonderful suite, as they've done on side two, seems potent testimony that no, they've far from lost it, and no, they haven't stopped trying. No, on the contrary, they've achieved here the closest thing yet to Beatles freeform, fusing more diverse intriguing musical and lyrical ideas into a piece that amounts to far more than the sum of those ideas."[17]

Reviews such as Mendelsohn's no doubt helped the Beatles' cause, sustaining *Abbey Road* as it entered the charts in the early weeks of October 1969. But fans were clearly hungry for new Beatles music, with more than a year having passed since the November 1968 release of *The White Album*—and only two singles, "Get Back" and "The Ballad of John and Yoko," in the interim. *Abbey Road* may have received an additional, highly unexpected boost on Sunday, October 12, 1969, when "Uncle" Russ Gibb, a popular disc jockey with Detroit's WKNR-FM, received an anonymous tip that Paul McCartney was dead. It wasn't the first time that rumors about McCartney's death had circulated. In the early months of 1967, rumors abounded that McCartney had died in a car accident on a London motorway. More recently, in mid-September 1969, Drake University's student newspaper, in Des Moines, Iowa, had published a story by editor Tim Harper headlined "Is Beatles Paul McCartney Really Dead?" In it Harper addressed a range of clues from recent Beatles LPs that supposedly referenced McCartney's passing, including an ostensible secret message ("Turn me on,

dead man") that could be gleaned by playing the beginning of *The White Album*'s "Revolution 9" backward. Years later, Harper would admit that "a lot of us, because of Vietnam and the so-called Establishment, were ready, willing, and able to believe just about any sort of conspiracy."[18]

By October 10, Apple press officer Derek Taylor addressed the rumors, remarking, "Recently we've been getting a flood of inquiries asking about reports that Paul is dead. We've been getting questions like that for years, of course, but in the past few weeks we've been getting them at the office and home night and day. I'm even getting telephone calls from disc jockeys and others in the United States." That same weekend, Russ Gibb's anonymous call fanned the flames. The rumors spread from Detroit to the nearby University of Michigan campus, and the *Michigan Daily* reported credulously with a range of death clues garnered from *Abbey Road*'s cover art, including the assertion the Beatles were dressed as a funeral procession, with Lennon as the white-coated minister, Starr as the darkly attired undertaker, the denim-clad Harrison as the gravedigger, and the barefoot McCartney, wearing a suit no less, as the corpse. As if the evidence weren't already flimsy enough, some fans took note of the white Volkswagen Beetle on the album cover, observing that its license plate read "28IF," in ostensible reference to McCartney's age. He actually was twenty-seven at the time, but that was of little consequence to amateur detectives as the myth gathered steam and made its way across the States. Obsessive fans studied earlier Beatles albums, over-interpreting bits of ephemera in a desperate effort to get to the heart of the mystery. Some took note of Lennon's ad-libbed "cranberry sauce" in the coda of "Strawberry Fields Forever"—interpreting his words as being "I buried Paul"—and others noted the *Magical Mystery Tour* cover art

featuring McCartney wearing a black carnation in comparison to the red ones worn by his mates.[19]

By October 21, losing his patience, Taylor described the hoax as "a load of rubbish" and declared that "Paul is still very much with us." A few days later, the BBC caught up with McCartney at his Scottish farm, where he had been lying low in recent weeks as the Beatles' situation seemed to be spiraling further out of his control. "Perhaps the rumor started because I haven't been much in the press lately," McCartney reasoned. "I have done enough press for a lifetime, and I don't have anything to say these days. I am happy to be with my family and I will work when I work. I was switched on for ten years and I never switched off. Now I am switching off whenever I can. I would rather be a little less famous these days." At the same time, Capitol Records had registered a clear uptick in Beatles record sales by the end of October. In a November press release, Rocco Catena, Capitol's vice president of national merchandising, predicted, "This is going to be the biggest month in history in terms of Beatles sales." In short order, *Sgt. Pepper* and *Magical Mystery Tour* reentered the *Billboard* charts already topped by *Abbey Road*. Later that month, the "Paul is dead" hoax reached its ridiculous nadir with New York City's WOR hosting a TV special with attorney F. Lee Bailey interrogating witnesses—including Allen Klein, of all people—to solve the mystery of McCartney's possible death once and for all.[20]

With the rumors having reached fever pitch, *Life* magazine dispatched a crew to Scotland to track down McCartney and break the story open. By this point, McCartney was livid. When reporters John Neary and Dorothy Bacon and photographer Robert Graham caught up with the Beatle on his farm, he screamed at them—with Martha barking wildly in the background—and threatened them with trespassing charges until they beat a hasty retreat. Then,

realizing the error of his ways, McCartney hopped in his Land Rover and went to coax the reporters to return, promising a proper interview and photographs for their trouble. "In the end," he later reflected, "I said, 'Well, we'd better play it for all it's worth. It's publicity, isn't it?'" Borrowing the words of Mark Twain, McCartney announced, "'Rumors of my death are greatly exaggerated.' There's nothing more I can do." Lennon couldn't help finding the humor in the saga, commenting at the time, "Paul McCartney couldn't die without the world knowing it. The same as he couldn't get married without the world knowing it. It's impossible—he can't go on holiday without the world knowing it. It's just insanity—but it's a great plug for *Abbey Road*." Meanwhile, in Scotland, McCartney posed for pictures with his wife Linda, who had given birth to daughter Mary in late August.[21]

Life magazine would run a November 7 cover story, with the banner "Paul is still with us" and a photo of the Beatle with his family. Given the hoopla, the issue was almost certain to be a runaway newsstand bestseller, netting even more publicity for the Beatles and generating more record sales. But when they talked with him, the team from *Life* couldn't help noticing that McCartney seemed unusually subdued. Perhaps the rumors had really gotten to him. "Can you spread it around that I am just an ordinary person and want to live in peace?" McCartney asked his visitors, confirming that, "for the record: Paul is not dead." But then he added—perhaps a little too gently for the *Life* crew to fully register the significance of his words—that "the Beatle thing is over."[22]

8

Letting It Be

At the time that the *Life* crew descended on his Scottish farm, McCartney had fallen into a protracted depression. Lennon had remained silent about the Beatles' status, but there had since been an ever more sobering meeting at Apple. The confab most likely occurred in mid-October, as rumors about McCartney's death roiled. With Starr away with his wife for a vacation in Los Angeles, Lennon's assistant Anthony Fawcett recorded the meeting for the drummer. Sitting together at Savile Row, the three Beatles and Neil Aspinall met to see if there might be a compromise position that they could effect in the wake of Lennon's request for a divorce. During the meeting, Lennon proposed that they consider recording a new LP, relegating four tracks for each of the band's three principal songwriters. But, first, Lennon had an issue to address with McCartney—namely, his tendency, as revealed by the *White Album* and *Abbey Road* sessions, to take up valuable album space with compositions that even McCartney found to be lackluster: "It seemed mad for us to put a song on an album that nobody really dug, including the guy who wrote it," he said to Paul, "just because it was going to be popular, 'cause the LP doesn't have to be that. Wouldn't it be better, because we didn't really dig them, you know, for you to do the songs you dug, and 'Ob-La-Di,

Ob-La-Da' and 'Maxwell' to be given to people who like music like that, you know, like Mary [Hopkin] or whoever it is needs a song. Why don't you give them to them? The only time we need anything vaguely near that quality is for a single. For an album we could just do only stuff that we really dug."[1]

At this, McCartney fell into an understandably defensive posture, while Lennon continued with his remarks. Clearly, McCartney's lack of interest in recording "Cold Turkey" still pained him. In short, Lennon was playing for equal time with McCartney:

> If you look back on the Beatles albums, good or bad or whatever you think of 'em, you'll find that most times if anybody has got extra time it's you! For no other reason than you worked it like that. Now when we get into a studio, I don't want to go through games with you to get space on the album, you know. I don't want to go through a little maneuvering or whatever level it's on. I gave up fighting for an A-side or fighting for time. I just thought, "well, I'm content to put 'Walrus' ["I Am the Walrus"] on the B-side [of "Hello, Goodbye"] when I think it's much better." . . . I didn't have the energy or the nervous type of thing to push it, you know. So I relaxed a bit—nobody else relaxed, you didn't relax in that way. So gradually, I was submerging.

McCartney already knew Lennon's concerns. Lennon had been openly talking about this, especially in September, when the bandmates conducted interviews with the music press in advance of the *Abbey Road* release. At times, his remarks were cutting: "The Beatles can go on appealing to a wide audience as long as they make albums like *Abbey Road*, which have nice little folk songs like 'Maxwell's Silver Hammer' for the grannies to dig." At the same time, he also criticized the notion of pop albums as art or high-concept productions. "An album to me is a bunch of records that you can't have. I like singles myself. I think Paul has conceptions of albums, or attempts it, like he conceived the medley thing. I'm

not interested in conceptions of albums. All I'm interested in is the sound. I like it to be whatever happens. I'm not interested in making the album into a show. For me, I'd just put 14 rock songs on."[2]

During the October meeting at Savile Row, McCartney's cautious posture turned to anger. Coming to his own defense, he protested that he had "tried to allow space on albums for John's songs, only to find that John hadn't written any"—evincing the days of the *Get Back* sessions when heroin had rendered Lennon incapable of producing new material. But "there was no point in turning 'em out," said Lennon. "I couldn't, didn't have the energy to turn 'em out and get 'em on as well." In the future, he added, "When we get in the studio, I don't care how we do it, but I don't want to think about equal time. I just want it known I'm allowed to put four songs on the album, whatever happens."[3]

Having made his case, Lennon expanded his argument to include Harrison. In retrospect, that may have been an error, given the Quiet Beatle's long-established discomfort with his status as junior songwriter in the band. "We always carved the singles up between us," Lennon said to Paul. "We have the singles market, [George and Ringo] don't get anything! I mean, we've never offered George B-sides; we could have given him a lot of B-sides, but because we were two people you had the A-side, and I had the B-side." At this point, as the recording reveals, the discussion took an odd turn, as the three Beatles began to openly assess the quality of Harrison's work. "Well the thing is," McCartney answered, "I think that until now, until this year, our songs have been better than George's. Now this year his songs are at least as good as ours."[4]

Instead of accepting the compliment, Harrison quickly intervened, stating, "Now that's a myth, 'cause most of the songs this year I wrote about last year or the year before, anyway. Maybe

now I just don't care whether you are going to like them or not, I just do 'em. . . . If I didn't get a break, I wouldn't push it. I'd just forget about it. Now for the last two years, at any rate, I've pushed it a bit more." Quickly coming to his mate's defense, Lennon observed, "I know what he's saying, 'cause people have said to me you're coming through a lot stronger now than you had." Then the meeting turned from an effort at conciliation to Harrison's long-standing discontent with the band's political—and economic—calculus. "I don't particularly seek acclaim," Harrison countered. "That's not the thing. It's just to get out whatever is there to make way for whatever else is there. You know, 'cause it's only to get 'em out, and also I might as well make a bit of money, seeing as I'm spending as much as the rest of you, and I don't earn as much as the rest of you!"[5]

For Harrison, inequities had been baked into the Beatles' fortunes—via the Northern Songs deal that Brian Epstein had concocted with music publisher Dick James back in 1963. But Harrison's concerns didn't stop there. "Most of my tunes," he said, "I never had the Beatles backing me." For Lennon, this was too far. "Oh, c'mon, George!" he exclaimed. "We put a lot of work in your songs, even down to 'Don't Bother Me'; we spent a lot of time doing all that and we grooved. I can remember the riff you were playing, and in the last two years there was a period where you went Indian and we weren't needed!" At this, Harrison went a step further, admitting that he had grown indifferent to what he had perceived to be Lennon's and McCartney's lack of interest in performing on his songs. "That was only one tune," said Harrison. "On the last album [*White Album*], I don't think you appeared on any of my songs—I don't mind." To this, all Lennon could offer was a riposte, his voice beginning to betray his hurt feelings: "Well, you had Eric [Clapton], or somebody like that."[6]

At this point, the Beatles' meeting fell into a pained silence, as each of the bandmates contemplated how they might chart a path forward together, even as their creative interests seemed to be growing apart. McCartney finally broke the silence, speaking in a near-whisper: "When we get in a studio, even on the worst day, I'm still playing bass, Ringo's still drumming, and we're still there, you know." With Harrison's apathy on full display—and McCartney seemingly uncomfortable with the notion of dividing up the songwriting spoils as Lennon had suggested—their impasse appeared to be even more formidable than they had experienced during the meeting on September 20. It had become clear that McCartney wanted the Beatles' working relationship to continue as always, in contrast with Harrison, who had become emotionally withdrawn from the band's internal politics. With the idea of recording an album seemingly off the table, Lennon suggested that they produce a Christmas single instead. After all, he reasoned, their annual holiday fan club record would be due before long. When this was met with silence and indifference, Lennon soberly concluded, "I guess that's the end of the Beatles."[7]

It was abundantly clear to Lennon, McCartney, and Harrison: their impasse had evolved into a full-blown standoff, and nobody was willing to give an inch. With a hint of finality, they went their separate ways. Lennon then turned his attentions back to "Cold Turkey," which was released just days later, backed with Ono's "Don't Worry, Kyoko (Mummy's Only Looking for a Hand in the Snow)," on October 24. As a cheeky reference to the A-side's bone-crunching guitar sound, the Apple record sleeve prominently featured the words "PLAY LOUD." Incredibly, given the song's dark, illicit subject matter, by November 15, "Cold Turkey" rose to number fourteen in the UK, where it held steady for a time. The single

fared less successfully in the States, where it topped out at number thirty.

Consumed, perhaps, by the fortunes of the Plastic Ono Band in the wake of the mega-selling *Abbey Road* and the ongoing Beatles drama, Lennon kept careful watch over the single's commercial progress. In the UK, "Cold Turkey" was soon banned by the BBC for its overt drug references. Lennon was bemused by the decision, commenting at the time, "It's like banning *The Man with the Golden Arm* because it showed Frank Sinatra suffering from drug withdrawal. To ban the record is the same thing. It's like banning the movie. Because it shows reality." This latter aspect was especially important, given his personal (and to this point largely unsuccessful) struggle to kick his habit. For Lennon, "Cold Turkey" was "self-explanatory: the result of experiencing cold turkey—withdrawal from heroin. It was an anti-drug song, if anything." By late November, his frustration had reached its boiling point, and on November 25 he dispatched his chauffeur, Les Anthony, to Buckingham Palace to return his MBE to the Queen. Lennon's medal was accompanied by a note that read, "I am returning this MBE in protest against Britain's involvement in the Nigeria-Biafra thing, against our support of America in Vietnam, and against 'Cold Turkey' slipping down the charts. With love, John Lennon of Bag." As the fall months wore on, Lennon was regularly in the news for his latest escapades with Ono on the global stage—but he managed to sit on the one story that would have turned the world upside down until just before the Christmas holidays, that is, when Ray Connolly visited him in Canada where John and Yoko were staying at the time. Connolly later recalled a giggling Lennon telling him "I've left the Beatles" and then swearing the journalist to absolute silence.[8]

While Lennon was waging his protest and secretly telling friends about the Beatles' breakup, McCartney, as noted, had descended into depression. The October meeting had felt like the end of their partnership—although, as with the September 20 contretemps, there was still wiggle room. Nothing had been made public, and Klein had sewn up the Capitol deal in the Beatles' favor, but McCartney sleepwalked through the days with the near-certainty of the Beatles' disbandment gnawing at him. As Paul and Linda prepared to make the long trip up to their Scottish retreat, Klein invited the couple to attend a screening of Lindsay-Hogg's *Get Back* footage, and they attended along with Harrison and Starr and their wives. In the months since he had first shared footage with Klein, Lindsay-Hogg had tidied up the documentary, focusing almost exclusively on the Beatles, as the manager had requested. After the latest screening had concluded, Klein wasted little time in selling the bandmates on the idea of releasing Lindsay-Hogg's documentary in the new year—along with a soundtrack album—in order to fulfill their outstanding contract with United Artists. Given that the "Get Back" single was old news by this time, Klein suggested that they change the name of the film to reflect one of the documentary's other standout cuts. *The Long and Winding Road* received strong consideration, but the Beatles settled on *Let It Be.* Before they went their separate ways that evening, Klein mentioned that he had recently met with Phil Spector in New York, and the celebrated American producer was interested in working with the Beatles. According to Klein, Lennon had already agreed to Spector's involvement in the soundtrack LP. While McCartney may not have been sold on the idea yet, he readily agreed to meet with Spector to discuss the project further.

With the group having fallen into a kind of limbo, Paul and Linda left London in early November for Scotland. There McCartney was

left to his own devices, and—save for the incursion of the *Life* reporters—the world was held at bay. And it was there that he realized how desperate he'd become. As McCartney later observed:

> I was going through a hard period. I exhibited all the classic symptoms of the unemployed, the redundant man. First, you don't shave, and it's not to grow a groovy beard, it's because you cannot be fucking bothered. Anger, deep deep anger sets in, with everything, with yourself number one, and with everything in the world number two. And justifiably so because I was being screwed by my mates. So I didn't shave for quite a while. I didn't get up. Mornings weren't for getting up. I might get up and stay on the bed a bit and not know where to go, and get back into bed. Then if I did get up, I'd have a drink. Straight out of bed. I've never been like that. There are lots of people who've been through worse things than that, but for me this was bad news because I'd always been the kind of guy who could really pull himself together and think, "Oh, fuck it," but at that time I felt I'd outlived my usefulness.

For McCartney, no longer being in the Beatles meant that his creative outlet had seemingly been taken away. He would later recall, "It was good while I was in the Beatles, I was useful, and I could play bass for their songs, I could write songs for them to sing and for me to sing, and we could make records of them. But the minute I wasn't with the Beatles anymore, it became really very difficult."[9]

After experiencing many dark nights of the soul, McCartney turned it around during the Christmas holidays, when he made his return home to Cavendish Avenue. He engineered his emergence from depression via the only means that truly mattered to him: he was going to record an album of his own. On December 26—the two-year anniversary of the *Magical Mystery Tour* television debacle—he had a Studer four-track recorder installed at home. He began work immediately, even though he lacked the VU (volume unit) meters and mixing desk that he was used to deploying only

a few blocks away at EMI Studios. Save for a few folks at Apple and EMI, nobody knew that McCartney was going it alone with Linda, which was exactly how he wanted things—at least for a time. "We decided we didn't want to tell anybody what we were doing," he explained a few months later during an interview with *Rolling Stone.* "That way it gets to be like home at the studio. No one knows about it, and there is no one in the studio or dropping by." Paul and Linda would snack on sandwiches and grape juice, while baby Mary crawled on the floor and Heather busied herself with toys. "I was feeling quite comfortable, the more I went on like this," McCartney later recalled. "I could actually do something again."[10]

Up first was "The Lovely Linda," a song he had composed in Scotland. By the new year, he was making steady progress. With Linda on harmonies, McCartney overdubbed all of the instruments himself. In many ways, his new music was very similar to a number of tracks on *The White Album* on which he'd performed most of the instrumentation, and the music took on a homespun, organic feel. With "The Lovely Linda" finished, McCartney captured a spate of new songs in short order, including another Scottish composition, "That Would Be Something," and an instrumental, "Valentine's Day," that he had ad-libbed. For "That Would Be Something," McCartney provided vocals, acoustic and electric guitars, bass, and drums.

On Saturday, January 3, 1970, McCartney returned to EMI Studios for the first time in months. As Klein had pointed out in November, the Beatles were contractually bound to release a soundtrack album in tandem with the United Artists documentary. On this day, McCartney, Harrison, and Starr convened in Studio 2 with Martin, who was celebrating his forty-fourth birthday. Lennon was absent, having gone on a long vacation with Ono to Denmark. For the Beatles and their producer, the tasks at hand

were completing "I Me Mine," a Harrison composition featured prominently in the *Let It Be* documentary, and "Let It Be," which had emerged as the title track and was already slated for release as a single in March. As they prepared to record "I Me Mine," Harrison acknowledged Lennon's absence with a wry reference to the popular British band Dave Dee, Dozy, Beaky, Mick, and Tich: "You all will have read that Dave Dee is no longer with us, but Mickey and Tich and I have decided to carry on the good work that's always gone down in Number 2." Recorded in sixteen takes, the basic rhythm track featured Harrison's acoustic guitar and guide vocal, McCartney's bass, and Starr's drums. At one point, the trio broke into an instrumental jam that morphed into Buddy Holly's "Peggy Sue Got Married." After selecting Take 16 of "I Me Mine" as the best, the group recorded electric guitar, electric piano, and lead and harmony vocal overdubs to complete recording of the relatively short song, which clocked in at 1:34.[11]

The next day, January 4, the Beatles' trio reconvened in Studio 2 to complete work on "Let It Be." With Phil McDonald and Richard Langham assisting, Martin conducted a nearly fourteen-hour session in which Harrison overdubbed a new lead guitar solo for the song. Harrison, McCartney, and Linda McCartney would later add new harmonizing vocals to the Beatles' January 31, 1969, performance of the song. To polish "Let It Be," Martin added an overdub involving two trumpets, two trombones, and a tenor saxophone. As the night wore on, he carried out additional overdubs with percussion from Starr and McCartney, along with another, still more sizzling guitar solo from Harrison. As the trio wrapped up work on the song, Glyn Johns waited in the wings to gather up the latest additions to his wayward project. Working at Olympic the next day, he concocted a third and final attempt at mixing the *Get Back* sessions into a cohesive whole to comprise the *Let It Be* soundtrack album.

A few weeks later, as McCartney threw himself into his solo album, Lennon and Ono returned from their vacation. Before leaving Denmark, the couple had dispatched a postcard to the McCartneys (comically addressed to them in "Grate Briton"). To his estranged mate, Lennon tenderly scrawled "we love you and will see you soon." As with McCartney, Lennon was suddenly eager to get back to work. Working "on heat," Lennon had recently composed "Instant Karma!," his homage to the concept that he, like Paul, had gleaned from the lectures of Maharishi Mahesh Yogi in Rishikesh. In contrast with McCartney— whose "Maxwell's Silver Hammer" required several days over a period of months to realize—Lennon was determined to treat the recording of "Instant Karma!" as a genuine act of spontaneity. Over the years that would follow, he liked to say that he "wrote it for breakfast, recorded it for lunch," and was "putting it out for dinner." While his words were hyperbolic, they weren't that far off the mark, with "Instant Karma!" enjoying a ten-day turnaround from ideation to completion.

Recorded at EMI on January 27, "Instant Karma!" was supervised by Spector, who had joined the production team earlier that day. Lennon had invited Harrison to play guitar on "Instant Karma!," only to discover that the Quiet Beatle was meeting with Spector in London to discuss Harrison's new solo project. Not missing a beat, Lennon had invited them to join him at EMI, where he had also assembled Klaus Voormann on bass, Billy Preston on organ, and Alan White on drums. Lennon rounded out "Instant Karma!" with his lead vocals and electric guitar and piano, along with Ono on backing vocals and Mal Evans providing hand claps and playing the chimes. Recorded in just ten takes, "Instant Karma!" (which gained the subtitle "We All Shine On") was treated to Spector's signature "wall of sound" that the producer effected by relaying the signal through the studio's echo chamber. For White's drums, Spector overloaded the

echo even further, creating a unique slapping sound that afforded Lennon's song with a distinctive texture. "Instant Karma! (We All Shine On)" was released on February 2 and landed in the Top 5 on the UK charts shortly thereafter.[12]

Just a few blocks away on Cavendish Avenue, McCartney continued working on his secret project. By early February, he had completed several additional songs, including the instrumental "Momma Miss America" and the hard-edged guitar fusion "Oo You." A few weeks later, McCartney left St. John's Wood with his Studer recordings for the first time, venturing to Morgan Studios in the North West London suburb of Willesden. Having exhausted his four-track recorder's capabilities, McCartney was forced to transfer his songs to eight-track tape to create more space for overdubs. To maintain secrecy, he booked his Morgan Studios session as "Billy Martin." During that same visit, he recorded "Hot as Sun," yet another instrumental, and "Kreen-Akrore," a percussion tour de force. As the month wore on, he recorded additional tracks at Cavendish Avenue, including a pair of one-time Beatles songs, "Junk" and "Teddy Boy." A companion instrumental piece to the former song, "Singalong Junk," was recorded shortly thereafter.

On February 21, McCartney shifted his production to the familiar confines of EMI Studios, where he recorded yet another one-time Beatles song, "Every Night," from the *Get Back* era, before turning to "Maybe I'm Amazed," a fairly new composition. Written as a passionate appreciation for Linda's steadfast support over the preceding challenging months, "Maybe I'm Amazed" was a standout piece of work to McCartney—something special, an instant classic in a similar vein as "Yesterday," or, more recently, "The Long and Winding Road" and "Let It Be." Still working under the name Billy Martin, McCartney recorded the impassioned piano ballad in Studio 2 on February 22. To McCartney, "Maybe I'm Amazed"

held incredible potential. Why waste such distinctive songwriting on the Studer at Cavendish Avenue, when the TG console was available at EMI? Delicately arraying "Maybe I'm Amazed" across the desk's eight-track landscape, McCartney achieved careful separation among his keyboards, including piano and organ, as well as on the low end of his bass and drum parts. In addition to his shimmering lead vocals, McCartney's lead guitar solo seemed to leap out of the mix—as a part of its composer's one-man ensemble yet separate from the tumult of the other instrumentation. Within a few days, he also completed "Man We Was Lonely," which would be the last song recorded for his inaugural solo LP, which he already intended to title *McCartney*. The only thing left, it seemed, was to work with the folks at Apple to confirm an April release date. As with Lennon and "Instant Karma! (We All Shine On)," McCartney was understandably anxious to share his latest music with the world as soon as possible.

That's when the Beatles' vexing interpersonal relations returned with a vengeance. McCartney's inquiries regarding his album's release date unearthed a spate of machinations by his bandmates and Klein, who had taken the reins of Apple and jettisoned a number of employees and hangers-on. To McCartney's chagrin, he learned of a logjam of forthcoming Apple LP releases—and his eponymous solo album was being delayed without consulting him. Up first was Starr's *Sentimental Journey* album, which had been slated for an April release—the same month in which McCartney planned to unveil his own debut solo record. Starr had approached Martin to produce *Sentimental Journey*, for which he planned to record a raft of old favorites and nostalgic throwbacks. As Martin recalled, "Ringo decided to sing an album of old songs, and he asked me to produce it. His stepfather Harry, who he regarded as his father, loved old songs, and Ringo, sentimentally,

wanted to make an album to please him." But it was more than that, as Starr later admitted. "I was lost for a little while. Suddenly, the gig's finished that I'd been really involved in for eight years." To bring the project off, Starr settled on a roster of album cuts with his mother Elsie back in Liverpool. Martin's plan for Starr's album of standards was a different arranger for each song and the George Martin Orchestra as accompaniment.[13]

In March 1970, as Martin conducted his orchestra while Starr filmed a promotional video for his new album at London's Talk of the Town nightclub, the erstwhile Beatles producer received an urgent phone call from McCartney, who was livid. He later recalled: "Paul rang me up one day and said, 'Do you know what's happened? John's taken all of the tapes.'" McCartney told Martin that John had given the *Get Back* tapes to Spector, who had never met with McCartney to discuss working for the Beatles. Worse, he told Martin, he had learned that his release date for the *McCartney* LP had been delayed to avoid glutting the market with two Beatles solo albums and the *Let It Be* soundtrack in a matter of weeks. By this point, McCartney soon learned, the soundtrack album was in an advanced state of production—even down to the cover art. That same month, Angus McBean's May 1969 EMI House photo of the band had been used as a mock-up for *Let It Be*'s cover art, only to be replaced by Ethan Russell's January 1969 photos of the group in performance.[14]

In an attempt to smooth things, Lennon and Harrison dispatched Starr to St. John's Wood in an attempt to reason with McCartney. But this quickly backfired, as an enraged McCartney began threatening the Beatles' drummer. "I'll finish you all now," McCartney bellowed. "You'll pay." In a last-ditch effort to find a solution, Starr begged McCartney to consider postponing the release of his solo LP, and McCartney threw him out onto Cavendish

Avenue. With seemingly no other recourse, Starr convinced Lennon and Harrison—and ultimately Klein—that the path of least resistance would be to release *Sentimental Journey* in late March, followed by McCartney's album on April 20, as Paul had originally planned, and finally *Let It Be* in May. "I felt since he was our friend and the date was of such immense significance to him," Starr later recalled, "we should let him have his own way."[15]

Until he had received McCartney's call, Martin too had been blissfully unaware of Spector's professional involvement on the Beatles' behalf. McCartney and Martin would soon realize the extent of the deception. Later that month, Spector was given access to the *Get Back* tapes at EMI Studios, where he cloistered himself away, often in room 4, working on remixing the songs slated for the *Let It Be* soundtrack. Martin could understand Spector's motives in jumping at the opportunity to work with the Beatles in spite of the group's current disarray. "Spector is the kind of person who was in the doldrums for a long time," Martin observed. "He made a tremendous name for himself many years ago as a producer with a particular sound. I mean, he became an original, and a characteristic of his sound was that of a big, spacious work, you know, enormous, putting everything but the kitchen sink in, and which worked frightfully well." It worked well, that is, with hitmakers like the Ronettes and the Righteous Brothers. Spector's postproduction work with *Let It Be* culminated in a massive overdubbing session in Studio 1 on April 1 for "The Long and Winding Road" and "Across the Universe," with orchestration provided by Richard Hewson. During the session, Spector applied his famous echo-laden "wall of sound" technique. In the case of "The Long and Winding Road," Spector overdubbed a thirty-three-piece orchestra, a fourteen-member choir, two studio musicians on guitar, and one drummer—Starr, the last Beatle to join the band and the

last to play on a Beatles session. At one point, Starr had to step away from his drum kit to quell one of Spector's notorious temper tantrums.[16]

That's when things got even worse. No longer in the dark about the soundtrack's production, McCartney and Martin received acetates for their review from Apple's Malcolm Davies. McCartney was dumbfounded by Spector's postproduction work on "The Long and Winding Road." "I couldn't believe it," he told Ray Connolly during an interview for the *London Evening Standard*. He was especially perturbed that Spector had tampered with his music by superimposing "harps, horns, an orchestra, and women's choir." Subsequently, at one point, McCartney unsuccessfully attempted to block the album's release. As his ire peaked, McCartney penned an acidic letter to the Beatles' manager with the unsubtle salutation, "Dear Fuck Klein." Martin was particularly incensed with Lennon, who had long championed the notion of releasing *Get Back* as an intentionally crude, "warts and all" production. Infuriated by the results of Spector's intervention, Martin later observed, "Through Allen Klein, John had engaged Phil Spector and done everything that he told me I couldn't do: he overdubbed voices, he added choirs and orchestras. I could have done that job easily, but he decided to do it that way, and I was very offended by that." Martin felt that Glyn Johns had received particularly unfair treatment. In a mere six sessions, Spector had put the soundtrack LP to bed. Thus was the album that Johns, often with Martin's production assistance, had toiled over for months on end. As Johns later wrote, "After the group broke up, John gave the tapes to Phil Spector, who puked all over them, turning the album into the most syrupy load of bullshit I have ever heard."[17]

Lennon never showed any misgivings about Spector's postproduction work on behalf of the *Let It Be* soundtrack, vehemently

defending Spector's efforts on the disintegrating band's be-half later that year during an interview with *Rolling Stone*'s Jann Wenner. Spector had "worked like a pig on it," Lennon recalled. "He'd always wanted to work with the Beatles, and he was given the *shittiest* load of badly recorded shit—and with a lousy feeling to it . . . and he made *something* out of it." For Martin and Johns, the soundtrack album's liner notes would prove to be especially unset-tling, casting *Let It Be* as "a new phase Beatles album. Essential to the content of the film *Let It Be* was that they performed live for many of the tracks; in comes the warmth and the freshness of a live performance as reproduced for disc by Phil Spector." Martin was disgusted, later remarking that "the album credit reads 'Produced by Phil Spector,' but I wanted it changed to 'Produced by George Martin. Overproduced by Phil Spector.'" For his part, Spector—never one to curb his vitriol—remarked at the time, "They don't know that it was no favor to me to give me George Martin's job, because I don't consider myself in the same situation or league. I don't consider him with me. He's somewhere else. He's an ar-ranger, that's all. As far as *Let It Be*, he had left it in a deplorable condition, and it was not satisfactory to any of them, they did not want it out as it was."[18]

With the battle lines drawn and the alliances exposed, a parade of Beatles-related LPs landed in the world's record stores. Up first was Starr's *Sentimental Journey*, which was released on March 27, complete with a nostalgic cover photo of the Empress pub, lo-cated in Liverpool just a few blocks away from Starr's boyhood home on Admiral Grove. In spite of its throwback subject matter, the album enjoyed strong sales—notching a Top 10 showing in the UK and landing at number twenty-two on *Billboard*'s album charts. But the critics had a field day, with Robert Christgau de-scribing the album in the *Village Voice* as being "for over-50s and

Ringomaniacs." Harrison reacted charitably, calling *Sentimental Journey* "a great album" and "really nice," but Lennon was unable to hold his tongue. In December 1970, he exclaimed to *Rolling Stone* that he was "embarrassed" by Starr's schmaltzy effort.[19]

McCartney's solo debut would follow, as planned, on April 20. McCartney's rage had steadily increased since his clash with Starr in March. Events involving Spector and the shoddy treatment of "The Long and Winding Road," which had clearly occurred with his mates' assent, had left him embittered. On April 9, McCartney decided to take matters into his own hands. While millions of *Life* magazine readers may have overlooked McCartney's seemingly offhanded remark in November that "the Beatle thing is over," his written comments, released to the press inside promotional copies of his solo LP, were unambiguous. As McCartney later recalled, "I had talked to Peter Brown from Apple and asked him what we were going to do about press on the album. I said, 'I really don't feel like doing it, to tell you the truth,' but he told me that we needed to have something. He said, 'I'll give you some questions and you just write out your answers. We'll put it out as a press release.' Well of course, the way it came out looked like it was specially engineered by me." While McCartney may not have engineered the resulting questionnaire, he certainly delighted in the upshot of the "killer scoop" in his press release, which would resound the world over on April 10:

> Q: Is it true that neither Allen Klein nor ABKCO [Klein's company] have been nor will be in any way involved with the production, manufacturing, distribution or promotion of this new album?
>
> A: Not if I can help it.
>
> Q: Did you miss the other Beatles and George Martin? Was there a moment when you thought, "I wish Ringo were here for this break?"

A: No. . . .

Q: Are you planning a new album or single with the Beatles?

A: No. . . .

Q: Is your break with the Beatles temporary or permanent, due to personal differences or musical ones?

A: Personal differences, business differences, musical differences, but most of all because I have a better time with my family. Temporary or permanent? I don't really know.

Q: Do you foresee a time when Lennon-McCartney becomes an active songwriting partnership again?

A: No.

Not surprisingly, McCartney's questionnaire cum press release caused a media firestorm in short order. The *Daily Mirror*—the same British daily that had trumpeted the onset of "BEATLEMA-NIA!" back in October 1963—took full advantage of McCartney's scoop with the April 10 headline, "PAUL IS QUITTING THE BEATLES." McCartney had gone and done the unthinkable. While Lennon had dutifully kept his pronouncements private for nearly seven months, his estranged songwriting partner had gone public.[20]

It was over.

9

Solid State

Now it was Lennon's turn to be livid. After McCartney's stunning admission, Lennon fumed at Ray Connolly at Tittenhurst Park: "Why didn't you write it when I told you in Canada at Christmas?" he exclaimed to the reporter, who reminded the Beatle that he had been sworn to secrecy. "You're the journalist, Connolly, not me," Lennon sneered. A few days later, Lennon reflected on McCartney's announcement in an interview with *Rolling Stone*, saying, "We were all hurt that he didn't tell us what he was going to do," conveniently sidestepping his own subterfuge with Spector. It was McCartney's public relations coup that really got to him. "Jesus Christ!" said Lennon. "He gets all the credit for it! I was a fool not to do what Paul did, which was use it to sell a record." Still, he had to tip his cap to McCartney, later remarking, "He's a good PR man, I mean he's about the best in the world, probably. He really does a job." According to Lennon, McCartney called him on the afternoon of April 10 when the news had already gone viral. "I'm doing what you and Yoko were doing," McCartney told him. "That makes two of us who have accepted it mentally," Lennon replied.[1]

As for the Beatles and Apple, Derek Taylor published one final press release on the matter of the band's future, writing, "Spring is here and Leeds play Chelsea tomorrow and Ringo and John and

George and Paul are alive and well and full of hope. The world is still spinning and so are we and so are you. When the spinning stops—that'll be the time to worry. Not before. Until then, the Beatles are alive and well and the Beat goes on, the Beat goes on." In short order, McCartney's solo debut rose to number two on the UK record charts and topped the *Billboard* chart Stateside, eventually going double-platinum. The LP's reviews were mixed, with a number of critics taking issue with the timing of *McCartney*'s release vis-à-vis the Beatles' disbandment. In his *Rolling Stone* review, Langdon Winner described the album as "distinctly second rate" in comparison to McCartney's work with the Fab Four. "If one can accept the album in its own terms, *McCartney* stands as a very good, although not astounding, piece of work," Winner wrote, concluding, "I like *McCartney* very much. But I remember that the people of Troy also liked that wooden horse they wheeled through their gates until they discovered that it was hollow inside and full of hostile warriors."[2]

In *Melody Maker*, Richard Williams cut McCartney to the quick, writing that "with this record, his debt to George Martin becomes increasingly clear" and describing the album's contents as "sheer banality," excepting "Maybe I'm Amazed," which was already a masterwork by fan and critic consensus. In a similar vein, the *Guardian*'s Geoffrey Cannon observed that the LP lacked "substance" and wrote, "Paul reveals himself in it as a man preoccupied with himself, and his own situation. The music is boastfully casual. . . . He seems to believe that anything that comes into his head is worth having. And he's wrong." By contrast, *NME*'s Alan Smith commented that "listening to [*McCartney*] is like hearing a man's personal contentment committed to the sound of music. Most of the sounds, effects, and ideas are sheer brilliance; much of the aura is of quiet songs on a hot summer night; and virtually all of the

tracks reflect a kind of intangible roundness. 'Excitement' is not a word to use for this album, [but] 'warmth' and 'happiness' are."[3]

But as with Starr's *Sentimental Journey*, McCartney's solo LP was a mere appetizer for *Let It Be*, which was released three weeks later on May 8. Not surprisingly, the LP proved to be an international bestseller, easily topping the charts in the UK and US. Writing in *NME*, Alan Smith asserted that "if the new Beatles soundtrack is to be their last, then it will stand as a cheapskate epitaph, a cardboard tombstone, a sad and tatty end to a musical fusion which wiped clean and drew again the face of pop." Smith concluded that the album revealed "contempt for the intelligence of today's record-buyer" and derided the bandmates for having "sold out all the principles for which they ever stood." *Rolling Stone*'s John Mendelsohn was equally acerbic, writing that "musically, boys, you passed the audition. In terms of having the judgment to avoid either over-producing yourselves or casting the fate of your get-back statement to the most notorious of all over-producers, you didn't."

Offering a minority opinion among a sea of critical voices, the *Sunday Times*'s Derek Jewell described *Let It Be* as a kind of "last will and testament, from the blackly funereal packaging to the music itself, which sums up so much of what the Beatles as artists have been—unmatchably brilliant at their best, careless and self-indulgent at their least." Writing in the *New York Times*, Craig McGregor didn't mince words in his assessment of the LP. "So the Beatles have broken up," McGregor wrote. "Judging by their latest album, *Let It Be*, it's about time. This is not to denigrate their total achievement: it's a truism that the Beatles have been the most imaginative and most influential of all rock groups. But it seems there comes a time in the progress of any artistic group—whether it be a theater company, a movie cooperative or a rock band— when it reaches some sort of creative impasse and has to decide

whether to rethink its purpose and work out a new direction for itself, or split up."[4]

If nothing else, as more than one critic observed, the *Let It Be* soundtrack surpassed the quality of Lindsay-Hogg's documentary, which had been soundly panned. In the UK, the *Sunday Telegraph*'s review was remarkably prescient, observing that "it is only incidentally that we glimpse anything about their *real* characters—the way in which music now seems to be the only unifying force holding them together, and the way Paul McCartney chatters incessantly even when, it seems, none of the others are listening." In the States, *Time* magazine was decidedly more curt, describing *Let It Be* as a "mildly enjoyable documentary newsreel." In contrast with the earlier Beatles film premieres, in which the Fab Four paraded for the press, none of the principals, save for director Michael Lindsay-Hogg, appeared at the London Pavilion debut on May 20. In spite of all the rancor, *Let It Be* would be remembered fondly during awards season, when the soundtrack took home an Academy Award for "Original Song Score," with Quincy Jones accepting the statuette on the absent bandmates' behalf. As it happened, McCartney would be on hand to accept *Let It Be*'s Grammy Award for Best Original Score.[5]

Both the film and the soundtrack LP were supported by near-constant radio airplay—particularly in the United States, where the Beatles charted two more number one singles. Released on March 6, "Let It Be" featured as its B-side the thirty-four-month-old "You Know My Name (Look Up the Number)," which lent welcome comedy to what would be the Beatles' final UK single. Writing in *NME*, Derek Johnson stated, "As ever with the Beatles, this is a record to stop you dead in your tracks and compel you to listen attentively." Stateside, the single easily notched *Billboard*'s top spot. But alas, in the UK it was simply not to be. The Beatles'

twenty-second and final single would climb no further than number two in their homeland. Two months later, the Beatles' final US single, "The Long and Winding Road" (backed with Harrison's "For You Blue") was released and quickly ascended to the number one spot. Spector's overproduced version of "The Long and Winding Road" netted the Beatles' record-making twentieth number one song in the United States. Praising Spector's work on the song as an elemental study of illusion and nostalgia, Ian MacDonald later observed, "'The Long and Winding Road' was so touching in its fatalistic regret, and so perfect as a downbeat finale to the Beatles' career that it couldn't fail, however badly dressed."[6]

During the whole *Let It Be* saga, only Klein, it seemed, had managed to come out smelling like a rose—a rare thing, indeed, for the gruff American businessman. While the January 1969 *Get Back* sessions had taken their toll on the Beatles' interpersonal relations—and the postproduction had proven to be their undoing—Klein had transformed the dour project into a sizable commercial success. It had yielded three number one singles in "Get Back," "Let It Be," and "The Long and Winding Road," for one thing, along with a best-selling album. In May 1970 alone, Klein was able to claim a $6 million profit for Apple. His negotiations with Capitol and United Artists, moreover, had set up the company and its ownership for yet more financial boons in the longer term. In spite of this, McCartney still refused to sign Klein's management contract—and he never would. As for any larger artistic achievement that *Let It Be* may have portended for the band, the soundtrack could simply never match the abiding quality of its predecessor. As Klein's biographer Fred Goodman astutely wrote, "Coming on the heels of the miraculous ending that was *Abbey Road*, the album and film were a flat and disappointingly inconsequential coda to the age's most brilliant career.

Let It Be could never quite become more than it was: a collection of tapes missing the Beatles' spark."[7]

In the coming months, as Lennon and McCartney settled into their respective corners, Harrison and Starr ventured out into the world—often together. More than a year later, in April 1971, Starr would release the Harrison-produced "It Don't Come Easy," which became a smash hit in the United States and UK alike. In a review in *NME*, Alan Smith praised the song as "undoubtedly one of the best, thumpin'est things the Starr man has ever done." But the single's real treasure may have been the B-side, "Early 1970," in which the drummer contemplated the contours of his post-Beatles life. With a backing band that included Harrison on electric guitar and Voormann on bass, Starr's countrified "Early 1970" served as a "disarming open letter," in the words of Nicholas Schaffner, to the other ex-Beatles. In a February 1970 interview with *Look* magazine, as he put the finishing touches on *Sentimental Journey* with Martin, Starr admitted to a lingering sense of bewilderment over his lost mates. "I keep looking around and thinking where are they? What are they doing? When will they come back and talk to me?" In one of the song's most heartfelt moments, Starr laments the distance that he feels in particular with McCartney:

> Lives on a farm, got plenty of charm, beep, beep
> He's got no cows but he's sure got a whole lotta sheep
> And a brand new wife and a family
> And when he comes to town, I wonder if he'll play with me.[8]

For Harrison, the Beatles' disbandment had been a welcome relief. By May 1970, he was already making significant progress on his next LP. With Spector in the producer's chair, Harrison had been rifling through his vast backlog of material—songs that, in

many cases, had been rejected or simply ignored by the Beatles in the late 1960s. One of those tunes, "All Things Must Pass," had already emerged as the title track for his album. He had rehearsed the song for the other Beatles during the *Get Back* sessions. As with "Here Comes the Sun," the song finds the composer contemplating the place of nature as both a dark and hopeful force in our transitory lives. Loosely based upon The Band's 1968 folk classic "The Weight," "All Things Must Pass" reminds us that "sunrise doesn't last all morning / a cloudburst doesn't last all day" and that, ultimately, in nature, "all things must pass away." As Andrew Grant Jackson surmised, "It's unclear whether Harrison was already yearning for the passing of the Beatles when he composed the song. Still, it must have bemused Harrison how perfectly it fit in the wake of the break-up." As it happened, the Beatles' disbandment wasn't the only rite of passage in Harrison's life. During the production of the eventual *All Things Must Pass* LP, his mother Louise succumbed to cancer at age fifty-nine.[9]

Predictably, Harrison was the most reflective of the Beatles in terms of their disbandment. In later years, Harrison would share a story from the Beatles' *Abbey Road* days as a means for explaining how constricting his place inside the group's framework had come to be. "I used to have an experience when I was a kid which used to frighten me," he would say. "I realized in meditation that I had the same experience, and it's something to do with always feeling really tiny. . . . I used to get that experience a lot when we were doing *Abbey Road*. I'd go into this big empty studio and get into a sound box inside of it and do my meditation inside of there, and I had a couple of indications of that same experience, which I realized was what I had when I was a kid." In May 1970, Harrison consented to an interview with WABC-FM's Howard Smith. During their discussion, Harrison arrived at the heart of the matter: "I got tired of

being in the Beatles," he explained, "because musically it was like being in a bag, and they wouldn't let me out of the bag, which was mainly Paul at the time." Not surprisingly, the immensely talented McCartney—who was also hardworking and, at times by his own admission, controlling to a fault—was also the Beatle whom Harrison had known the longest; indeed, they had met on a Liverpool school bus when Paul was twelve and George was eleven.[10]

Harrison saw his long-standing relationship with McCartney as having been the key to both the success and failure of their professional relationship throughout the Beatles years. As Harrison put it, "It's just a thing like, you know, he'd written all these songs for years and stuff, and Paul and I went to school together. I got the feeling that, you know, everybody changes and sometimes people don't want other people to change, or even if you do change they won't accept that you've changed. And they keep in their mind some other image of you, you know. Gandhi said, 'Create and preserve the image of your choice.' And so different people have different images of their friends or people they see." For his part, Geoff Emerick would underscore this point when asked about the Beatles' breakup, which he attributed to the simple fact that, as they careened toward their thirties, the band members had simply grown apart. "Sadly, inevitably, there was no common ground anymore, only a common history," Emerick wrote.[11]

Harrison wasn't the only member of the Beatles' inner circle to be largely relieved after their disbandment. If Martin felt any sting from McCartney's words in his press release cum questionnaire, he never revealed it, preferring to understand the end of the Beatles in a more philosophical light. Readily admitting that "it's pretty obvious that without the Beatles I wouldn't be where I am," Martin felt momentary sadness after McCartney's April 1970 announcement. "I felt a little bit of emptiness, but on the other hand it was almost

a relief because I had gained my freedom," he later wrote. "I had devoted eight years of my life to them; they were always Number One in my book, and all my other artists had to understand they took second place to the Beatles. After Brian [Epstein] died, I felt some responsibility for their careers, too. I didn't want to fail them; I wanted them always to be successful. Suddenly, that responsibility was removed." As 1970 came to a close, Martin busied himself expanding his AIR holdings, which now included a lucrative, state-of-the-art recording studio. It was during this same period—as *Abbey Road* racked up sales records in the UK and United States alike—that EMI offered Martin his old job back. For Martin, there was never a real possibility that he would give up his independence and return to Parlophone, the subsidiary that he had slaved over in order to fight off extinction and render it profitable. He was proud of how the once disparaged "third label" had gone from also-ran status to one of the most successful brands in the world—largely on the back of Martin and the Beatles' unparalleled success. But still, when the offer came from managing director Len Wood, George enjoyed a laugh of recognition as he caught a glimpse of the salary, £25,000—more than double the amount that Martin had rejected back in 1965 before leaving EMI and founding AIR. And to think that his only mission in the mid-sixties had been to force the record conglomerate to provide him with a few paltry residuals for his world-class efforts. In 1965, an offer of £25,000 might well have kept him in EMI's employ. But now, a few years later, he barely gave it a second thought. Like Harrison, the Beatles' producer had enjoyed his first brush with independence, and there was simply no way he was going back.[12]

As for Lennon, stepping from the Beatles' omnipresent shadow had proven not altogether easy. On December 11, 1970, he released *John Lennon / Plastic Ono Band*, the LP that for many critics was

his most important musical statement outside of his work with the Beatles. Having endured Arthur Janov's primal-scream therapy with Ono earlier in the year, Lennon was poised to expiate his demons—including heroin—once and for all. With the song "Mother," he came to terms with the untimely loss of his mother Julia in July 1958. But with "God," he had even bigger game in mind as he wrestled with the overwhelming place of the Beatles—as gods of another kind—in his world. In the latter song's emotional climax, Lennon screams "I don't believe in Beatles!" before singing, in nearly a whisper, "I just believe in me." As 1970 came to a close, Lennon learned how difficult it would be to come to terms with his Beatles experience, that shedding his mates and consigning them to history would never be easy.

If he needed an object lesson in this regard, Lennon had seen it firsthand the previous spring, when he and Ono visited *Rolling Stone* editor Jann Wenner and his wife Jane in San Francisco. On a whim, the couples took in a showing of the *Let It Be* documentary during an afternoon matinee. Sitting together in the darkened cinema, they watched Lindsay-Hogg's film unfold, finally settling on the image of a bearded McCartney singing "Get Back" during the rooftop concert. "And it's just the four of us in the center of an empty theater," Wenner recalled, "all kind of huddled together, and John is crying his eyes out."

Clearly there were mixed feelings. In a no-holds-barred December 1970 interview for *Rolling Stone*, Lennon told Wenner that being in the Beatles "was awful, it was fuckin' humiliation. One has to completely humiliate oneself to be what the Beatles were, and that's what I resent." Going even further, Lennon described his bandmates as "the most big-headed uptight people on earth." As the interview with Wenner concluded, Lennon reflected on the acerbic nature of his remarks and concluded that "this is gonna be

some fucking thing. I don't care, this is the end of it." Not long afterward, the interview hit the newsstands. In 1971, Wenner would publish it as the book-length *Lennon Remembers*, which the ex-Beatle took to describing as "*Lennon Regrets*," for he had come to feel genuine remorse over his hurtful comments. But by then, it was too late. After reading the interview in the pages of *Rolling Stone*, McCartney had felt the sting of Lennon's words. During the last week of December 1970, McCartney filed High Court proceedings to end the Beatles' partnership.[13]

But by then, McCartney's legal maneuver was just another piece of noise to be replayed ad nauseam in the press and in rock history books. It would be another four years before Lennon finally put pen to paper and signed the agreement to conclude the group's partnership. He would do this in a hotel room in Walt Disney World, of all places. As Lennon had sung in "God," "The dream is over." When they had stepped away from their last photo shoot in Tittenhurst Park back in August 1969, it had been all over but the crying. Sure, there would be plenty of hemming and hawing over the coming months and years from the individual Beatles about the relative permanence of their disbandment—and fans the world over would clamor for a reunion until an assassin's bullets felled Lennon in New York City in December 1980. They would never perform together again. But as Lennon sagely observed, the Beatles' mythos was always secondary to their achievement. In the end, it was the music that truly mattered. "It's just natural, it's not a great disaster," said Lennon. "People keep talking about it like it's the end of the earth. It's only a rock group that split up, it's nothing important. You know, you have all the old records there if you want to reminisce."[14]

If Lennon had lived to experience the digital revolution—as the Beatles' music shifted through one format change after another, from vinyl, eight-track, and cassette tapes through compact disc,

MP3, and streaming technologies—he might have been gratified by the myriad ways in which the group's creative accomplishments in the studio continued to blossom, evergreen, from one generation to the next. No matter the format changes, their albums and singles resonated because of the sheer greatness of their music—timeless, finely crafted songs that benefited from the bandmates' superlative musicianship, an innovative production team, and an evolving studio technology.

With the *Abbey Road* album, the Beatles succeeded in cementing the power of their achievement in unique and long-lasting ways. With virtuosic performances in such songs as "Come Together," "Something," "I Want You (She's So Heavy)," "Here Comes the Sun," and the medley, they demonstrated their extraordinary evolution as musicians from their comparatively primitive performances on "Love Me Do" and the *Please Please Me* (1963) album. Walter Everett describes this incredible growth as a form of "progressive tonality," in which the Beatles expanded their overall sound and musical ability from one album to the next. In contrast with their earliest recordings, *Abbey Road* evinces the band members—both as songwriters and as performers—regularly shifting among different time and key signatures. Their musical skills—as revealed by the "exquisite" three-part harmonies on "Because" or their seemingly effortless solo work on "The End"—are in full flower, with the bandmates singing and playing their instruments with ease and panache at once. The album's production also occurred in the nick of time. As Richard Buskin has observed, "After the Beatles failed to get back to where they once belonged, Lennon was tempted to 'break the myth' by releasing the 'shitty version . . . with our trousers off.' Instead, they regrouped to play the game one last time with their trousers on. And thank the rock gods for that, because the result was *Abbey Road*: a slick testament

to how far they'd advanced in the studio during the six-plus years since *Please Please Me*, as well as a schizoid demonstration of Lennon and McCartney's increasingly divergent musical paths—with Harrison blazing his own trail straight down the middle."[15]

With *Abbey Road*, the Beatles also benefited from their production team having reached the zenith of their technological capacities during the life of the band, especially in terms of their work with the TG console. After the discord that Martin had experienced during the *White Album* and *Get Back* sessions, he was eager to revisit the high-end production that had created masterworks in *Revolver* and *Sgt. Pepper's Lonely Hearts Club Band*. With Emerick as engineer, Martin succeeded in regaining the artistic synergy that had typified the Beatles' studio years. The expansive sound palette and mixing capabilities of the TG console enabled Martin and Emerick to imbue the Beatles' sound with greater definition and clarity. The warmth of solid-state recording also afforded their music with brighter tonalities and a deeper low end that distinguished *Abbey Road* from the rest of their albums, providing listeners with an abiding sense that the Beatles' final LP was markedly different. Eventually it was seen that they had ended their career on a new and elevated level in terms of their sonic capabilities. Martin and Emerick had been daring and undeterred in their efforts to capture the songwriters' visions. Their production team, including talented newcomers like Chris Thomas and John Kurlander, was essential in carrying the band to the astonishing heights they attained with *Abbey Road*.

In their work, Martin and Emerick shared in the creation of the Beatles' most enduring album, an LP that secured their place at the top of twentieth-century popular music's pantheon and afforded them with an unforgettable exit from the world stage. With *Abbey Road*, the Beatles made their exodus in fine style. While their

interpersonal travails may have been harrowing at times, the result was a recording for the ages. *Abbey Road*'s innovative cover art depicts the bandmates strolling away from the studio where they made their art and into the waiting arms of history.

Over the years, Iain Macmillan's striking cover photograph would be parodied over and over—from Booker T. and the MG's *McLemore Avenue* (1970) and the Red Hot Chili Peppers' naked romp on *The Abbey Road EP* (1988) through McCartney's *Paul Is Live* (1993) and Kanye West's *Late Orchestration* (2006), among a host of others. Almost from the moment of the album's release in September 1969, fans from the world over flocked to St. John's Wood to recreate the Beatles' iconic poses on the *Abbey Road* LP cover, routinely staying traffic to get the perfect shot as they mimic the Fab Four's famous footsteps. As Mark Lewisohn has observed, "*Abbey Road* is the most imitated and famous of all rock music sleeves. To this day, and doubtless for a long time to come, not a single day passes without tourists visiting the zebra crossing to pose for their own cameras, many removing their shoes and socks to walk barefoot à la Paul McCartney on August 8th 1969, a fine summer's day."[16]

In 2011, EarthCam erected a webcam that flashes twenty-four-hour, minute-by-minute digital images of the famous zebra crossing, capturing visitors as they stroll across the legendary crosswalk. In 2010, the zebra crossing itself was accorded English Heritage Grade II status by the British government for the location's "cultural and historical importance." As with the studio itself—which had been for sale by property developers in 2009—the zebra crossing was now lawfully protected from any major alterations that would detract from its vaunted place in history. As John Penrose, minister for tourism and heritage, remarked during a dedication, "This London zebra crossing is no castle or cathedral but, thanks

to the Beatles and a 10-minute photo-shoot one August morning in 1969, it has just as strong a claim as any to be seen as part of our heritage." In addition to the zebra crossing, fans often make pilgrimages to the studio to add their names and favorite Beatles' lyrics on the wall that fronts the facility's car park. Over the years, the studio's management has encouraged such graffiti as a kind of public arts installation in which fans celebrate the band members' lives and music in colorful and inspiring ways. The wall is subjected to a monthly whitewash to give new visitors the opportunity to leave their mark.[17]

As for the studio itself, the Beatles' *Abbey Road* album has become nearly synonymous with the facilities at 3 Abbey Road in St. John's Wood. When he was promoted as the operation's general manager in 1974, Ken Townsend began the process of rebranding EMI Studios as Abbey Road Studios. Made official in 1976, the rechristening proved to be a deft marketing move that has ensured the building's much-deserved global fame. For Townsend, the rebranding made perfect business sense: EMI would benefit from the Beatles' renown. The name change also made the studio more palatable as a working destination for members of the recording industry beyond EMI artists. As Brian Southall has pointed out, "Throughout the Sixties and into the Seventies, all of EMI's UK-based acts were encouraged to use Abbey Road, and no artists signed to other labels were allowed to record there." To Townsend, the long-term fiscal health of Abbey Road Studios depended on keeping its recording spaces fully booked and operational. For Townsend, a professional recording studio should be a collegial place where artists and staffers share ideas—not merely with each other but also with the broader recording industry. For many years, this perspective contravened studio practices. At one point, according to Howard Massey, "There was apparently a

pact between the studio managers of Decca and EMI that no staff would be given a job at either of the other ones." As Townsend later recalled, EMI and Decca personnel weren't even allowed to speak to one another "because you had your own recording techniques and they were absolutely dead secret."[18]

For Townsend, rebranding EMI Studios as Abbey Road Studios was partly an effort to break down this wall, to open things up. To market the name change, Townsend commissioned artist Alan Brown to create a logo for Abbey Road Studios. Townsend's gambit succeeded on every front. At present, Abbey Road Studios draws recording artists from around the world—and from a wide range of labels. At Townsend's direction, the studio also made a strategic effort to attract film projects. Since 1980, when Townsend established a partnership with Anvil Post-Production, Abbey Road Studios has been in high demand for film scoring and soundtrack production. Over the years, Studio 1 has hosted recording for such blockbusters as *Raiders of the Lost Ark* (1982), *Return of the Jedi* (1983), and *The Lord of the Rings* trilogy (2001–3), among numerous other movies.

In many ways, Townsend is the studio's keeper of the flame. Having started at EMI Studios in 1954 as a recording engineer after a four-year apprenticeship at the company's Hayes facility, Townsend witnessed the whole of the Beatles' EMI years as they unfolded. He was there on their first day of recording—June 6, 1962—when "a giant farting sound" erupted as McCartney's road-worn bass amp failed on the studio floor. Wearing his white lab coat in adherence with EMI studio policy, Townsend traced the noise to Studio 2, where he remedied the situation by hauling a "very large, very heavy" Tannoy speaker in from its place in the basement echo chamber. With that, McCartney could perform on the session—and eventually, with Martin's

guidance, the Beatles would embark upon a musical career like no other.[19]

Townsend was there at the end too, when the bandmates left Abbey Road Studios for the last time in August 1969, having virtually rewritten recording rites and redefined popular music. For Townsend, working at Abbey Road and walking in the footsteps of industry giants was an honor. And others felt it too. For Alan Parsons, working with the Beatles was an extraordinary privilege. "It was a great thrill to be trusted in a room with one of the greatest bands of all time," he put it bluntly. "It was tremendous." For Parsons, who later achieved worldwide fame with the Alan Parsons Project, *Abbey Road* was only the beginning of his experience working the TG console. In 1973, he would earn a Grammy Award nomination for his engineering efforts on Pink Floyd's groundbreaking *The Dark Side of the Moon*. Indeed, with *Dark Side of the Moon*, Parsons had come to redefine the role of record producer as a kind of recording director, in the tradition of filmmakers like Stanley Kubrick and Martin Scorsese, who were not merely movie techs but people whose vision involved shaping the scope of their productions on an epic scale.[20]

It would be impossible to imagine the creative heights of artists such as Pink Floyd without the Beatles' trailblazing. For the Beatles themselves and, in retrospect, generations of fans and critics, *Abbey Road* provided a means for establishing a sense of closure to a remarkable career, a coda to the pop-cultural epoch that the Beatles had helped birth. With *Abbey Road*, as Martin and Emerick deployed solid-state technology in tandem with the group's virtuosic musical talents, the Beatles succeeded in ending their career in fine style, not only for themselves but for legions of listeners. In this way, "solid state" exists as a metaphor for the technologies that made the album possible and also for the sense of completion,

of finality, that the album represents. In the decades since its release, *Abbey Road* has continued to echo throughout pop culture, its place secure in rock history. In many ways the album has come to define the trajectory of the group's career, a unique fusion that inspired the band's enduring, multigenerational popularity. For the Beatles, *Abbey Road* was the foundation of a solid state.

Acknowledgments

A project of this magnitude could not possibly come to fruition without the efforts of a host of friends and colleagues. I am particularly grateful to Lizzie Bravo, Ray Connolly, David Crosby, Geoff Emerick, John Kurlander, Richard Langham, Alan Parsons, Ken Scott, Brian Southall, Chris Thomas, and Ken Townsend for sharing their memories of the Beatles' life and times. I am also thankful for the encouragement and support of Keith Ainsworth, Gary Astridge, Mirta Barrea-Marlys, Helen Bowden, Richard Buskin, Al Cattabiani, Ken Dashow, Howie Edelson, Tom Frangione, Scott Freiman, Jerry Hammack, Jude Southerland Kessler, Jason Kruppa, Mark Lapidos, Jim LeBlanc, Spencer Leigh, Mark Lewisohn, Giles Martin, Jacob Michael, Kit O'Toole, Alan Pell, Joe Rapolla, Jack Riley, Tim Riley, Robert Rodriguez, Bob Santelli, Sara Schmidt, Bruce Spizer, David Stark, Al Sussman, and Steve Turner. I owe a debt to the folks at Cornell University Press, including Mahinder Kingra and Dean Smith, for their patience and unfailing goodwill. My indefatigable publicist Nicole Michael deserves special thanks, as does my family—particularly my wife, Jeanine, who makes all things possible.

This book is dedicated to Geoff Emerick (1945–2018), the engineer whose innovative studio techniques came to define the

sound of generations of recording artists. His fearless, tech-savvy approach to the Beatles' artistry allowed them to soar increasingly higher in such albums as *Revolver* (1966), *Sgt. Pepper's Lonely Hearts Club Band* (1967), and *Abbey Road* (1969). Later the four-time Grammy Award winner left his pioneering stamp on such landmark LPs as *Band on the Run* (Paul McCartney and Wings, 1973) and *Imperial Bedroom* (Elvis Costello and the Attractions, 1982).

Notes

Introduction: "Unmitigated Disaster"

1. Nik Cohn, "The Beatles: For 15 Minutes, Tremendous," *New York Times*, October 5, 1969.

2. Robert Christgau, "Secular Music," *Esquire*, December 1967, 283; Richard Goldstein, "We Still Need the Beatles, but . . . ," *New York Times*, June 18, 1967.

3. Keith Badman, *The Beatles off the Record: Outrageous Opinions and Unrehearsed Interviews* (London: Omnibus, 2001), 332–33.

4. "Take a Ride through the Beatles' Magical Mystery Tour," WCBS-FM, New York City, 2011.

5. Kenneth Womack, *The Beatles Encyclopedia: Everything Fab Four*, vol. 1 (Santa Barbara, CA: Greenwood, 2014), 4–5.

6. Christgau, "Secular Music"; David Benjamin Levy, *Beethoven: The Ninth Symphony* (New Haven: Yale University Press, 1995), 155.

7. B. C. Southam, ed., *The Critical Heritage* (London: Routledge, 1970), 192–93; Henry Claridge, ed., *F. Scott Fitzgerald: Critical Assessments*, vol. 1 (London: Routledge, 1992), 178.

8. William Mann, "Those Inventive Beatles," in *The Beatles: Paperback Writer—40 Years of Classic Writing*, ed. Mike Evans (London: Plexus, 2012), 241.

9. George Martin with William Pearson, *With a Little Help from My Friends: The Making of "Sgt. Pepper"* (Boston: Little, Brown, 1994), 46.

1. EMI TG12345 Mk1

1. Ray Connolly, *John Lennon: A Restless Life* (London: Weidenfeld and Nicolson, 2018), 285–86; Peter Doggett, *Abbey Road/Let It Be: The Beatles* (New York: Schirmer, 1998), 34; Barry Miles, *Paul McCartney: Many Years from Now* (New York: Holt, 1997), 567.

2. Paul Trynka, "Where Magic Was Made," *Guardian*, March 11, 2005, www.theguardian.com/film/2005/mar/11/abbeyroadfilmfestival.festivals4.

3. Kevin Ryan and Brian Kehew, *Recording the Beatles: The Studio Equipment and Techniques Used to Create Their Classic Albums* (Houston: Curvebender, 2006), 112–13; Alan Parsons, interview with author, January 29, 2019.

4. Ryan and Kehew, *Recording the Beatles*, 112–15.

5. Ken Townsend, interviews with author, August 21 and 29, 2018; Parsons interview.

6. Ryan and Kehew, *Recording the Beatles*, 113.

7. George Martin, *Playback: An Illustrated Memoir* (Guildford, UK: Genesis Publications, 2002), 60–61.

8. Steve Turner, *Beatles '66: The Revolutionary Year* (New York: HarperCollins, 2016), 126–27.

9. David Crosby, interview with author, June 7, 2018.

10. Mark Lewisohn, *The Complete Beatles Recording Sessions: The Official Abbey Road Studio Session Notes, 1962–1970* (New York: Harmony, 1988), 96.

11. Ibid., 146.

12. Ibid., 153.

13. Tony Barrell, "The Basement Tapes," chap. 3 in *The Beatles on the Roof* (London: Omnibus, 2017); Doggett, *Abbey Road/Let It Be*, 36.

14. John Lennon, *Lennon Remembers*, interview by Jann Wenner, new ed. (New York: Verso, 2000), 83.

15. Ryan and Kehew, *Recording the Beatles*, 506; Beatles, *The Beatles Anthology*, ABC television series, 1995.

16. Doug Sulpy and Ray Schweighardt, *Get Back: The Unauthorized Chronicle of the Beatles' "Let It Be" Disaster* (New York: Griffin, 1997), 232.

17. Steve Turner, *A Hard Day's Write: The Stories behind Every Beatles Song* (London: Carlton, 1994), 306.

18. William J. Dowlding, *Beatlesongs* (New York: Simon and Schuster, 1989), 284; Barrell, "Basement Tapes."

19. Lewisohn, *Complete Beatles Recording Sessions*, 170.

20. Geoff Emerick and Howard Massey, *Here, There, and Everywhere: My Life Recording the Music of the Beatles* (New York: Gotham, 2006), 277.

21. Beatles, *The Beatles Anthology* (San Francisco: Chronicle Books, 2000), 330, 332; Lennon, *Lennon Remembers*, 40.

22. Barry Miles, "1969," chap. 11 in *The Beatles Diary*, vol. 1, *The Beatles Years* (London: Omnibus, 2007); Richie Unterberger, *The Unreleased Beatles* (San Francisco: Backbeat, 2006), 265.

23. George Harrison, *I Me Mine* (San Francisco: Chronicle, 2002), 152; Lewisohn, *Complete Beatles Recording Sessions*, 156.

24. Rolling Stone, *Harrison* (New York: Simon and Schuster, 2002), 38; Dave Thompson, "Fire and Rain," chap. 4 in *Hearts of Darkness: James Taylor, Jackson*

Browne, Cat Stevens, and the Unlikely Rise of the Singer-Songwriter (Milwaukee: Backbeat, 2012).

25. Miles, "1969."

26. Spencer Leigh, "And in the End (1969)," chap. 9 in *Love Me Do to Love Me Don't: The Beatles on Record* (Sleaford, UK: McNidder and Grace, 2016).

2. Stereophonic Sound

1. Beatles, *The Beatles Anthology* (San Francisco: Chronicle Books, 2000), 41.

2. Geoff Emerick and Howard Massey, *Here, There, and Everywhere: My Life Recording the Music of the Beatles* (New York: Gotham, 2006), 269.

3. Beatles, *Beatles Anthology* (2000), 337.

4. Kenneth Womack, *The Beatles Encyclopedia: Everything Fab Four*, vol. 1 (Santa Barbara, CA: Greenwood Press, 2014), 72.

5. Ibid.

6. Beatles, *Beatles Anthology* (2000), 333.

7. Emerick and Massey, *Here, There, and Everywhere*, 269–70.

8. Ibid., 129; Beatles, *The Beatles Anthology*, recording of 1995 ABC television series, with bonus disc (London: EMI Records, 2003), DVD.

9. "Stereo Rattles Stations; Mfrs. Strangle Monaural," *Billboard*, January 6, 1968, 1; George Martin, "The Producer Series, Part 1," interview by Ralph Denver, *Studio Sound*, January 1985, 58.

10. Beatles, *Beatles Anthology* (2000), 334; John Kurlander, interview with author, November 8, 2017.

11. Bob Spitz, *The Beatles: The Biography* (Boston: Little, Brown, 2005), 297; Brian Southall, *Abbey Road: The Story of the World's Most Famous Studios* (Wellingborough, UK: Patrick Stephens, 1982), 52.

12. Emerick and Massey, *Here, There, and Everywhere*, 277; Kevin Ryan and Brian Kehew, *Recording the Beatles: The Studio Equipment and Techniques Used to Create Their Classic Albums* (Houston: Curvebender, 2006), 113.

13. George Harrison, *I Me Mine* (San Francisco: Chronicle, 2002), 312; Steve Turner, *A Hard Day's Write: The Stories behind Every Beatles Song* (London: Carlton, 1994), 294.

14. J. Kordosh, "The George Harrison Interview," *Creem*, December 1987 and January 1988, http://beatlesnumber9.com/creem.html; "Remembering the Forgotten Beatle," *Rolling Stone*, December 5, 2001; George Martin, "Listen to My Story: George Martin Interview with *Melody Maker*," interview by Richard Williams, *Melody Maker*, August 21, 1971, n. p.

15. Kurlander interview.

16. Mark Lewisohn, *The Complete Beatles Recording Sessions: The Official Abbey Road Studio Session Notes, 1962–1970* (New York: Harmony, 1988), 173, 191.



17. Emerick and Massey, *Here, There, and Everywhere*, 10.

18. John C. Winn, *That Magic Feeling: The Beatles' Recorded Legacy*, vol. 2, *1966–1970* (Sharon, VT: Multiplus, 2003), 280.

19. Andy Babiuk, *Beatles Gear: All the Fab Four's Instruments, from Stage to Studio* (San Francisco: Backbeat, 2001), 219.

20. Ibid., 88–89.

21. Ibid., 219.

22. Walter Everett, *The Beatles as Musicians: Revolver through the Anthology* (Oxford: Oxford University Press, 1999), 245; Beatles, *Beatles Anthology* (2000), 338.

23. Lewisohn, *Complete Beatles Recording Sessions*, 151.

24. Beatles, *Beatles Anthology* (2000), 312.

25. Lewisohn, *Complete Beatles Recording Sessions*, 162.

26. Ibid., 174.

27. "Four Cats on a London Roof," *TV Guide*, April 25–29, 1969, 14; Lewisohn, "Double Lives: Between *The Beatles'* Grooves," lecture, Monmouth University, November 10, 2018.

28. Glyn Johns, *Sound Man: A Life Recording Hits with the Rolling Stones, the Who, Led Zeppelin, the Eagles, Eric Clapton, the Faces* (New York: Blue Rider, 2014), 140.

29. Winn, *That Magic Feeling*, 282; Lewisohn, *Complete Beatles Recording Sessions*, 175.

30. Chris Thomas, interview with author, November 11, 2018; Beatles, *Beatles Anthology* (2000), 266.

31. Emerick and Massey, *Here, There, and Everywhere*, 282.

32. George Martin, *Playback: An Illustrated Memoir* (Guildford, UK: Genesis Publications, 2002), 188.

33. John Lennon, *Lennon Remembers*, interview by Jann Wenner, new ed. (New York: Verso, 2000), 25; Spitz, *Beatles*, 667.

34. George Martin with Jeremy Hornsby, *All You Need Is Ears* (New York: St. Martin's, 1979), 171; Doug Sulpy and Ray Schweighardt, *Get Back: The Unauthorized Chronicle of the Beatles' "Let It Be" Disaster* (New York: Griffin, 1997), 169.

35. Beatles, *Beatles Anthology* (2000), 326; Spitz, *Beatles*, 832.

36. Brian Southall with Rupert Perry, "Robin Hood, Riding through the Glen," chap. 1 in *Northern Songs: The True Story of the Beatles Song Publishing Empire* (London: Omnibus, 2009).

37. Spencer Leigh, "And in the End (1969)," chap. 9 in *Love Me Do to Love Me Don't: The Beatles on Record* (Sleaford, UK: McNidder and Grace, 2016).

38. Ibid.

39. Barry Miles, *Paul McCartney: Many Years from Now* (New York: Holt, 1997), 548.

40. Beatles, *Beatles Anthology* (2000), 44.

3. Tales of Men and Moog

1. Beatles, *The Beatles Anthology* (San Francisco: Chronicle Books, 2000), 94.
2. John Mendelsohn, "Records," *Rolling Stone*, May 17, 1969.
3. Turner, *Beatles*, 361.
4. Anthony Fawcett, *John Lennon: One Day at a Time—A Personal Biography of the Seventies* (New York: Grove Press, 1976), 51.
5. Paul Du Noyer, *John Lennon: The Stories behind Every Song, 1970–1980* (London: Carlton, 2010), 21.
6. Frank Mastropolo, "How John Lennon and Yoko Ono's Montreal Bed-In Led to 'Give Peace a Chance,'" *Ultimate Classic Rock*, May 26, 2014, http://ultimateclassicrock.com/john-lennon-give-peace-a-chance-bed-in.
7. Ibid.
8. Ibid.
9. Philip Norman, *John Lennon: The Life* (New York: HarperCollins, 2008), 608.
10. John Lennon, *Lennon Remembers*, interview by Jann Wenner, new ed. (New York: Verso, 2000), 93.
11. Alan Clayson, "Off the Wall," *Mojo*, 2003 special edition ("1,000 Days of Revolution"), 50.
12. Billy Preston, liner notes, *That's the Way God Planned It*. LP. (Hollywood, CA: Apple, 1969).
13. Chuck Miller, "Wendy Carlos: In the Moog," *Goldmine*, January 23, 2004, 47–48.
14. Beatles, *Beatles Anthology* (2000), 340.
15. John C. Winn, *That Magic Feeling: The Beatles' Recorded Legacy*, vol. 2, *1966–1970* (Sharon, VT: Multiplus, 2003), 265.
16. "Jackie Lomax," obituary, *Telegraph*, September 17, 2013, www.telegraph.co.uk/news/obituaries/culture-obituaries/music-obituaries/10316228/Jackie-Lomax.html; Winn, *That Magic Feeling*, 321.
17. George Martin with William Pearson, *With a Little Help from My Friends: The Making of "Sgt. Pepper"* (Boston: Little, Brown, 1994), 121; "Get Back to the Staircase," *Genealogy of Style*, December 8, 2014, http://thegenealogyofstyle.wordpress.com/2014/12/08/get-back-to-the-staircase.
18. "Stairwell to Pop History Heaven," *Independent*, August 13, 1995. www.independent.co.uk/news/uk/home-news/stairwell-to-pop-history-heaven-1596031.html.
19. Brian Southall with Rupert Perry, "Buying, Bidding, and Splitting," chap. 3 in *Northern Songs: The True Story of the Beatles Song Publishing Empire* (London: Omnibus, 2009); Bob Spitz, *The Beatles: The Biography* (Boston: Little, Brown, 2005), 845.
20. Barry Miles, *Paul McCartney: Many Years from Now* (New York: Holt, 1997), 556; Beatles, *Beatles Anthology* (2000), 337.

21. Peter Doggett, *Abbey Road / Let It Be: The Beatles* (New York: Schirmer, 1998), 49; William J. Dowlding, *Beatlesongs* (New York: Simon and Schuster, 1989), 287.

22. George Martin, "The Producer Series, Part 1," interview by Ralph Denver, *Studio Sound*, January 1985, 58.

23. Keith Badman, *The Beatles off the Record: Outrageous Opinions and Unrehearsed Interviews* (London: Omnibus, 2001), 471.

24. Doggett, *Abbey Road / Let It Be*, 49.

4. "The Long One"

1. George Martin, "The Producer Series, Part 1," interview by Ralph Denver, *Studio Sound*, January 1985, 58; George Martin with William Pearson, *With a Little Help from My Friends: The Making of "Sgt. Pepper"* (Boston: Little, Brown, 1994), 55.

2. Martin and Pearson, *With a Little Help from My Friends*, 55.

3. Ibid.; George Martin with Jeremy Hornsby, *All You Need Is Ears* (New York: St. Martin's, 1979), 264.

4. Mark Lewisohn, *The Complete Beatles Recording Sessions: The Official Abbey Road Studio Session Notes, 1962–1970* (New York: Harmony, 1988), 178; Richard Langham, interview with author, February 8, 2014.

5. Bob Spitz, *The Beatles: The Biography* (Boston: Little, Brown, 2005), 838.

6. Geoff Emerick and Howard Massey, *Here, There, and Everywhere: My Life Recording the Music of the Beatles* (New York: Gotham, 2006), 278.

7. Barry Miles, *Paul McCartney: Many Years from Now* (New York: Holt, 1997), 558; Steve Turner, *A Hard Day's Write: The Stories behind Every Beatles Song* (London: Carlton, 1994), 315.

8. Joe Goodden, *Riding So High: The Beatles and Drugs* (London: Pepper and Pearl, 2017), 223; Lewisohn, *Complete Beatles Recording Sessions*, 178.

9. William J. Dowlding, *Beatlesongs* (New York: Simon and Schuster, 1989), 291.

10. Ibid., 275.

11. Miles, *Paul McCartney*, 557.

12. Keith Badman, *The Beatles off the Record: Outrageous Opinions and Unrehearsed Interviews* (London: Omnibus, 200), 473–74.

13. Miles, *Paul McCartney*, 557.

14. Mick Jagger, "Mick Jagger Remembers," interview by Jann Wenner, *Rolling Stone*, December 14, 1995, www.rollingstone.com/music/music-news/mick-jagger-remembers-92946.

15. Lewisohn, *Complete Beatles Recording Sessions*, 178; Keith Richards with James Fox, *Life* (London: Weidenfeld and Nicolson, 2010), 272.

16. Beatles, *The Beatles Anthology* (San Francisco: Chronicle, 2000), 340.

17. Ibid., 160; Eric Clapton, *Clapton: The Autobiography* (New York: Random House, 2007), 106.

18. Beatles, *Beatles Anthology* (2000), 339.

19. Lewisohn, *Complete Beatles Recording Sessions*, 178.

20. Martin, "Producer Series, Part 1," 58–59.

21. Peter Doggett, *Abbey Road/Let It Be: The Beatles* (New York: Schirmer, 1998), 59–60; Martin, "Producer Series, Part 1," 58–59.

22. Turner, *Hard Day's Write*, 298; Miles, *Paul McCartney*, 554; Doggett, *Abbey Road / Let It Be*, 102.

23. Lewisohn, *Complete Beatles Recording Sessions*, 179.

24. Badman, *Beatles off the Record*, 469; Doggett, *Abbey Road / Let It Be*, 2.

25. Goodden, *Riding So High*, 217.

26. Lewisohn, *Complete Beatles Recording Sessions*, 180.

27. Emerick and Massey, *Here, There, and Everywhere*, 285.

28. Turner, *Hard Day's Write*, 299.

29. Beatles, *Beatles Anthology* (2000), 339.

30. Turner, *Hard Day's Write*, 299.

31. Walter Everett, *The Beatles as Musicians:* Revolver *through the* Anthology (Oxford, UK: Oxford University Press, 1999), 246.

32. John C. Winn, *That Magic Feeling: The Beatles' Recorded Legacy, vol. 2, 1966–1970* (Sharon, VT: Multiplus, 2003), 332.

33. Emerick and Massey, *Here, There, and Everywhere*, 277–78; Howard Massey, "Abbey Road (EMI Studios)," chap. 1 in *The Great British Recording Studios* (Milwaukee: Hal Leonard, 2015); Dowlding, *Beatlesongs*, 277.

34. Beatles, *Beatles Anthology* (2000), 338.

5. The Wind-Up Piano and Mrs. Mills

1. Beatles, *The Beatles Anthology* (San Francisco: Chronicle, 2000), 337.

2. Ibid., 338.

3. William J. Dowlding, *Beatlesongs* (New York: Simon and Schuster, 1989), 293; Beatles, *Beatles Anthology* (2000), 338.

4. Ibid., 288.

5. Beatles, *Beatles Anthology* (2000), 337.

6. Geoff Emerick and Howard Massey, *Here, There, and Everywhere: My Life Recording the Music of the Beatles* (New York: Gotham, 2006), 289.

7. John C. Winn, *That Magic Feeling: The Beatles' Recorded Legacy, vol. 2, 1966–1970* (Sharon, VT: Multiplus, 2003), 309.

8. Emerick and Massey, *Here, There, and Everywhere*, 289.

9. Keith Badman, *The Beatles off the Record: Outrageous Opinions and Unrehearsed Interviews* (London: Omnibus, 2001), 472; Emerick and Massey, *Here, There, and Everywhere*, 289.

10. Mark Lewisohn, *Tune In: The Beatles—All These Years* (New York: Crown, 2013), 315.

11. Steve Turner, *A Hard Day's Write: The Stories behind Every Beatles Song* (London: Carlton, 1994), 312.

12. Beatles, *Beatles Anthology* (2000), 337.

13. Lewisohn, *Tune In*, 328.

14. Turner, *Hard Day's Write*, 312; Lewisohn, *Tune In*, 329.

15. Barry Miles, *Paul McCartney: Many Years from Now* (New York: Holt, 1997), 557; Turner, *Hard Day's Write*, 313; Badman, *Beatles off the Record*, 472.

16. Sara Schmidt, interview with author, December 26, 2018.

17. Howard Sounes, *Fab: An Intimate Life of Paul McCartney* (Cambridge, MA: Da Capo, 2010), 259; Turner, *Hard Day's Write*, 313.

18. Turner, *Hard Day's Write*, 313.

19. Ibid.; Dowlding, *Beatlesongs*, 290.

20. Scott Freiman, interview with author, January 12, 2019.

21. Emerick and Massey, *Here, There, and Everywhere*, 290.

22. Bob Spitz, *The Beatles: The Biography* (Boston: Little, Brown, 2005), 840; Emerick and Massey, *Here, There, and Everywhere*, 290; Joe Goodden, *Riding So High: The Beatles and Drugs* (London: Pepper and Pearl, 2017), 221.

23. Emerick and Massey, *Here, There, and Everywhere*, 290.

24. Jason Kruppa, interview with author, December 30, 2018.

25. Mark Lewisohn, *The Complete Beatles Recording Sessions: The Official Abbey Road Studio Session Notes, 1962–1970* (New York: Harmony, 1988), 183.

26. John Kurlander, interview with author, November 8, 2017; Lewisohn, *Complete Beatles Recording Sessions*, 183.

27. Alan Parsons, interview with author, January 29, 2019.

28. George Martin with William Pearson, *With a Little Help from My Friends: The Making of "Sgt. Pepper"* (Boston: Little, Brown, 1994), 90–91.

29. Andy Babiuk, *Beatles Gear: All the Fab Four's Instruments, from Stage to Studio* (San Francisco: Backbeat, 2001), 169; George Martin with Jeremy Hornsby, *All You Need Is Ears* (New York: St. Martin's, 1979), 134.

30. Beatles, *Beatles Anthology* (2000), 326.

6. Virtuosi

1. Anthony Sfirse, "Engineering the Sound: The Beatles' *Abbey Road*," *Enmore Audio*, May 28, 2018, http://enmoreaudio.com/engineering-the-sound-the-beatles-abbey-road.

2. William J. Dowlding, *Beatlesongs* (New York: Simon and Schuster, 1989), 285.

3. Steve Turner, *A Hard Day's Write: The Stories behind Every Beatles Song* (London: Carlton, 1994), 308; Barry Miles, *Paul McCartney: Many Years from Now* (New York: Holt, 1997), 555.

4. Geoff Emerick and Howard Massey, *Here, There, and Everywhere: My Life Recording the Music of the Beatles* (New York: Gotham, 2006), 292; George

Martin, "The Producer Series, Part 1," interview by Ralph Denver, *Studio Sound,* January 1985, 59.

5. Emerick and Massey, *Here, There, and Everywhere,* 292; Dowlding, *Beatle-songs,* 285.

6. George Martin, *Playback: An Illustrated Memoir* (Guildford, UK: Genesis Publications, 2002), 90.

7. Martin, "Producer Series, Part 1," 59; Mark Lewisohn, *The Complete Beatles Recording Sessions: The Official Abbey Road Studio Session Notes, 1962–1970* (New York: Harmony, 1988), 184; Dowlding, *Beatlesongs,* 286.

8. Miles, *Paul McCartney,* 218.

9. Chris Thomas, interview with author, November 11, 2018; Lewisohn, *Complete Beatles Recording Sessions,* 185.

10. Emerick and Massey, *Here, There, and Everywhere,* 282–83.

11. Lewisohn, *Complete Beatles Recording Sessions,* 185; Miles, *Paul McCartney,* 55.

12. Lewisohn, *Complete Beatles Recording Sessions,* 185.

13. Ibid.; Martin, "The Producer Series, Part 2," interview by Ralph Denver, *Studio Sound,* February 1985, 54.

14. John Kurlander, interview with author, November 8, 2017; Emerick and Massey, *Here, There, and Everywhere,* 287.

15. Kurlander interview; Emerick and Massey, *Here, There, and Everywhere,* 294–95; "100 Greatest Beatles Songs," *Rolling Stone,* September 29, 2011, www.rollingstone.com/music/lists/100-greatest-beatles-songs-20110919.

16. Lewisohn, *Complete Beatles Recording Sessions,* 13; Emerick and Massey, *Here, There, and Everywhere,* 297; Beatles, *The Beatles Anthology* (San Francisco: Chronicle, 2000), 341.

17. John C. Winn, *That Magic Feeling: The Beatles' Recorded Legacy,* vol. 2, *1966–1970* (Sharon, VT: Multiplus, 2003), 314.

18. Martin, "Producer Series, Part 1," 62.

19. Lewisohn, *Complete Beatles Recording Sessions,* 190.

20. Emerick and Massey, *Here, There, and Everywhere,* 300.

21. Ibid., 283.

22. Michael Lang, *The Road to Woodstock: From the Man behind the Legendary Festival* (New York: HarperCollins, 2009), 83–84.

23. Francis Hanly, dir., *Produced by George Martin* (Eagle Rock Entertainment, 2012), DVD.

24. Dowlding, *Beatlesongs,* 98; Miles, *Paul McCartney,* 558; Richard Ellmann, *James Joyce,* 2nd ed. (Oxford, UK: Oxford University Press, 1982), 521.

25. Beatles, *The Beatles Anthology* (2000), 340.

26. Andy Babiuk, *Beatles Gear: All the Fab Four's Instruments, from Stage to Studio* (San Francisco: Backbeat, 2001), 247.

27. Dowlding, *Beatlesongs,* 292; Emerick and Massey, *Here, There, and Everywhere,* 301.

28. Emerick and Massey, *Here, There, and Everywhere*, 263.

29. Lewisohn, *Complete Beatles Recording Sessions*, 192–93; Dowlding, *Beatlesongs*, 278.

7. Tittenhurst Park

1. Beatles, *The Beatles Anthology* (San Francisco: Chronicle, 2000), 345; Ethan Russell, interview with Jack Riley, WPRK-FM, Winter Park, Florida, June 3, 2017.

2. Russell interview.

3. Glyn Johns, *Sound Man: A Life Recording Hits with the Rolling Stones, the Who, Led Zeppelin, the Eagles, Eric Clapton, the Faces* (New York: Blue Rider, 2014), 142.

4. Joe Goodden, *Riding So High: The Beatles and Drugs* (London: Pepper and Pearl, 2017), 218, 227.

5. Ibid., 227–28.

6. Keith Badman, *The Beatles off the Record: Outrageous Opinions and Unrehearsed Interviews* (London: Omnibus, 2001), 477.

7. Jordan Runtagh, "The Beatles' Revelatory *White Album* Demos: A Complete Guide," *Rolling Stone*, May 29, 2018, www.rollingstone.com/music/music-lists/the-beatles-revelatory-white-album-demos-a-complete-guide-629178.

8. Badman, *Beatles off the Record*, 462; Beatles, *Beatles Anthology* (2000), 347.

9. Badman, *Beatles off the Record*, 464–65.

10. Ibid., 464; John C. Winn, *That Magic Feeling: The Beatles' Recorded Legacy, vol. 2, 1966–1970* (Sharon, VT: Multiplus, 2003), 267.

11. Badman, *Beatles off the Record*, 458; Bob Spitz, *The Beatles: The Biography* (Boston: Little, Brown, 2005), 846.

12. Badman, *Beatles off the Record*, 466.

13. Ibid.; Spitz, *Beatles*, 846.

14. Badman, *Beatles off the Record*, 467.

15. Beatles, *Beatles Anthology* (2000), 348.

16. Gordon Thompson, *Please Please Me: Sixties Pop, Inside Out* (Oxford, UK: Oxford University Press, 2008), 200.

17. Kenneth Womack, *The Beatles Encyclopedia: Everything Fab Four*, vol. 1 (Santa Barbara, CA: Greenwood Press, 2014), 4–5.

18. Kevin Courrier, *Artificial Paradise: The Dark Side of the Beatles' Utopian Dream* (Westport, CT: Praeger, 2008), 254.

19. R. Gary Patterson, "I Buried Paul: The Search for Conspiracy," chap. 2 in *The Walrus Was Paul: The Great Beatle Death Clues* (New York: Fireside, 1998); "Beatle Paul McCartney Is Really Alive," *Lodi (CA) News-Sentinel*, October 11, 1969, 5.

20. Beatles, *Beatles Anthology* (2000), 340; John Burks, "A Pile of Money on Paul's 'Death,'" *Rolling Stone*, November 29, 1969.

21. Beatles, *Beatles Anthology* (2000), 342.
22. John Neary, "The Magical McCartney Mystery," *Life*, November 7, 1969, 103–6.

8. Letting It Be

1. Anthony Fawcett, *John Lennon: One Day at a Time—A Personal Biography of the Seventies* (New York: Grove Press, 1976), 95–97.
2. William J. Dowlding, *Beatlesongs* (New York: Simon and Schuster, 1989), 281; Beatles, *The Beatles Anthology* (San Francisco: Chronicle, 2000), 338.
3. Barry Miles, *Paul McCartney: Many Years from Now* (New York: Holt, 1997), 564.
4. Fawcett, *John Lennon*, 95–97.
5. Ibid.
6. Ibid.
7. Ibid.; "Summer and Fall 1967—Love and Death in G Major," *Fabcast*, no. 5 (June 23, 2016), podcast with Howie Edelson, Stephen Bard, and Dave Morrell.
8. Beatles, *Beatles Anthology* (2000), 347; Joe Goodden, *Riding So High: The Beatles and Drugs* (London: Pepper and Pearl, 2017), 229; Ray Connolly, *John Lennon: A Restless Life* (London: Weidenfeld and Nicolson, 2018), xi.
9. Miles, *Paul McCartney*, 568–69.
10. Ibid., 571.
11. Mark Lewisohn, *The Complete Beatles Recording Sessions: The Official Abbey Road Studio Session Notes, 1962–1970* (New York: Harmony, 1988), 195.
12. Tim Riley, *Tell Me Why: A Beatles Commentary* (New York: Knopf, 1988), 371.
13. George Martin, *Playback: An Illustrated Memoir* (Guildford, UK: Genesis Publications, 2002), 190; Michael Seth Starr, "It Don't Come Easy," chap. 12 in *Ringo: With a Little Help* (Milwaukee: Hal Leonard, 2015).
14. Martin, *Playback*, 189.
15. Fred Goodman, *Allen Klein: The Man Who Bailed out the Beatles, Made the Stones, and Transformed Rock 'n' Roll* (New York: Houghton Mifflin Harcourt, 2016), 193.
16. Spencer Leigh, "You Know How Hard It Can Be," chap. 10 in *Love Me Do to Love Me Don't: The Beatles on Record* (Sleaford, UK: McNidder and Grace, 2016).
17. Goodman, *Allen Klein*, 194; Martin, *Playback*, 189; Bob Spitz, *The Beatles: The Biography* (Boston: Little, Brown, 2005), 849; Glyn Johns, *Sound Man: A Life Recording Hits with the Rolling Stones, the Who, Led Zeppelin, the Eagles, Eric Clapton, the Faces* (New York: Blue Rider, 2014), 140.
18. John Lennon, *Lennon Remembers*, interview by Jann Wenner, new ed. (New York: Verso, 2000), 101–2; Leigh, "You Know How Hard It Can Be"; Richard Williams, *Phil Spector: Out of His Head* (London: Omnibus, 2009), 148.

19. Starr, "It Don't Come Easy."

20. McCartney, press release, London, April 9, 1970, www.beatlesinterviews. org; Spitz, *Beatles*, 849.

9. Solid State

1. Ray Connolly, *John Lennon: A Restless Life* (London: Weidenfeld and Nicolson, 2018), xii; Tim Riley, *Lennon: The Man, the Myth, the Music* (New York: Hyperion, 2011), 489.

2. Barry Miles, *Paul McCartney: Many Years from Now* (New York: Holt, 1997), 574–75; Langdon Winner, "McCartney," *Rolling Stone*, May 14, 1970.

3. Howard Sounes, *Fab: An Intimate Life of Paul McCartney* (Cambridge, MA: Da Capo, 2010), 271; Geoffrey Cannon, "The Beatles' Solo Albums Reviewed," *Guardian*, December 19, 1970, www.theguardian.com/music/2016/dec/19/beatles-solo-albums-reviewed-1970; Alan Smith, "Paul McCartney: *McCartney* (Apple)," *NME*, April 18, 1970.

4. John Harris, "*Let It Be*: Can You Dig It?" *Mojo*, 2003 special edition ("1,000 Days of Revolution"), 132; Craig McGregor, "So in the End, the Beatles Have Proved False Prophets," *New York Times*, June 14, 1970.

5. Craig Cross, *The Beatles: Day-by-Day, Song-by-Song, Record-by-Record* (New York: iUniverse, 2005), 306; "Cinema: McCartney and Others," *Time*, June 8, 1970.

6. Derek Johnson, "Next Beatle Album in Depth: NMExclusive," *NME*, November 1, 1969; Ian MacDonald, *Revolution in the Head: The Beatles' Records and the Sixties* (New York: Holt, 1994), 273.

7. Fred Goodman, *Allen Klein: The Man Who Bailed out the Beatles, Made the Stones, and Transformed Rock 'n' Roll* (New York: Houghton Mifflin Harcourt, 2016), 192.

8. Nicholas Schaffner, *The Beatles Forever* (New York: McGraw-Hill, 1978), 140; Alan Smith, "Singles Reviews," *NME*, April 24, 1971; Bruce Spizer, *The Beatles Solo on Apple Records* (New Orleans: 498 Productions, 2005), 294.

9. Andrew Grant Jackson, *Still the Greatest: The Essential Songs of the Beatles' Solo Careers* (Lanham, MD: Scarecrow, 2012), 19.

10. William J. Dowlding, *Beatlesongs* (New York: Simon and Schuster, 1989), 275.

11. George Harrison, radio interview, New York, May 1, 1970, www. beatlesinterviews.org; Geoff Emerick and Howard Massey, *Here, There, and Everywhere: My Life Recording the Music of the Beatles* (New York: Gotham, 2006), 324.

12. George Martin, *Playback: An Illustrated Memoir* (Guildford, UK: Genesis Publications, 2002), 189.

13. Joe Hagan, *Sticky Fingers: The Life and Times of Jann Wenner and Rolling Stone Magazine* (New York: Vintage, 2017), 3, 174; John Lennon, *Lennon Remembers*, interview by Jann Wenner, new ed. (New York: Verso, 2000), 45, 105.

14. Beatles, *The Beatles Anthology*, ABC television series, 1995.

15. Richard Buskin, interview with author, December 31, 2018.

16. Mark, Lewisohn, *The Complete Beatles Recording Sessions: The Official Abbey Road Studio Session Notes, 1962–1970* (New York: Harmony, 1988), 186.

17. "Beatles' Abbey Road Zebra Crossing Given Listed Status," *BBC News*, December 22, 2010, www.bbc.com/news/uk-england-london-12059385.

18. Brian Southall with Ruper Perry, "Robin Hood, Riding through the Glen," chap. 1 in *Northern Songs: The True Story of the Beatles Song Publishing Empire* (London: Omnibus, 2009); Howard Massey, "The Big Three," chap. 2 in *The Great British Recording Studios* (Milwaukee: Hal Leonard, 2015); Ken Townsend, interview with author, January 8, 2019.

19. Ken Townsend, interview with author, August 21, 2018; Lewisohn, *Complete Beatles Recording Sessions*, 17.

20. Townsend interview, August 21, 2018; Peter Chakerian, "Legendary Engineer-Producer and Musician Alan Parsons Talks Beatles, Floyd, Upcoming Cleveland 'Greatest Hits' Concert," *Plain Dealer* (Cleveland), May 7, 2014, www.cleveland.com/music/index.ssf/2014/05/legendary_engineer-producer_al.html.

Bibliography

Babiuk, Andy. *Beatles Gear: All the Fab Four's Instruments, from Stage to Studio*. San Francisco: Backbeat, 2001.

Badman, Keith. *The Beatles off the Record: Outrageous Opinions and Unrehearsed Interviews*. London: Omnibus, 2001.

Barrell, Tony. *The Beatles on the Roof*. London: Omnibus, 2017.

"Beatle Paul McCartney Is Really Alive." *Lodi (CA) News-Sentinel*, October 11, 1969.

Beatles. *The Beatles Anthology*. Music documentary. Produced by Neil Aspinall. Broadcast on ABC in 1995.

———. *The Beatles Anthology*. San Francisco: Chronicle, 2000.

———. *The Beatles Anthology*. DVD of 1995 ABC television series, with bonus disc. London: EMI Records, 2003.

"Beatles' Abbey Road Zebra Crossing Given Listed Status." *BBC News*, December 22, 2010, www.bbc.com/news/uk-england-london-12059385.

The Beatles Interview Database. www.beatlesinterviews.org.

Burks, John. "A Pile of Money on Paul's 'Death.'" *Rolling Stone*, November 29, 1969.

Cannon, Geoffrey. "The Beatles' Solo Albums Reviewed." *Guardian*, December 19, 1970, www.theguardian.com/music/2016/dec/19/beatles-solo-albums-reviewed-1970.

Chakerian, Peter. "Legendary Engineer-Producer and Musician Alan Parsons Talks Beatles, Floyd, Upcoming Cleveland 'Greatest Hits' Concert." *Plain Dealer* (Cleveland), May 7, 2014, www.cleveland.com/music/index.ssf/2014/05/legendary_engineer-producer_al.html.

Christgau, Robert. "Secular Music." *Esquire*, December 1967, 283–86.

"Cinema: McCartney and Others." *Time*, June 8, 1970.

Clapton, Eric. *Clapton: The Autobiography*. New York: Random House, 2007.

Claridge, Henry, ed. *F. Scott Fitzgerald: Critical Assessments*, vol. 1. London: Routledge, 1992.

Clayson, Alan. "Off the Wall." *Mojo*, 2003 special edition ("1,000 Days of Revolution"), 50.

Cohn, Nik. "The Beatles: For 15 Minutes, Tremendous." *New York Times*, October 5, 1969.

Connolly, Ray. *John Lennon: A Restless Life*. London: Weidenfeld and Nicolson, 2018.

Courrier, Kevin. *Artificial Paradise: The Dark Side of the Beatles' Utopian Dream*. Westport, CT: Praeger, 2008.

Cross, Craig. *The Beatles: Day-by-Day, Song-by-Song, Record-by-Record*. New York: iUniverse, 2005.

Doggett, Peter. *Abbey Road / Let It Be: The Beatles*. New York: Schirmer, 1998.

Dowlding, William J. *Beatlesongs*. New York: Simon and Schuster, 1989.

Du Noyer, Paul. *John Lennon: The Stories behind Every Song, 1970–1980*. London: Carlton, 2010.

Ellmann, Richard. *James Joyce*. 2nd ed. Oxford, UK: Oxford University Press, 1982.

Emerick, Geoff, and Howard Massey. *Here, There, and Everywhere: My Life Recording the Music of the Beatles*. New York: Gotham, 2006.

Everett, Walter. *The Beatles as Musicians: Revolver through the Anthology*. Oxford, UK: Oxford University Press, 1999.

Fawcett, Anthony. *John Lennon: One Day at a Time—A Personal Biography of the Seventies*. New York: Grove Press, 1976.

"Four Cats on a London Roof." *TV Guide*, April 25–29, 1969, 14–15.

"Get Back to the Staircase," *Genealogy of Style*, December 8, 2014, http://thegenealogyofstyle.wordpress.com/2014/12/08/get-back-to-the-staircase.

Goldstein, Richard. "We Still Need the Beatles, but . . ." *New York Times*, June 18, 1967.

Goodden, Joe. *Riding So High: The Beatles and Drugs*. London: Pepper and Pearl, 2017.

Goodman, Fred. *Allen Klein: The Man Who Bailed Out the Beatles, Made the Stones, and Transformed Rock 'n' Roll*. New York: Houghton Mifflin Harcourt, 2016.

Hagan, Joe. *Sticky Fingers: The Life and Times of Jann Wenner and Rolling Stone Magazine*. New York: Vintage, 2017.

Hanly, Francis, dir. *Produced by George Martin*. DVD. Eagle Rock Entertainment, 2012. Co-produced with BBC Arena.

Harris, John. "*Let It Be*: Can You Dig It?" *Mojo*, 2003 special edition ("1,000 Days of Revolution").

Harrison, George. *I Me Mine*. San Francisco: Chronicle, 2002.

"Jackie Lomax." *Telegraph*, September 17, 2013, www.telegraph.co.uk/news/obituaries/culture-obituaries/music-obituaries/10316228/Jackie-Lomax.html.

Jackson, Andrew Grant. *Still the Greatest: The Essential Songs of the Beatles' Solo Careers*. Lanham, MD: Scarecrow, 2012.

Jagger, Mick. "Mick Jagger Remembers." Interview by Jann Wenner. *Rolling Stone*, December 14, 1995, www.rollingstone.com/music/music-news/mick-jagger-remembers-92946.

Johns, Glyn. *Sound Man: A Life Recording Hits with the Rolling Stones, the Who, Led Zeppelin, the Eagles, Eric Clapton, the Faces*. New York: Blue Rider, 2014.

Johnson, Derek. "Next Beatle Album in Depth: NMExclusive." *NME*, November 1, 1969.

Lang, Michael. *The Road to Woodstock: From the Man behind the Legendary Festival*. New York: HarperCollins, 2009.

Lawrence, Alistair. *Abbey Road: The Best Studio in the World*. London: Bloomsbury, 2012.

Leigh, Spencer. *Love Me Do to Love Me Don't: The Beatles on Record*. Sleaford, UK: McNidder and Grace, 2016.

Lennon, John. "Beatles Music Straightforward on Next Album." Interview by Alan Smith. *Hit Parader*, December 1969, www.beatlesinterviews.org/db1969.0503.beatles.html.

———. *Lennon Remembers*. Interview by Jann Wenner. New ed. New York: Verso, 2000. First published 1971.

Levy, David Benjamin. *Beethoven: The Ninth Symphony*. New Haven, CT: Yale University Press, 1995.

Lewisohn, Mark. *The Complete Beatles Recording Sessions: The Official Abbey Road Studio Session Notes, 1962–1970*. New York: Harmony, 1988.

———. *Tune In: The Beatles—All These Years*. New York: Crown, 2013.

MacDonald, Ian. *Revolution in the Head: The Beatles' Records and the Sixties*. New York: Holt, 1994.

Mann, William. "Those Inventive Beatles." In *The Beatles: Paperback Writer—40 Years of Classic Writing*, edited by Mike Evans, 241–42. London: Plexus, 2012.

Martin, George. "Listen to My Story: George Martin Interview with *Melody Maker*." Interview by Richard Williams. *Melody Maker*, August 21, 1971, n. p.

———. *Playback: An Illustrated Memoir*. Guildford, UK: Genesis Publications, 2002.

———. "The Producer Series, Part 1." Interview by Ralph Denver. *Studio Sound*, January 1985, 56–64.

——. "The Producer Series, Part 2." Interview by Ralph Denver. *Studio Sound*, February 1985, 52–58.

Martin, George, with Jeremy Hornsby. *All You Need Is Ears*. New York: St. Martin's, 1979.

Martin, George, with William Pearson. *With a Little Help from My Friends: The Making of "Sgt. Pepper."* Boston: Little, Brown, 1994.

Massey, Howard. *The Great British Recording Studios*. Milwaukee: Hal Leonard, 2015.

Mastropolo, Frank. "How John Lennon and Yoko Ono's Montreal Bed-In Led to 'Give Peace a Chance.'" *Ultimate Classic Rock*, May 26, 2014, http://ultimateclassicrock.com/john-lennon-give-peace-a-chance-bed-in.

McGregor, Craig. "So in the End, the Beatles Have Proved False Prophets." *New York Times*, June 14, 1970.

Mendelsohn, John. "Records." *Rolling Stone*, May 17, 1969.

Miles, Barry. *The Beatles Diary*, vol. 1, *The Beatles Years*. London: Omnibus, 2007.

——. *Paul McCartney: Many Years from Now*. New York: Holt, 1997.

Miller, Chuck. "Wendy Carlos: In the Moog." *Goldmine*, January 23, 2004, 47–48.

Neary, John. "The Magical McCartney Mystery." *Life*, November 7, 1969, 103–6.

Norman, Philip. *John Lennon: The Life*. New York: HarperCollins, 2008.

"100 Greatest Beatles Songs." *Rolling Stone*, September 29, 2011, www.rollingstone.com/music/lists/100-greatest-beatles-songs-20110919.

Patterson, R. Gary. *The Walrus Was Paul: The Great Beatle Death Clues*. New York: Fireside, 1998.

Preston, Billy. *That's the Way God Planned It*. LP. Hollywood, CA: Apple, 1969.

"Remembering the Forgotten Beatle." *Rolling Stone*, December 5, 2001.

Richards, Keith, with James Fox. *Life*. London: Weidenfeld and Nicolson, 2010.

Riley, Tim. *Lennon: The Man, the Myth, the Music*. New York: Hyperion, 2011.

——. *Tell Me Why: A Beatles Commentary*. New York: Knopf, 1988.

Rolling Stone. *Harrison*. New York: Simon and Schuster, 2002.

Runtagh, Jordan. "The Beatles' Revelatory *White Album* Demos: A Complete Guide." *Rolling Stone*, May 29, 2018, www.rollingstone.com/music/music-lists/the-beatles-revelatory-white-album-demos-a-complete-guide-629178.

Russell, Ethan. Interview with Jack Riley. WPRK-FM, Winter Park, Florida, June 3, 2017.

Ryan, Kevin, and Brian Kehew. *Recording the Beatles: The Studio Equipment and Techniques Used to Create Their Classic Albums*. Houston: Curvebender, 2006.

Schaffner, Nicholas. *The Beatles Forever*. New York: McGraw-Hill, 1978.

Sfirse, Anthony. "Engineering the Sound: The Beatles' *Abbey Road*." *Enmore Audio*, May 28, 2018, http://enmoreaudio.com/engineering-the-sound-the-beatles-abbey-road.

Smith, Alan. "Paul McCartney: *McCartney* (Apple)." *NME*, April 18, 1970.

——. "Singles Reviews." *NME*, April 24, 1971.

Sounes, Howard. *Fab: An Intimate Life of Paul McCartney*. Cambridge, MA: Da Capo, 2010.

Southall, Brian. *Abbey Road: The Story of the World's Most Famous Studios*. Wellingborough, UK: Patrick Stephens, 1982.

——, with Rupert Perry. *Northern Songs: The True Story of the Beatles Song Publishing Empire*. London: Omnibus, 2009.

Southam, B. C., ed. *The Critical Heritage*. London: Routledge, 1970.

Spitz, Bob. *The Beatles: The Biography*. Boston: Little, Brown, 2005.

Spizer, Bruce. *The Beatles Solo on Apple Records*. New Orleans: 498 Productions, 2005.

"Stairwell to Pop History Heaven." *Independent*, August 13, 1995, www.independent.co.uk/news/uk/home-news/stairwell-to-pop-history-heaven-1596031.html.

Starr, Michael Seth. *Ringo: With a Little Help*. Milwaukee: Hal Leonard, 2015.

"Stereo Rattles Stations; Mfrs. Strangle Monaural." *Billboard*, January 6, 1968, 1.

Sulpy, Doug, and Ray Schweighardt. *Get Back: The Unauthorized Chronicle of the Beatles' "Let It Be" Disaster*. New York: Griffin, 1997.

"Summer and Fall 1967—Love and Death in G Major." *Fabcast*, no. 5 (June 23, 2016). Podcast with Howie Edelson, Stephen Bard, and Dave Morrell.

"Take a Ride through the Beatles' Magical Mystery Tour." WCBS-FM, New York City, 2011.

Thompson, Dave. *Hearts of Darkness: James Taylor, Jackson Browne, Cat Stevens, and the Unlikely Rise of the Singer-Songwriter*. Milwaukee: Backbeat, 2012.

Thompson, Gordon. *Please Please Me: Sixties Pop, Inside Out*. Oxford, UK: Oxford University Press, 2008.

Trynka, Paul. "Where Magic Was Made." *Guardian*, March 11, 2005, www.theguardian.com/film/2005/mar/11/abbeyroadfilmfestival.festivals4.

Turner, Steve. *Beatles '66: The Revolutionary Year*. New York: HarperCollins, 2016.

——. *A Hard Day's Write: The Stories behind Every Beatles Song.* London: Carlton, 1994.

Unterberger, Richie. *The Unreleased Beatles.* San Francisco: Backbeat, 2006.

Williams, Richard. *Phil Spector: Out of His Head.* London: Omnibus, 2009.

Winn, John C. *That Magic Feeling: The Beatles' Recorded Legacy, vol. 2, 1966–1970.* Sharon, VT: Multiplus, 2003.

Winner, Langdon. "McCartney." *Rolling Stone*, May 14, 1970.

Womack, Kenneth. *The Beatles Encyclopedia: Everything Fab Four.* 2 vols. Santa Barbara, CA: Greenwood Press, 2014.

Index